StARTing With...

Second Edition

Kit Grauer & Rita L. Irwin

Editors

Canadian Society for Education through Art
Toronto, Ontario

Kit Grauer or Rita L. Irwin
Department of Curriculum Studies
University of British Columbia
2125 Main Mall
Vancouver, B. C. V6T 1Z4 Canada

To purchase this or any other CSEA material contact:
CSEA National Office,
Dr. Michelle Wiebe Zederayko
School of Design, George Brown College
P.O. Box 1015, Station B
Toronto, Ontario M5T 2T9
Phone: (416) 415 5000 x 3475
Fax: (416) 415-2094

Layout and Design: Belidson Dias
Cover: Tita do Rêgo Silva, *Kindheitserzählungen* or *Contos de infância* or Tales from childhood, woodcut, 1997.

We wish to thank Tita do rêgo Silva for giving us copyright permission to use her woodcuts for the cover and throughout the book

ISBN 0-9738340-0-5
Printed in Canada

StARTing with ...

Second Edition

Kit Grauer & Rita L. Irwin

Editors

I want my classroom to be a place of inspiration, wonder and creativity and be the kind of teacher that bring joy and adventure to learning. I want my students t dream, imagine, draw, paint, sculpt, build, create and invent. I want to help students explore and appreciat.

the beauty and diversity in the world and learn to se things in new ways and explore new perspectives. I wan to find out how art can open worlds and ways of seeing. want to find ways of teaching art that are engaging an imaginative and touch children's lives in meaningful ways

Contents

Introduction vi
Kit Grauer & Rita L. Irwin

1 Learning In, Through, and From Art 1
Rita L. Irwin

2 Windows to a Child's World: Perspectives on Children's Art Making 9
Sylvia Wilson Kind

3 The Role of the Teacher and Teaching Strategies 19
Christa Volk

4 Putting on Your Happy Face? Exploring Identity through Authentic Art Education 23
Michael J. Emme

5 Visual Thinking Journal 31
Belidson Dias & Kit Grauer

6 Breaking the Grip: Drawing beyond anxiety and visual realism 43
Nadine Kalin

7 The Elements of Art 51
Heather A. Pastro

8 Themes, Cross-Curricular Connections and Daily Drawing 62
Harold Pearse

9 Art Education and Human Values 72
Boyd White

10 First Nations Art and Culture: Tradition and Innovation 80
Bill Zuk and Robert Dalton

11 Art is Like a Bowl of Fruit: Aesthetics and Art Criticism in the Elementary School 88
Steve Elliott

12 Lights, Camera - Conversations? Using Digital Media to Talk with Artists in our Local Communities. **Don Krug** 96

13 Art Education and Social Justice: An Elementary Perspective 104
Graeme Chalmers

14 Starting with Art: Relating Children's Visuals and Written Expression 110
Kit Grauer

15 Learning in the Art Gallery: Essential Not Enrichment! 118
Jennifer Eiserman

16 Putting it on Show 128
Mary Blatherwick

17 Image Development: The Mystery and the Magic of Art 136
Sharon McCoubrey

18 Approaches to Elementary Art Assessment 145
Fiona M. Blaikie

19 Don't Run With the Scissors 154
Nadine Kalin

Introduction
Kit Grauer and Rita L. Irwin

StARTing with… is an introduction to the art of art teaching in Canadian schools. This second edition was designed and written by art teachers and art teacher educators from across Canada who wanted to provide a stARTing point for those interested in teaching as they think about their beliefs and values toward art education. With this in mind, we want you to be actively engaged with the ideas presented in the next hundred plus pages by becoming a co-author, making connections with the ideas you have about art in the education of children, reflecting on how the ideas fit within your conceptions of yourself as a teacher of art, and especially, imagining, (in image or in text) how you will use this information in your own teaching repertoire. We want you to push the boundaries of this book at all levels - questioning the assumptions, exploring some of the possibilities, and researching what lies beyond, as you consider your own personal experiences and the literature in the field of art education. What follows are some suggestions on how you might use the text as a working resource.

No resource book can provide all the inspiration, knowledge, pedagogical strategies and techniques necessary to make a great art teacher. This book introduces you to the key roles, values and issues concerning teachers of art at the elementary level while also asking you to move beyond the pages into the realm of the possible. Many of you will be using this text in conjunction with your elementary art education curriculum and instruction classes, and as such, will have the opportunity to explore the ideas within a community of beginning teachers representing a range of understandings about the place of art in schools. We hope you will take advantage of this opportunity to listen carefully to the stories of others as you make sense of your own beliefs and practices. We firmly believe the process of becoming a teacher is a process of starting from your experience, while exploring new ideas and conceptions, as you build a basis for making the best decisions possible in the classrooms you will teach. This process is a life long journey as a teacher. We hope you will take the initiative to go beyond what is within these pages in order to search out what is meaningful to you in your memories and experiences, as well as in art galleries, museums, community centers and cultural events, and even media sources such as books, articles, magazines, film, video and the internet.

One of the important places to start this search is from your own art experiences in school: have your own experiences shaped what you believe to be possible? Deborah Smith-Shank (1993) uses the metaphor of dragon teachers - those teachers of art, who like dragons, inflict injury on their students – who teach unreflectively and in so doing, often make art classrooms a site for anxiety and

angst rather than a place of transformation. No one intentionally, we hope, becomes a dragon teacher. By starting with your own experiences and continuing to critically reflect on them as you move through theory and practice, we hope you become aware of, and critically examine, your underlying assumptions with the view toward positively transforming children's learning through art experiences.

What are some of the ways you can reflect on your experiences with art in school? One possibility is to create a visual metaphor of yourself as a teacher of art. Select a metaphorical image, either from a found source, an existing artwork, or an image of your own creation, and use it to discuss your beliefs around art in children's lives and your place within that vision. Visual metaphors are open to interpretations that may not be obvious at the time of choosing. They also open up sites of emotion and ambiguity as well as reasoned argument. Comparing visual metaphors during your teacher education program, or during your ongoing development as a teacher, may help you articulate or visualize your changing perceptions of your role as a teacher. Other possibilities might include personal written narratives of your experiences with art that are in turn shared with others. Some of these stories may have inspired, nurtured, confused or destroyed your own encounters with art. Use these narratives as springboards for journal writing, drawing or collaging in the open spaces within each chapter layout. Record your thoughts and beliefs as you encounter each new chapter and consider how they fit or do not fit into your own worldview. These types of reflections are designed to build a connection between your personal and professional experiences, as you highlight what experiences may help or hinder the place of art in the lives of children. It is surprising how differently we may wish to teach once we recall our experiences as children. We hope you will start with some form of reflective process as you begin this journey of becoming an art teacher. Do the dragons of your experience stop you from the possibilities or do they make you more steadfast in your quest?

Moving from your own beliefs and experience, we also ask you to venture out into the world around you and observe children in the process of making and responding to art. Watch a group of two or more children draw. Bring the drawings back into class and use them as springboards for discussion as you consider theories of children's drawing development or what young children do or say. You might ask yourself some questions such as: What surprises you or adds to your knowledge? What differences did you observe between the engagement of individual children and children of various ages? In your continuing quest you could interview adults and children about their definitions of art (and learning in art) and consider their conceptions alongside your own growing definition of art and learning in and through art before asking yourself even

more questions. What art activities bring joy to you or challenge your values and assumptions? When is it appropriate to teach skills and what skills need to be taught? How should we endeavor to balance art making with responding to art, and how do we choose whose art to study? It is instructive to learn from others as you position your own beliefs within the field.

There are a plethora of resources available to teachers in books, magazines, and on the internet, that give lesson and unit ideas for art in elementary schools. Start collecting sample lessons or units on various topics. You might want to start with some of the ideas presented within this resource to see how the topics are played out in other contexts. You will be amazed at how many resources are available to teachers and how many will need to be modified or discarded. Choose those that fit with your beliefs about how art should be taught - share them with your class mates and be prepared to reflect critically on why they should be taught. Debating what might work and why is an important characteristic of excellent teachers. Curriculum guides and instructional resources are just that - guides and resources. It is up to you as a teacher to make the pedagogical choices that bring ideas to life in your classroom. Question how your art lesson may or may not be integrated in a thoughtful way with other curriculum areas. Collect copies of how teachers evaluate student's artistic learning and question whether the evaluation values the learning. What are the criteria used for making judgments? How are students a part of the process or recipients of judgments? What does this information tell you about the conceptions of art education being employed?

Investigate the resources you have as a teacher in your area: you might be pleasantly surprised to find an artist in your neighbourhood or you might expand your definition of art, who makes art, and what art is for through your interactions with local venues such as galleries. Think about how we incorporate experiences with art and artists as we give children a chance to connect to the world outside of school. Furthermore, consider how we display the art works of children as a site for conversations around teaching and learning in art.

Many of the chapters will ask you questions as a way to help you make connections with your own experiences and the experiences of others. This book is of particular benefit to educators interested in the changing Canadian context. It is situated in the collective experience of the authors as art teacher educators working alongside beginning art teachers over many decades. As much as possible, we have tried to present a visually rich format to echo our belief in the power of images. Belidson Dias, the art educator who took on the design of the book, deserves the credit for making this concept a reality. We are indebted to him for his keen sense of vision, not only within these pages, but also in the very embodiment of the book itself. Please make this book a resource for you as you question and shape your identity as the teacher of art you envision.

Reference

Smith-Shank, D.L.(1993) Beyond this point there be dragons: pre-service elementary teachers' stories of art and education. *Art Education*. 46 (5), 45-51.

Acknowledgments

We would like to acknowledge the following individuals and groups for providing us with copyright permission to use photographs and images throughout this text:

Alexander Scurr

Art Image Publications, Montreal

Belidson Dias

Bill Zuk & Robert Dalton

Boundary Beach Elementary -Grade two-1998

Boyd White

Cathy Swabey

Kit Grauer

Harold Pearse

Harpreet Deol

Heather Pastro

Michael Emme

Sharon McCoubrey

Sylvia Kind

UBC Preservice teachers, Graduate and Children's art classes 2001-2004

Vicky Cannon

Violette Baillargeon

Visual Journals from Delta, Richmond and Vancouver schools

Learning In, Through, and From Art

Rita L. Irwin

When I visit galleries, museums, or concert halls, I know I will have particular kinds of experiences. These venues are designed and maintained in ways that inspire particular qualities of experience: we enter each place knowing we are going to pay attention to something. I know when I venture into one of these environments I am bringing my unique set of attitudes, beliefs and knowledge with me as I experience the features of the event or object. I enter these environments also knowing, perhaps expecting, to be enriched. Once inside, my senses are recharged, my imagination is ignited, my emotions are revealed, and my soul often finds meaning in unexpected ways.

Whereas venues for the arts call us to experience the fullness of our humanity, schools are often limited to, or defined by, reaching the cognitive potential of students at the expense of realizing our full potential as human beings. Unfortunately, less attention is often given to knowing through our bodies, emotions, and spirits than the attention given to our minds where testing and rankings are used to measure intellectual rigour, competencies, and ultimately, one's abilities in narrowly defined ways.

As I reflect upon my learning experiences in each of the earlier mentioned venues I am struck by a fairly obvious revelation, one that so many of us know but gradually disregard under societal pressures. Being in environments rich with artistic activity, whether as a spectator or creator, calls me into experiencing the world in holistic ways. I am instantly transported into a space and time that causes me

> **Unfortunately, less attention is often given to knowing through our bodies, emotions, and spirits than the attention given to our minds where testing and rankings are used to measure intellectual rigour, competencies, and ultimately, one's abilities in narrowly defined ways.**

to feel, to perceive, to move, and to contemplate. I am thrust into the wholeness of my being. I am no longer objectifying knowledge, rather, I am experiencing knowing. For instance, why is it that most of us cannot retain facts we have memorized for an exam? I suspect it is because we did not experience that knowledge (see Dewey, 1934). When I have allowed myself to experience meaning making through movement, emotional response, and soulful attachments, as well as perceptual engagement, I have always retained my new found knowing. It stays with me. It means something to me. I understand it in very concrete ways.

Schools, and the curriculum found within our schools, have something to learn from the arts and from venues that celebrate and challenge the arts. Holistic learning is essential for learning (see for instance Hocking, Haskell, & Linds, 2001; Miller, 1988; Nava, 2001) and the easiest way to ensure that learning is holistic is to embrace learning in and through the arts (see for instance Burnaford, Aprill, & Weiss, 2001; Grauer, Irwin, de Cosson & Wilson, 2002; Krug & Cohen-

consciously enlarge our repertoires of lesson planning so children are able to experience learning through art in a variety of ways.

Evron, 1999). Sylvia Kind outlines in her chapter in this volume, ways in which children enact or perform art(or image) making. These performances portray a range of entry points into understanding how children learn through art. Whether it is through story telling, play, relationship building, active learning or attending to the sensory qualities, children learn in a variety of ways. As teachers we need to consider these entry points and

A number of the authors in this volume talk about the importance of the arts to the rest of the curriculum. Recent research shows when students are involved in learning activities that include the arts, their mathematics achievement scores increase (Upitis & Smithrim, 2003). This is but one small reminder that a holistic education which includes the arts is not provided at the expense of mathematics. In fact, more mathematics instruction does not necessarily yield higher mathematics scores. Research suggests the opposite: a balanced curriculum, which includes the arts, actually strengthens all learning. Students would be engaged with their own learning, find their own passion, and create their own minds (Eisner, 2002).

What can we learn from the arts? A number of educators have written extensively on the importance of the arts (eg. Chalmers 1996; Eisner 2002; Greene, 1995; Lankford 1992; McFee & Degge, 1980). If you were to read their work you would see that people value the arts for a wide range of reasons. For instance, the arts provide pleasurable, sentimental, inspirational, informative, and surprising experiences; the arts provide economic, social and political influences; and the arts provide insight into society through skillful accomplishments, historical interpretations, and cultural characterizations. Art communicates by generating, recording and transmitting ideas.

Art acts as a cultural source and resource by helping people form identities and recognize accomplishments while also destabilizing practices that are problematic. Art enhances our lives by making the ineffable tangible. In very general terms, the arts contribute to our personal efficacy as well as our interconnectedness with all living and spiritual entities.

Learning in art provides a rich base from which to explore ideas, sensory qualities, penetrating questions, and personal feelings through the use of materials, in the case of studio-based art, or through the use of texts (highlighting art history, criticism, or aesthetics), in the case of discourse-based art. Nothing can replace learning in art. Just as I recognize learning to play the piano offers me greater scope in appreciating the work of great pianists, so too does my learning in art offer me greater understanding of the work of those who spend their lives committed to the discipline of their art. As I paint, I understand the work of painters even more.

I appreciate the work of artists whose ideas and styles are similar to, yet different from, my own. Recently, I experienced an artist-in-residence program in which an African drummer visited a school. He created simple drums for his students and together they played impressive rhythms. Needless to say, students requested drums for

their holiday gifts later in the year. Drumming became an important expressive and creative activity for his students.

While the arts are important for many reasons, one might wonder what principles should guide educators as they design curricula. Eisner (2002), a foremost art educator and curriculum specialist, articulates five principles that can guide our practices. He states: "In justifying its case, art education should give pride of place to what is distinctive about the arts … foster the growth of artistic intelligence … help students learn how to create satisfying visual images … help students recognize what is personal, distinctive, and even unique about themselves and their work … [and] make special efforts to enable students to secure aesthetic forms of experience in everyday life (pp. 42-45)." Keeping these principles for designing curricula in mind, several authors in this volume

What can art teach us about learning that will inspire a love affair with learning itself?

elaborate upon how a teacher might go about planning for quality art instruction. Christa Volk explores aspects around curriculum planning in art education. Many of the ideas found in her chapter are elaborated upon in Michael Emme's chapter. For instance he further develops the themes introduced in Volk's chapter: a) the elements and principles of design as a visual dialect; b) materials and processes found in craft, clutter and joyous decision-making; and c) responding to art through visual strategies. Emme goes on to add the themes of image development through self-portraiture and non-verbal self-reflection. Each of these themes forms a basis for exploring how the arts can enhance the emotional well-being of children. Sharon McCoubrey continues along this same line by providing in-depth examples of image development sources, strategies, and skills as well as a rich array of image development activities. Nadine Kalin calms our anxietes over drawing and leads us through some strategies that are sure to break an abiding grip on visual realism. These chapters have helped us understand how to make image development both personally and socially meaningful. Heather

Pastro outlines the elements of design in great detail, not only for their basic properties, but also for their use within a range of studio based activities. This listing of ideas should serve to introduce the design elements to teachers in very practical ways. Implementing these ideas into lesson planning will surely enhance the effectiveness of one's goals. Fiona Blaikie discusses art assessment practices in BC, Ontario and Nova Scotia. Though many practices are similar a few differences exist. This comparison should help teachers analyze the best assessment practices for their classroom.

I opened this chapter by arguing for a holistic education and in so doing, presented the case for the arts to be infused throughout our learning experiences. The arts invite us to address learning in a holistic manner. *Learning through art* provides the basis for experiential learning to take place: learning that is durable in and through time. I then went on to support this rationale for learning through art by reflecting upon the many reasons the arts are distinctly important in our lives. I then articulated the principles art educators could use to design *learning in art*. Art for art's sake is critical because art transforms our consciousness. We understand our selves, our cultures, and our histories, through our sensory and aesthetic experiences. "Work in the arts is not only a way of creating performances and products; it is a way of creating

our lives by expanding our consciousness, shaping our dispositions, satisfying our quest for meaning, establishing contact with others, and sharing our culture" (Eisner, 2002, p. 3). Harold Pearse has done this within his own life. In this volume he illustrates how making cross-curricular connections through thematic daily drawing experiences opened up opportunities for learning with and through art in richly stimulating ways. Focusing on his dog, he *learned with art* (by studying art works with dogs he was able to learn about dogs) and *he learned through art* (by expressing his feelings toward his dog through his art making, he came to appreciate his relationship with his dog even more).

Yet it was his *learning in art*, or his drawing experiences, that allowed him to explore a wide array of ideas. Making connections *in* and *through art* became powerful learning experiences for Pearse to explore his relationship with his dog. Graeme Chalmers takes learning through art to another dimension when he attempts to have us look critically at why we teach art. He posits that teachers and students alike need to recognize that all art is political and even elementary students can make visual statements about injustice. Bill Zuk and Robert Dalton guide us through understanding how to include First Nations art and culture in an art curriculum. They place much emphasis on tradition and innovation, showing how both are important to understanding First Nations cultures today. Don Krug discusses the importance of technology to learning and describes how teachers might use technology for understanding how community-based artists and their work are dynamic cultural change agents engaged in acts of socio-cultural meaning making. Steve Elliott guides teachers through discussions on the nature of art and details how one might help students talk about art using notions of art criticism. Boyd White shares insights on how we might help learners engage with aesthstics as they discuss values, feelings and visual destination. Kit Grauer draws to our attention how art making and writing share similar yet different processes. By understanding this teachers may be able to strengthen their planning practices in both language arts and art instruction. This is further strenghtened by the chapter on visual thinking journals by Belidson Dias and Kit Grauer. As students and teachers embark upon visual and textual inquiry in these process journals, their learning across the curriculum is strengthened. Jennifer Eiserman takes us into the realm of visual literacy and illustrates how teachers can access art

in galleries and museums. Several models are described and Eiserman outlines how each can be integrated into one process. For those teachers who are unable to take advantage of galleries and museums, one might be able to create a school art museum for all students, teachers and community members to enjoy. Mary Blatherwick adds an important dimension to this volume by elaborating on how student art exhibitions are an important part of an art education curriculum as those involved learn to talk about art, appreciate it and learn from it in ways that are only accomplished through the display of ongoing art making experiences.

Learning in art and *learning through art* are both important to a vital educational program for all students. Yet there is one more twist of phrase to be considered. *Learning from art*. What can art teach us about learning that will inspire a love affair with learning itself? As I reflect upon treasured experiences in my studio, my many long walks in nature, or my lingering visits with works of art, I am struck by the ways the arts have caused me to keep learning out of the sheer joy and excitement I feel for learning. The arts have taught me there isn't one right answer; how something is communicated is just as important as what is communicated; imagination transforms understanding in unique and surprising ways; aesthetic sensibilities one's quality of life; being purposefully flexible enhances work and life; and lingering in an experience is vital to appreciating the inherently rich

qualities I initially sought from the experience (see Eisner 2002). As I have reflected upon these ideas over my career, I have attempted to consider my teaching as an art form. At times this means paying attention to the rhythms of the day and the lesson being taught while being careful to attend to patterns of interactions, to spatial relationships between individuals as well as between individuals and objects, to the colours in the classroom as well as tonal qualities in other sensory experiences, and to the storytelling nature of learning. These qualities have often sparked my attention to the ineffable, to that quality of experience that is difficult to talk about yet is easily recognizable by all who experience it. Performing teaching as an art form, calls teachers into a space of artistic work many seldom consider. Teachers who attend to

their practice as an art form are often viewed as the teachers we remember years later, those teachers whose practices/processes make just as much difference, if not more, than the actual products of learning. People follow passion. Everyone wants to love what they do and who they are. When we experience teachers who are passionate about their own learning and their work, as learners we find ourselves motivated to learn for we want what our teachers have!

Learning in, through, and from art are each important to the design of curriculum experiences in any learning environment at any age level. Possibilities for learning are endless if one considers the magnitude of these ways of learning.

Learning in, through, and from art are each important to the design of curriculum experiences in any learning environment at any age level.

References

Burnaford, G., Aprill, A., & Weiss, C. (2001). *Renaissance in the classroom.* Mahwah, NJ: Lawrence Erlbaum.

Chalmers, F. G. (1996). *Celebrating pluralism: Art, education and cultural diversity.* Los Angeles, CA: The J. Paul Getty Trust.

Dewey, J. (1934). *Art as experience.* New York: Minton, Balch.

Eisner, E. W. (2002). *The arts and the creation of mind.* New Haven, CT: Yale.

Grauer, K., Irwin R. L., deCosson, A., & Wilson, S. (2001). Images for understanding: Snapshots of learning through the arts. *International Journal of Education & the Arts,* http://ijea.asu.edu/v2n9/

Greene, M. (1995). *Releasing the imagination: Essays on education, the arts, and social change.* San Francisco, CA: Jossey-Bass.

Hocking, B., Haskell, J., & Linds, W. (Eds.). (2001). *Unfolding bodymind: Exploring possibility through education.* Brandon, VT: Foundation for Educational Renewal.

Krug, D. & Cohen-Evron, N. (1999). Curriculum integration: Positions and practices in art education. *Studies in Art Education: A Journal of Issues and Research in Art Education,* 41(3), 258-275.

Lankford, E.L. (1992). *Aesthetics: Issues and inquiry.* Reston, VA: National Art Education Association.

McFee, J. K., & Degge, R.M. (1980). *Art, culture and environment: A catalyst for teaching.* Dubuque, IA: Kendall Hunt.

Miller, J. P. (1988). *The holistic curriculum.* Toronto, ON: OISE Press.

Nava, R. G. (2001). *Holistic education: Pedagogy of universal love.* Brandon, VT: Foundation for Educational Renewal.

Upitis, R. & Smithrim, K. (2003). *Learning through the arts national assessment.* Toronto, ON: Royal Conservatory of Music.

CONNECTING, REFLECTING AND IMAGINING

Windows to a Child's World: Perspectives on Children's Art Making

Sylvia Kind

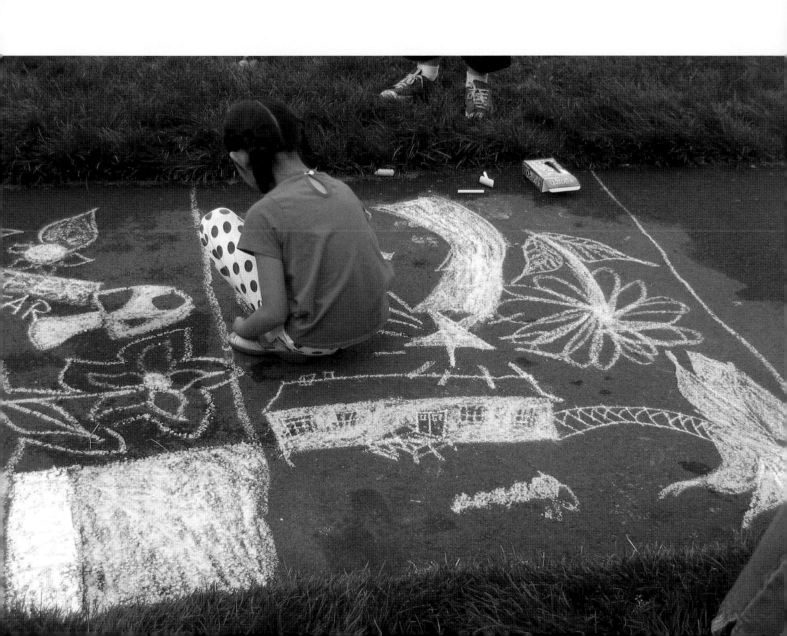

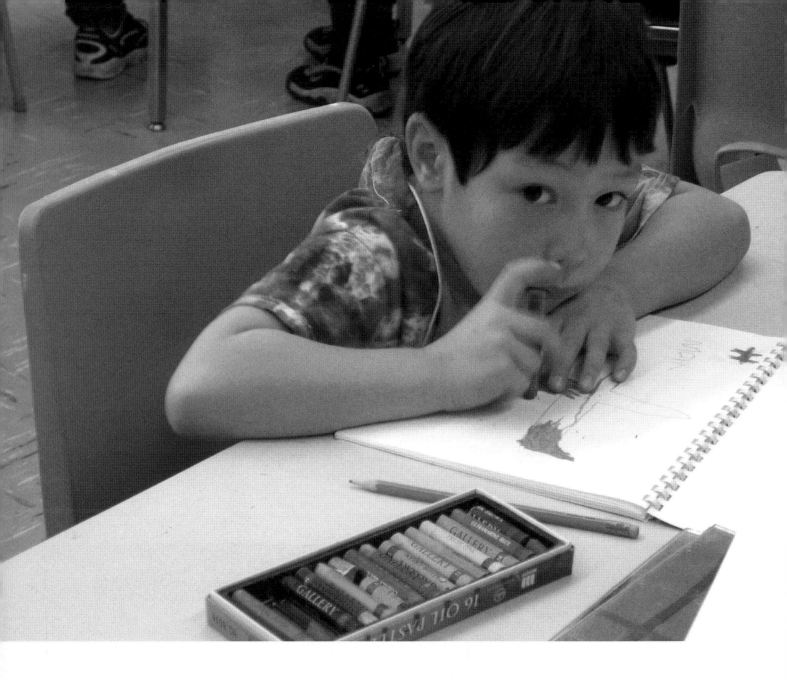

For the past several years I have been teaching a course at the University of British Columbia involving elementary school aged children and pre-service and practicing teachers. About 30 children from the community come for an eight-week Saturday art program while the adults registered in the course plan, facilitate, teach, and observe the children. The children work in a variety of media – drawing, painting, pastels, clay, textiles, collage, and 3D mixed media work – while exploring particular themes relevant to their lives. It's an exciting, high-energy course and the teachers, through observing, interacting, and listening to the children, as well as discussing current research in art education, consider what children do and intend when they make art.

Over the years I have sought ways to help teachers understand and enter into the children's world of art making believing that insight into children's actions and intentions when they make art is a very important factor in being able to provide quality art instruction and support for young artists. A focus primarily on the end product or the art images or objects children produce generally leads to an emphasis on skills and techniques and attention to the way a work looks. While this is a valued part of art making and art instruction, an awareness of children's intentions, processes, ways of working, and differing motivations can lead to support in multiple ways of framing a project, help enrich children's experiences and learning, deepen their means of expression, and offer multiple avenues for exploring an issue or theme. It also helps teachers facilitate art making activities and art learning experiences in ways that are meaningful to children. This chapter outlines some of the views I encouraged teachers

to take throughout the course.

A Developmental View

A developmental framework is one of the most familiar lenses to look through in trying to understand children's art and image making. In general, a developmental view outlines children's beginnings with scribbling and random mark making and charts a progression to symbolic representations and more differentiated and complex imagery. One of the most common models presented in educational literature is that of universal and linear stages of development. This is marked by a sequential progression from scribbling, through to pre-schematic and schematic stages, to realistic representations (Kellogg, 1969; Lowenfeld & Brittain, 1987). Each stage flows out of the previous one as children move through the sequence of random mark making, creating enclosed shapes, tadpole figures, early realism including x-ray, fold-over and floating images where children draw what they know rather than what they see, and naturalism or mature realism where children attend more to the visual details of an object and begin to draw more what they see rather than what they know.

Although research has challenged the linearity of scribbles to realism progression, proposing a more map-like model (Kindler & Darras, 1997), a multiple end points approach (Duncum, 1999), or one that is contextualized by socio-cultural influences (Wilson & Wilson, 1977; 1985), a developmental view is located within a particular understanding that sees the scope of what children do in art as development from simple to complex representations based on psycho-biological, as well as socio-cultural influences.

quickly progress from early developmental stages to more complex imagery and structural forms. And once children progress past a certain point, a developmental framing of children's art making loses its relevancy. While one can teach within this framework by encouraging the unfolding of children's artistic expression as well as facilitating continued progression and growth within the zones of proximal development (Vygotsky, 1978), this is difficult when working with other materials such as textiles, papier-mâché, or collage. It is difficult to say what 'development' in these areas looks like and it does not even seem to be a relevant frame for these and other art media. As Pearson (2001a) argues, in order to take this view and encourage continued development, one must understand what it means to be 'artistically developed.'

This view is most useful as a general way to situate and understand young children's work and is an important and helpful beginning point. In the course I was teaching this view helped teachers get to know the students and their abilities, and plan for drawing instruction. It helped them understand what certain children were able to do and look ahead to how to help them progress. Nevertheless, while teachers certainly should be aware of current research in children's development in art as it offers significant insight and understanding, there are limits to this view. With the exception of Claire Golomb's work on children's development in clay sculpture, most of the research tends to focus on children's drawings. Although there are reasons for this as children's drawings are readily available and are easy to collect and store, it is problematic, as most often children's skills in graphic representation don't transfer directly to other art media. Each art medium can evoke different ways of thinking, understanding, working, and image making. Anna Kindler (1997) believes, children's artistic processes and representations are inherent in the limitations and unique characteristics of the medium. Their level of comfort and experience with that medium influences how an image takes shape. Additionally, it tends to promote the idea that to be 'developed artistically,' means to draw well.

The limits of the model can be seen in giving a clay lesson for example. Without any instruction most children will create spiders, flat figures, snakes, bowls or other simple objects (Golomb, 1974; 1992). After one lesson on clay building techniques children will

A developmental perspective suggests a movement towards something, an end point or direction to the development. Whether it is a map metaphor (Kindler & Darras, 1997), a river (MacGreggor, 1997), a multiple end points perspective (Duncum, 1999), movement, change, growth, or a journey towards a destination is inherent in this view (Pearson, 2001a). Each assumes that a line (whether it is straight, curved, meandering or other) of development can be plotted between early representations and more 'developed' ways of representing. To encourage continued development in each media, teachers must be aware of where one is going.

After using a developmental framing to look at children's art making processes, it seemed necessary to consider other views. Rather than seeing children's art making as a developmental movement towards greater skill and competency, I found it useful to view their art making as range of "repertoires" (Kindler, 1999, p.

331) or "representational performances" (Freeman in Pearson, 2001b, p. 68), as events enacted in relation to the materials one works with, children's different interests and learning styles, and cultural values and meanings.

Children's Art as 'Representational Performance'

Understanding children's art making efforts as a 'representational performance' is based on certain underlying, yet connected, ideas or principles. First, visual art is not just visual – it engages much more than just *visual* ways of knowing and experiencing. Creating art is an engaging, embodied, sensory, sensual, tactile, kinesthetic, communicative, critically reflective, culturally negotiated, private and social endeavour. It is a process that is understood through experience and active engagement (Grallert, 1991) and is dynamic, participatory, and grounded in the physicality of making. How one engages with art making also changes and shifts according to the materials one works with.

Working with particular art materials can enliven one's senses and evoke memories and experiences that are

uniquely related to the supplies being worked with. The heavy, damp, dense texture of the clay, the cold, slippery, gooey feel of wet papier-mâché, the warmth and comfort of certain textiles, and the thick, vibrant, rich globs of paint lying waiting on the palate, all are part of the art experience and influence how the art image or art object takes shape.

Through the materials, stories, events, and characters are enacted, fantasy worlds created, imaginations inspired, bodies and senses engaged, ideas expressed, struggled with, and worked through, as visual details are rendered.

Second, it is loosely based on Gardner's theory of multiple intelligences (1983) and the MUSE, entry points approach to looking at and talking about art (1996). Although I question the idea of distinct intelligences, there are multiple ways of engaging with learning and understanding something. Each learner brings his/her own perspectives and dispositions and learning styles to a task. In the MUSE entry points approach to engaging children with viewing and talking about art, Jessica Davis proposes a model that takes this into account. Children are drawn into the artists' works through different entry points such as aesthetic, narrative, logical/quantitative, foundational, and experiential pathways. Davis acknowledges art as a process of constructing and comprehending meaning and how children learn, describe, make sense of, and communicate experience varies among learners.

Thirdly, it is based on the understanding that art making is both a personally and socially constructed act. Art making may serve different purposes for different children and what children do cannot be separated from the culture and society of which they are a part. How one enacts one's life, the meanings that are constructed around certain activities, and how they are viewed and received by others is to a large extent, socially constructed. It is possible then, to view children's art making as an act or performance, not merely as an individual representational impulse, but as a social performance that changes according to the context and meanings attached to the art-making act (Pearson, 2001a).

I outline here 5 modes of representational performance: narrative, experiential, social, action, and aesthetic. This is not intended as a complete list and each mode is not necessarily exclusive of the others. There may be several modes at play when children create and that which is most prominent may shift and change according to the nature of the art activity, the materials used, the meanings attached to the art, as well as children's own learning styles and interests.

I have found however, that it is a useful way to frame discussions on how children enact or perform art or image making in the classroom.

Narrative

When children create images and art objects, their art may tell a story or relay an experience to others or to one's self. The story may be fantasy or real. It may act out a narrative or construct one through images. Art is used for story telling and story making. It has a communicative function and intention and is an enacted as a way to remember, celebrate, make meaning, describe, invent, or come to terms with an experience. Children may create art to communicate, express, and articulate experience (Steele, 1998). The resulting art image or object may look like a map, a 'typical' self-portrait, a clay figure, collage, or a variety of other representations but the means by which it was thought through and came into being was through narrative.

Julia Kellman (1995) describes three kinds of narrative in children's art: narrative as invention, as description and as negotiation. In the first, stories are told to create diversions, fantasy worlds, or to provide a means of escape, and make-believe lands and imaginary worlds are brought into being. Kellman illustrates this through the example of Nelly, a Jewish child growing up in hiding inside Czechoslovakia during the Second World War. Her images were of beautiful places, where there was no war or danger, where "everyone liked each other…and all the people were as free as kites in the sky or butterflies in the field" (Toll in Kellman, p. 19). Rather than depicting the realities of war, loss, or fear, her drawings created a world that was safe, hopeful, and beautiful.

Creating art also acts as a description of the circumstances, events, feelings, people, pets, and places that are part of a child's immediate life. Children are able to share the daily details of their lives with others through their created images and illustrate the particulars of the time and place in which they live. Their images act as a record of the circumstances of their lives and of their interests and preoccupations.

Narrative can also act as negotiation and as a way of dealing with and making sense of experiences and human interactions.

Narrative then can be used to describe, invent, and come to terms with one's circumstances. In listening to what children have to say about their art works during their process of creating them, one can observe the prominence of narrative in framing children's understanding of what they were engaged with and creating. Narrative is central to human experience (Bruner, 1990) and is the frequently process by which children make sense of their lives.

Experiential

Children also learn and create through play, movement, and through the physicality of working with art materials. An art activity frequently prompts engagement in sensory, kinesthetic, and physical ways. The tactile and sensory qualities of an art medium may be the most important feature to some children both in inviting participation and being a deterrent (i.e. the temperature of the wet papier-mâché or the tight constricting sensation of clay drying on one's hands). And when children work with unfamiliar materials this may take precedence.

In clay, for example, the process of creating, building and rebuilding may be more important to some children than ending up with a product. Or experimentation with the media, that is finding out what it

can do through manipulating it, may be the most engaging and inviting aspect of an art activity. In the Saturday art program for example, whenever we did a collage activity, students who had limited previous experience with a wide variety of collage materials found it difficult to attend to the aesthetic, narrative aspects of the art project and were more intent on playing with and manipulating the materials, adding as many items as they could irrespective of the content or intention of the art project.

Learning through one's hands and understanding through one's body in interaction with the art materials is an important part of art making. For some children art making can be a very kinesthetic, exploratory, largely unplanned and emergent endeavour. The materials may lead and direct one's imagery, and representation may arise out of the process of discovery and experimentation. Although this may be more typical of how we think very young children work, it isn't limited to this age group. Children's human sense, or sense they make of the world, is situated and tied to their experiences and to what is familiar to them (Walsh, 1999). Mastery in a medium depends to a large extent, on becoming familiar with that medium, learning about its properties and limitations and children need time to explore and experiment. Each material presents particular limits and possibilities. Some children may be more kinesthetic learners and enter into art making though the tactile and sensory qualities of the materials.

Social

Art making can be an enjoyable social activity. For many children, art is experienced as a shared activity, or as play, interaction, and social bonding. Drawing (or any other form of art or image making) may be a form of securing social approval (Pearson, 2001a) and negotiating relationship. As children create art they share, converse, learn from others, and become part of a community (Eisner, 2002). What children create, and the images and representations that result may be secondary to their social interactions. As children create papier-mâché puppets for example, the characters may come alive and join the circle of friends sitting around the table. In textiles, the act of stitching and talking, helping each other thread needles and sort through the scrap fabric box may be of primary importance so

that the resulting work may be more representative of the social interactions that occurred than it is of any attempt to visually represent something.

Pearson (2001a) describes drawing as a social practice that leaves an "artifactual residue" (p. 348). Residue suggests the traces, remains, and marks left behind. They reference the location, place, people, objects, and activities but only are trace reminders of the lived, experienced actions and the meanings within an art activity are not always explicit in the residual traces.

Action

Action pictures or 'action representations' (Matthews, 1984) are descriptive, embodied, and enacted depictions using a combination of drawn marks, speech acts, and movements. A child may draw a train for example, enacting its sound and movements, yet all that remains on the page is a long squiggly line as evidence of

its journey. Although this may be more common in very young children's representational activities, older children may also act out or perform an image with gestural, verbal, and visual cues. The visual image may reference an action and be incomplete on its own.

There also are images and marks that leave no residual evidence or trace, but are rather, enacted, performed, and denoted by movement, drawings in the air, or sculptures represented in bodily movements. For some children these enactments constitute the core of their art making and imagery (Kindler, 1999). A child creating a clay sculpture of an elephant for example may get down on the ground and become the elephant, posing as he or she imagines the sculpture to turn out. Such representations may seem to be more related to play acting or drama, yet are inseparable from the child's visual art and image making as he or she 'becomes the art.' Anna Kindler (1999) describes this in detail in her discussion of alternate modes of representational activities where children perform a visual image and in a sense state, 'I am the art.'

Aesthetic

And finally, an aesthetic orientation attends to the surface qualities, physical properties, and/or the visual elements of an emerging artwork. What the art image or object looks like may be the most important factor to some children and may take precedence over any story it may tell or other communicative or expressive purposes. This does not necessarily mean that realism is the goal, but that the visual and physical qualities, such as how to create balance in a clay sculpture of a standing horse without using an armature, or how to create the illusion of distance in a painting, may take precedence over other considerations. Primary attention is given to how to make it look a particular way.

For example, in the events Anna Kindler (1992) relays of her son's drawing of a goat, and his searching for a satisfying visual representation, what it looked like was the main issue he explored. He wasn't interested in 'creative expression' or narrative aspects of pictorial representation. His primary interest was in how to create an image of a goat that looked like he thought a goat should look. This kind of a focus is also determined by the nature of the art activity and the socially and culturally constructed meanings that are part of it. Cultural meanings around what one draws, how one draws, how one perceives one's drawings, and what it means to draw are all part of children's experience and understandings of drawing. Students likely will approach mixed media work, collage, puppet making, and drawing differently as there are different meanings attached to different art processes. Artistic expression and creation are culturally situated activities (Wilson, 1997) and as Pearson describes, "Whatever value drawing [or other forms of art making] has for children is bound to the context in which it takes place, and as the context shifts so does the value" (2001a, p. 358).

Conclusion

In the Saturday art program, teachers were asked to consider what children do and intend to do when they make art while also considering what art making means to them. Teachers were also asked to reflect on what happens when children make art and what could they learn from them in order to support, extend, and enrich their art making efforts. The views presented here were helpful in understanding the children's actions and endeavours and were useful starting points for generating many interesting discussions. They illustrated as well that learning and experience in art making is multi sensory, multi modal, kinesthetic, experiential, social, and for many children, is much more than just a visual means of expression. Creating images may involve stories, sound, movement, gestures, play, social interaction, and cannot be understood solely from the images or traces that result.

What I have discussed here is not intended as an exhaustive or exclusive list or even as a model of children's development, growth, learning, or behaviour in art, rather is intended to illustrate that there are different windows one can look through or views one can take in trying to understand what children are doing when they make art. It is not intended to position one over another or even to find the 'best' view as if there were only one 'right' way to view children's art making, but to describe some of the possibilities at play. Children will approach art making from multiple perspectives and a good art program will try to create multiple entry points for children's explorations in art.

Understanding, supporting, and facilitating children's intentions and interests are key to developing meaningful and relevant art learning opportunities.

Therefore, rather that speaking of stages and development or metaphors of maps, journeys, beginnings or end points, we should be starting with what is meaningful to children and think of ways to deepen, enliven, and enrich the ways that art making and art learning is enacted in children's lives and in our schools. Developing meaningful content and engaging children in 'art that matters' is critical. So is approaching it from multiple perspectives and modalities. Daniel Walsh (1993) describes art as a human construction, and as "a tool that human beings use to make sense of their existence, of themselves as human beings... It is not a medium for transporting meaning or beauty or truth. It is a tool for constructing meaning" (p. 20). Educators then, should be looking for ways to enlarge the space of the possible, to find ways to facilitate children's artistic constructions and performances so that children may tell deeper, more resonant, richer, life-informed stories and enact their artistic representations in multiple, and meaningful ways.

References

Bruner, J. (1990). *Acts of meaning*. Cambridge, MA: Harvard University Press.

Davis, J. (1996). *The MUSE book: Museums uniting with schools in education: Building on our knowledge*. Cambridge, MA: Project Zero: Harvard Graduate School of Education.

Duncum, P. (1999). A multiple pathways/multiple endpoints model of graphic development. *Visual Arts Research* 25(2), 38-47.

Eisner, E. W. (2002). *The arts and the creation of mind*. New Haven, CT: Yale University Press.

Gardner, H. (1983). *Frames of mind: The theory of multiple intelligences*. New York: Basic Books.

Golomb, C. (1974). *Young children's sculpture and drawing: A study in representational development*. Cambridge, MA: Harvard University Press.

Golomb, C. (1992). *The child's creation of a pictorial world*. Berkeley, CA: University of California Press.

Grallert, M. (1991). Working from the inside out: A practical approach to expression. *Harvard Educational Review*, 61(3), 79-89.

Kellman, J. (1995). Harvey shows the way: Narrative in children's art. *Art Education*, 48(2), 18-22.

Kellogg, R. (1969). *Analyzing children's art*. Palo Alto, CA: National Press Books.

Kindler, A. M. (1992). Worship of creativity and artistic development of young children. *Canadian Society for Education Through Art Journal*, 23(2), 12-16.

Kindler, A. M. (1997). Child development in art: Perspectives and interpretations. In A. M. Kindler (Ed.), *Child development in art*, (pp. 1-7). Reston, VA: National Art Education Association.

Kindler, A. M. (1999). "From endpoints to repertoires": A challenge to art education. *Studies in Art Education*, 40(4), 330-349.

Kindler, A. M. & Darras, B. (1997). Map of artistic development. In A. M. Kindler (Ed.), *Child development in art*, (pp.17-44). Reston, VA: National Art Education Association.

Lowenfeld, V. & Brittain, L. (1987). *Creative and mental growth*, (8th edition). New York: Macmillan.

MacGreggor, R. N. (1997). Development and practice: What can the literature tell the teacher? In A. M. Kindler (Ed.), *Child development in art*, (pp. 183-192). Reston, VA: National Art Education Association.

Matthews, J. (1984). Children's drawing: Are young children really scribbling? *Early Child Development and Care, 18*, 1-39.

Pearson, P. (2001a). Towards a theory of children's drawing as social practice. *Studies in Art Education*, 42(4), 348-365.

Pearson, P. (2001b). Children's drawings as "artistic development": Art education's conceptual twilight zone. *Visual Arts Research*, 27(1), 60-74.

Steele, B. (1998). *Draw me a story: An illustrated exploration of drawing-as-language*. Winnepeg, MN: Peguis Publishers.

Walsh, D. J. (1993). Art as a socially constructed narrative: Implications for early childhood education. *Arts Education*

Policy Review, 94(6), 18-23.

Walsh, D. J. (1999). Constructing an artistic self: The historical child and art education. *Visual Arts Research*, 25(2), 4-13.

Wilson, B. (1997). Child art, multiple interpretations, and conflicts of interest. In A. M. Kindler (Ed.), *Child development in art*, (pp. 81-94). Reston, VA: National Art Education Association.

Wilson, B. & Wilson, M. (1977). An iconoclastic view of the imagery sources in the drawings of young people. *Art Education*, 30(1), 5-11.

Wilson, B. & Wilson, M. (1985). The artistic tower of Babel: Inextricable links between cultural and graphic development. *Visual Arts Research*, 11(1), 90-104.

Vygotsky, L. S. (1978). *Mind in a society*. Cambridge, MA: Harvard University Press.

CONNECTING, REFLECTING AND IMAGINING

The Role of the Teacher and Teaching Strategies

Christa Voik

This chapter focuses on the role of the art teacher and specifically the development of teaching strategies within instructional planning. Strategies are not an isolated component of the teaching process; they arise from the planning framework for art lessons, units or a grade level program. In selecting media, for example (drawing, clay, batik or watercolour), knowledge of the content, the process of the lesson, the desired learning outcomes, and student assessment should guide teachers in planning teaching strategies. Lesson topics might deal with the sources of ideas for expression, how these ideas can be presented in different ways, and how one's selection of media has a bearing on the process of how an idea takes form. A simple unit might be based on a particular subject such as animals or people explored through different materials. In other words, a unit focused on horses might be represented in oil pastels, charcoal or clay.

In a practical sense, as teachers recognize the needs of their students, they are better able to select appropriate learning strategies. Thus, one needs to take the characteristics of students for whom the art activity is planned into consideration. Typically, activities selected for young students are often inappropriate for older students. For instance, teachers often need to include more manipulative types of art activities that can be completed in short time intervals for younger students, while older students will require more challenging activities that could involve more complex integration with other curriculum areas. At all grade levels, teachers also need to take into account the social, cultural and economic factors that affect students' readiness for learning in art. In essence, strategies encompass all art activities teachers use to accommodate the needs of their students.

Teacher's Role

The teacher's role in art education is multifaceted and multidimensional. The best art teaching requires the same qualities of a good teacher in other subjects. The teacher of a productive art class is prepared, has knowledge of art fundamentals, is creative, enjoys working with children and personally enjoys art. Her/his knowledge, attributes and commitment towards students, set within a particular classroom environment, are the first ingredients for successful learning in art. Yet teachers must have some technical knowledge of the subject being taught. This does not mean one needs to be an artist but one should have adequate knowledge of the subject in order to be an effective teacher. Teachers need to be able to communicate and interrelate with their students as they consider individual talents, prior knowledge, feelings and attitudes. As well, flexibility and spontaneity are necessary to enjoy unplanned "aha" moments with one's students - after all this is art!

An art program should facilitate students' *art making*, provide for *aesthetic learning* and foster knowledge of *art history* (art forms that are created across time and cultures). Art education should help students develop their powers of perception so they might more readily respond to qualities in works of art and their environment. Thus, the art learning experiences one provides should inspire students to continue with lifelong learning in art.

Planning Goals and Teaching Strategies

Teachers need to be well prepared when standing in front of a classroom packed with thirty-some students eager to create. Three critical areas that must be planned for when employing teaching strategies: *milieu*, *subject matter* and *the teacher*. These collectively provide the learning context where general goals and learner-specific objectives can be established and taught. Let's explore each in turn. The milieu is the facility or classroom available for one's art program. For instance, teachers may not plan for a clay project if the school doesn't have a kiln. For art education lessons, we also rely on the availability of a variety of materials such as coloured construction paper, tissue and origami paper, paint and brushes. Lessons need to be planned around available materials. The milieu also attends to students and their characteristics, as well as the classroom environment. Creating art and artistic learning is complex and influenced by the environment in which it occurs.

A teacher might consider the following questions:

- Do my art lessons match the abilities, skills and age levels of the students?
- What timeline should be made to complete projects – is it realistic?
- Should I provide students with art exemplars?

- Is information on how I will assess the process and/or project provided during the lesson/unit?
- Does my art program attend to diverse student learning styles and diverse student abilities?
- Have I planned a variety of art learning experiences so that students have opportunities for personal expression?
- Are students able to learn about different societies and cultures through their arts?
- Is the classroom environment conductive to learning?
- Am I able to foster a joyful atmosphere?
- How might I be able to stay organized without being inflexible?
- Am I able to respect individual differences in my students?

The above questions may help teachers focus their attention on the characteristics of a quality art program. Teachers must be able to plan, organize and provide educationally sound classroom procedures. Ultimately, teachers must address what will be taught and how it will be taught at a given grade level.

All teachers need to recognize school district or a provincially developed art curriculum before designing sequential content and the appropriate teaching strategies. Most elementary art teachers group lesson development into five organizers: themes, media, design, styles and products. These organizers can provide teachers with a wealth of choices and allows for sequentially designed content gradually becoming more complex and challenging overtime. These organizers may serve as a single focus for a lesson or in combination with one another as teachers design teaching units.

Themes

Themes within art may include all recognizable objects in the natural and man-made world as well as related themes such as people, landscapes, seascapes, animals and plants. Personal and social events provide colourful seasonal or historic events, such as holidays, birthdays, or taking part in a school play. Themes can also be found in feelings and in real or imagined things or events. Examples would be painting an imaginary landscape, drawing a self-portrait, creating a collage of a cityscape, painting a character from a fable, constructing imaginary puppets or creating mythical creatures.

Media

Media includes all the physical materials used to create art. One can actually say, "My thinking is translated into art forms using materials." Media may include: various papers, paints, drawing tools, fibers, film, computer programs, plaster, clay, plasticine, glue, brushes, and calligraphy pens. This list is not exhaustive. Since each material has inherent qualities that are very specific to the material, it is important to consider the materials when designing learning objectives. Just consider the difference between three paint products: watercolour paint, tempera paint and acrylic paint. Each paint has unique qualities that can be focused on so that students learn the skills to make informed choices appropriate for their ideas.

When designing strategies of instruction, teachers will need to keep in mind lesson set-up, the qualities and distribution of materials, storage of art works, and clean up. For instance, a lesson that relies on media as a focal point might have as its objective the exploration of clay. Through experimentation, children may learn that clay is well suited for making particular forms.

Design

The study of the elements of design includes an examination of line, shape, space, form, colour and texture, and the principles of design includes an appreciation of rhythm, balance, emphasis, unity and contrast. Lessons may be designed around the elements and principles of design singly or in combination. An example might be for students to study how colour can create different moods, or how combining particular colours and lines creates a different mood or feeling. There are numerous examples in the world of art where artists have focused on the elements and principles of art. Everywhere in our visual world one can identify the design elements and principles. Teachers and students can use their life experiences as a starting point for many artistic projects.

Styles

Art objects that share a historic time or location are often referred to within particular stylistic groupings such as: Egyptian, realist, romantic, impressionism, Haida, cubism, and pop art. Art forms, which belong to a style, usually share some common features by which they can be identified. Design elements, principles,

media and themes can be combined with particular styles. For instance, one might create a spring landscape created with dots and dabs in an impressionist style.

Products

Products include creative and innovative crafts such as: fabric arts, jewelry, photographs, masks, macramé, Christmas tree decorations and others. Lessons can be designed toward the creation of products that function in unique ways, for example, decoration, propaganda, advertising, ceremony and costuming.

A broad range of art content, media and teaching strategies should be employed in planning an art program. The teacher's knowledge of resources is essential for good planning. Many teachers ask themselves: How will I structure each teaching unit and what resources and materials are needed? There are many possible answers. In order to ensure success, teachers need to prepare well in advance taking material needs, resource requirement, and facility needs into consideration. Good planning also helps to ensure that lessons or unit are interesting, sequential and fosters creative growth. In general, students will respond positively to art instruction when the classroom is organized and the art activity is highly motivating.

So far we have paid attention to short term planning. However teachers need to attend to long range planning as well. For any grade level planning should be structured into a long range plans that include:
- a timeline for projects, activities, and learning objectives.
- materials and resources needed.
- assessment and evaluation strategies.

An elementary art program should include a wide variety of activities and materials as a way to provide for rich learning experiences. Any of the previously identified five organizers can become the initiative to create art forms. Implicit within this variation is a variety of media, such as: drawing, painting, printmaking, media, collage, sculpture, fabric arts and technology arts. Yet variation should also be evident through integrated art lessons making connections across disciplines. If possible, art teachers also attempt to include learning experiences with art history, cultural diversity, and art appreciation.

In summary, teachers are the catalyst, the ones who carefully plan and organize the art learning experiences for their students and determine if students have achieved the learning objectives. Teaching is a powerful activity for helping students learn. Being well-prepared will go a long way to ensuring that quality art instruction will occur.

Planning an elementary art program includes strategies that are often challenging. With commitment and increased knowledge about the subject matter, facing those thirty-two eager young artists will fill you with anticipation knowing that art education is an important component in the lives of children.

CONNECTING, REFLECTING AND IMAGINING

PUTTING ON YOUR HAPPY FACE? EXPLORING IDENTITY THROUGH AUTHENTIC ART EDUCATION

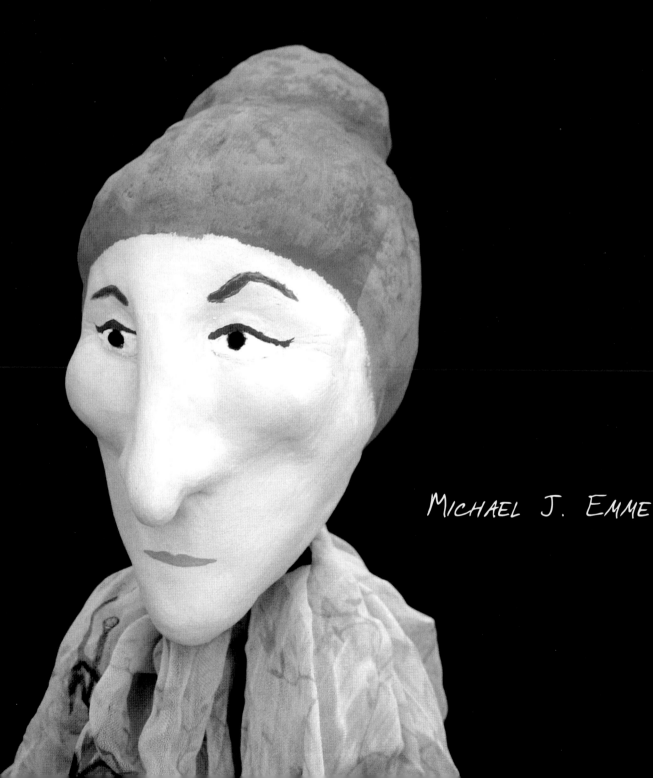

MICHAEL J. EMME

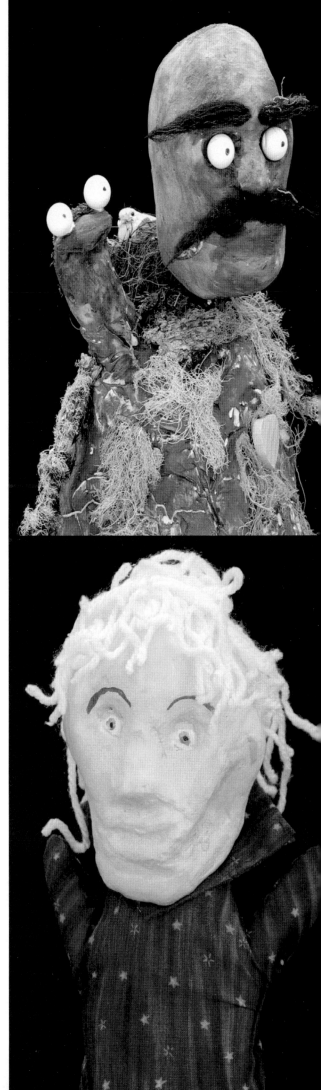

"I want my students to feel good about themselves so I am going to teach an art unit on feelings. We'll make a flower for Mom on mother's day, and maybe a red heart for Valentine's day, but first, lets draw faces that are happy, sad, angry and surprised.

heard in the halls more than once

With pure hearts and the best of intentions we sometimes make choices as teachers that confound our own goals not to mention complicating our students' lives. A quick look at the health education curriculum in any province will show that a common goal among primary educators that typically can be traced through the entire elementary curriculum is helping children develop more sensitivity to their peers' emotions.[1] The good intuition that leads us to believe that art is an appropriate and even powerful vehicle for affective self-understanding and meaning making is supported throughout the art and general education literature.[2] There is, however, a flaw in our logic if we assume that this convergence of art and feelings means that we need to focus the emotional potential of children's art making by closely dictating the territory they will explore. This impulse is natural and understandable. Every elementary teacher struggles with the organizational challenges of their job. It does not follow, though, that limited time and resources combined with unlimited curricular demands implies that the twenty minutes on the Friday afternoon before February 14th be devoted to an exploration of love as expressed in shades of pink, red and white.

One of the contributions that the field of psychology has made to art education through the work of Howard Gardner and Harvard's Project Zero is the proposal that we and our students have many intelligences. Our visuality, kinesthetic skill, and ability to be emotionally tuned in to ourselves and others are all recognizable as important human capacities that can be nurtured and developed and are essential to our experience of life. A search under the heading 'emotional intelligence' reveals a library full of writings by authors such as David Goleman (1995) and others who have moved from cognitive science into a more therapeutic emphasis while arguing for the centrality of emotional growth in education. There is much of value in this literature and I certainly share the belief of most teachers that our students' emotional well being is a central concern of education...

...BUT...

...one of the core challenges of making or responding to art that certainly holds true for children's art is that it is rarely formulaic. Of course children use schema from simple circles to more complex figures as they learn to represent themselves in the world, but these come out of a process of personal discovery and invention that is at the heart of art experiences. Consider the fact

24

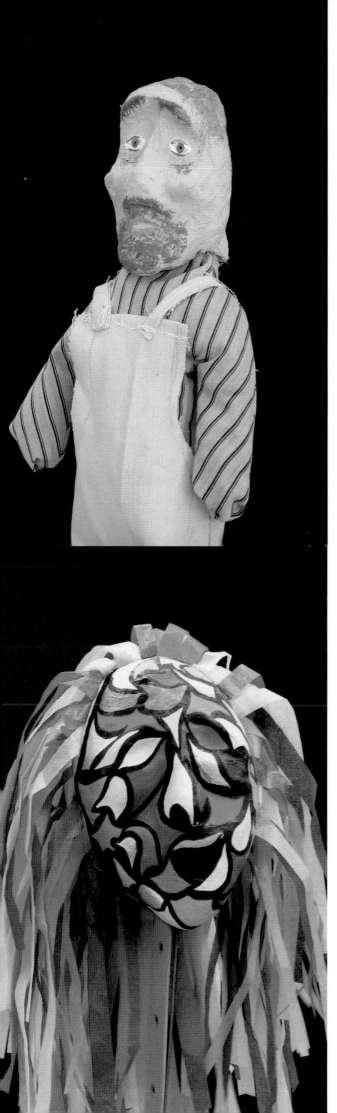

that there is no prescribed visual path for viewing an image (unlike written languages which insist on a particular linear sequence). The fundamental importance of the unique path each student's eyes take when they look at an image, any image, should make it clear that most of the work in a vibrant art classroom is strongly individualized.

Holt (1997) warns against art curriculum that rewards passive compliance in the early years. His research suggests that early passivity leads to frustration and an impaired ability to develop drawing skills in later years. Colouring in a copied page, cutting out a stenciled pattern and gluing the pieces so that they look just like the example on the board represents passive learning. Whether expressed through word or artistic action as an opinion about a colour choice, subject matter, framing or an internet research thread, there are an abundance of indicators when your students are actively involved in their art ideas. Count on the fact that if your students are involved in their art as ideas, those ideas will have a strong emotional component that your students can articulate.

So, an art program that embraces the world and invites children to show what they are learning, what they know and what they feel will be rich with emotions. That same program can employ an endless array of strategies to invite children to talk about these authentic feelings that already exist in their visual work. The challenge for you as a teacher is to nourish your own interpersonal and visual skills so that you can respond to what your students will show you.

What follows are four clusters of ideas I hope will give a practical sense of how to draw out the emotions in children's art. I am using the basic structure of the British Columbia elementary art curriculum (http://www.gov.bc.ca/bced/) as a framing device for exploring four aspects of the role that feelings can play in an art programme

Image Development: Self-portraiture and Nonverbal Self-reflection

As Wilson & Wilson (1982) noted some time ago, children have lots of reasons for drawing. The past 50 years of art education have focused, primarily on the expressive. More recently, programmes influenced by the Regio Emilio approach (Tarr, 2001), among others have drawn attention to children's use of the arts as a way of coming to understand how things work (Collado, 1999; Brooks, 2002). Others have attended to the fact that when children make art about their lives, they sometimes explore difficult topics (Duncum, 1989). In representing themselves in drawing you may see the past, the present, or the future, you may see dreams or fears, or you may simply see someone who is getting pleasure from the process.

Bob Steele, the author of the heartfelt and richly illustrated exploration of children's drawing, *Draw Me a Story*

(Steele, 1998), was my printmaking teacher for several years. He insisted in dividing our classes up into 'your time' and 'my time.' While he had limitless enthusiasm for our self-generated projects, he was equally insistent that we let him teach us. In both supporting and stretching your students 'your time/my time' is a good policy. An example of 'my (teacher) time' and image development could be as open as simply asking your students to draw themselves,[3] or could involve portraying themselves in the style of a favourite artist they have researched at which point pose, technique and materials might all be dictated by you directly, or indirectly as a result of the research. In either example and to varying degrees, you are initiating the choice of imagery.

With 'your (student) time' the choices become much more student driven, so that even the idea of self-portraiture becomes optional. Many of the schools I know have a quiet time intended to encourage independent reading (and post-lunch hour settling). This strategy can also be a powerful opportunity for self-expression as a 15-minute sketchbook/journal time. For those students who want to tell stories visually or explore ideas through pictures, quiet, self-directed time is precious. While it will be necessary to provide some students with starters such as themes, provoking questions or even technical how-to sheets, for many students a sketchbook can become an important private place in an otherwise public school world. Combining the options of reading, writing or drawing for this quiet, private time means that each student can elect the focus that is most meaningful for them.

When children draw themselves, they draw themselves.

This apparent redundancy insists that you take the time to look twice at any work by a child that is a self-image. Every self-portrait is a revelation. A portfolio of self-portraits drawn for a variety of reasons over the school year can be an important place for you and your student to reflect on meanings and feelings. Something as apparently unplanned as changes in the quality of line between different drawings can suggest different levels of energy, or a different attitude. The addition of special objects and special people can add dimensions to your understanding of that student's world. Student reflections on the context of a self-portrait's creation can be the frame that completes the picture.

Elements and Principles: Exploring Visual Language

The formal language of design (line, shape, balance, contrast etc.) is a legacy of the modernist formalization of art knowledge in the 20th century. These words can help us to describe the visual choices made in organizing a work of art. They are also common to virtually all elementary art curricula. Typically it is assumed that students should be fluent in these concepts by about grade 7. As an elementary teacher you need to know this stuff, but it is also quite easy to find on-line or in commercial resources. While these terms are powerful tools in helping us talk with each other about art they are also used to create analytical distance between ourselves and the art we are looking at. Sometimes a formal design analysis, revealing as it is, can be a bit like dissecting a frog when it might be more fun to watch the frog splash around.

Recently the concept 'visual culture' (see e.g. Heywood & Sandywell 1999) has been used by art educators to begin conversations about all the visual products of society, including art but also including the consumer and pop cultural stuff that few of us would consider art. Shiffman described the differences in our design choices that are a result of our specific cultural identity as "visual dialect" (Shiffman, 1994). She describes our culturally specific visual preferences as ethnovisual and sociovisual elements of design. In your classroom, projects that encourage children to recognize the colour, pattern and ordering principles of objects from their family traditions can be a formal exploration of their own visual dialect. All design concepts tend to nudge us towards certain notions of 'good' work. As teachers, for example, we sometimes tend to assume that a composition that has elements that are in careful balance is better than something that seems chaotic, even though the second image can be exciting. One way of ensuring that your student's identities have a place in your classroom is to complicate the notions of what might constitute 'good' art. In a unit on quilt making, inviting students to design their individual quilt block based on discovered patterns, colour and content from home can result in a final class quilt that is less symmetrical than the 'one's in the book' because many design dialects will be represented. The journaling and discussions that can grow out of such a quilt are almost unlimited. Each block may introduce a unique system of symbols, specific identity concepts regarding gender, ethnicity and cultural history, interesting juxtapositions of the traditional and contemporary, and more.[4] You will likely see materials and choices from a variety of traditions as well as from

pop or consumer culture. You may also see your class for the first time!

Materials and Process: Craft, Clutter and the Joy of Decision-making

I did an education periodical search of the term 'clutter' and discovered that every article indexed assumed that clutter was a bad thing. I was shocked! I'm not sure that art can be taught in a clutter-free environment. How much of all that we do as teachers, as parents and as children boils down to striking a balance between order and chaos? We have all had the experience, over time, of becoming comfortable with seemingly chaotic situations which come to make more sense as they become more familiar. This is most people's experience if they learn to drive... it really does become easier with time. Clearly the same thing holds for teaching. I had a big burly painter who also worked as a barroom bouncer visit my junior high classroom for a week as an 'artist in the schools.' He hid in the supply room during every class change because he found that particular chaos overwhelming. I suppose the fact that we can learn to understand the apparent chaos of a vibrant classroom is one reason why there are salary increments for teaching experience.

For many new elementary generalists, art classes can be similarly daunting. The potential for disasters in a room full of children who may be moving around and chatting as they handle materials that can spill and stain may seem like too much to handle. In teaching your students about art materials and the different techniques involved in their use you need to consider three things: craft, choice, and your mental health. Concern with craft and your mental health may suggest that what is needed in the classroom is control and at a certain obvious level this is true. However, consider the most typical example of a rigorous, controlled materials assignment: asking students to fill in a colour wheel. Using tiny portions of paint each student carefully mixes secondary colours and then paints within the lines of the photocopied colourwheel. They are learning to mix colour and to be very, very careful with their brush. You can quote the curriculum guide by chapter and verse if your principal drops in, and except for the furrowed brows and the muttering, the room can seem perfect. But, look around! For many students this kind of assignment is painfully frustrating and boring. It's actually amazing how often spills seem to coincide with frustration and boredom. Sometimes choice, and the

purposefulness it brings, can result in fewer spills, more concern with craft, and maybe even a happier teacher.

Here is an example of a painting sequence that addresses skill development without losing the element of choice. After introducing the colour wheel to my students and demonstrating how to achieve intense clean colours when mixing tempera paint, I send them in small groups to paper covered tables (or tarps on the floor, or outside, or... sorry, but you still have to look after your own mental health!). They are each encouraged to invent colours. The only rule is that as they invent colours, they have to name them and write the name next to the colour. The names can be silly (brush your teeth more often yellow) or serious (prairie sunset) but they have to be specific to the colour the student invented. The naming and the resulting small group chatter slows down the painting in ways that is both a valuable part of the learning (how did you mix that?) and good way to avoid the kind of frenzy that produces spills. This actually is a good end of day experience because you want these colours to dry undisturbed. Once the named colours have dried your students get to go shopping. Each is encouraged to collect about six colours along with the descriptive names. Each student now has a set of colour swatches and some descriptive language. You can discuss how the colours each student selected, goes together. You can discuss what primary colours went into creating each

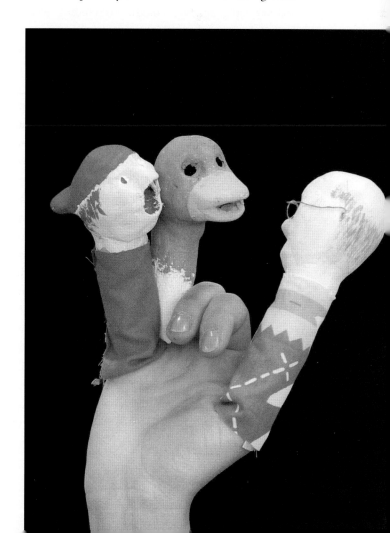

invented colour. A creative writing experience where each student tries to incorporate the descriptive language they collected can suggest both a story and an illustration. For younger students the colour swatches can be used in collage to illustrate their stories. For older students they can take on the challenge of trying to match the colours in their swatch as they paint illustrations for their stories. By the end of this experience your students will have a good sense of how brush and tempera paint work. Chaotic? It can seem that way. Out of control? Rarely. My experience has been that this project, by asking them to think about and live with choices results in skill, craft and rich personal imagery.

Responding to Art: Visual Strategies for Looking and Thinking about the Work of Others

Chapter 16 of Edmund Feldman's *Varieties of Visual Experience* (Feldman, 1972) describes art criticism as a performance that involves description, analysis, interpretation and judgement. In the 30 years since its publication, this analytical model has served as the foundation for most elementary art curriculum that has tried to encourage "talk about art" (p. 471). The British Columbia elementary art curriculum (http://www.gov. bc.ca/bced/) has, since the mid-1980s, chosen to use the phrase 'responding to art' to head a portion of the curriculum that focuses on both art criticism and art history. I am sure that the term 'responding' was chosen, in part, because there are so many negative connotations linked to the term criticism. I am also sure that the idea of response was appealing because it broadens how we might act in the face of another's work.

More recent writing in criticism has helped art educators recognize that along with its formal meanings, art represents the culture of its maker. Further, we now see that all images, but particularly mass-media images, play a central part in the complex communications that both link and separate world communities and institutions. Through the images we choose (and exclude) and the things we say (and don't say) about art with our students, we are, unavoidably, teaching about gender (Pazienza, 1997), race (jagodzinski, 1999), spirituality (Bullard, 1998), economic status (Fehr, 1993), sexual orientation (Lampela, 2001), and more. In learning to respond to our visual world, this complexity of critical content puts heavy emphasis on the 'multi' in multi-cultural that makes questions more helpful than answers. The biggest question might be: How can you address the challenging need to bring together careful looking and learning, with authentic complexity and student self-representation?

The answer?: Visually!

Though some art educators have concerns about copying, most now recognize that copy work can be an important part of children's development in drawing (Wilson & Wilson, 1982; Smith, 1998). Encouraging children to sketch artworks they are studying can both stretch their drawing skills and encourage close analytical looking. These visual notes do not need to be displayed or shared with other students to be an important part of a student's 'critical performance.'

Annie Smith in *Getting Into Art History* (1993) encourages costumed role playing and playful juxtapositions between traditional artworks and contemporary media. Taking on the character of a figure from a European painting of an 'exotic savage' can lead to important, empathetic dialogue. Adding Baroque ornamentation to everyday objects such as backpacks or computer monitors can lead to discussions about the meanings of design and consumerism.

George Szekely (2002) is an art educator who is interested in collections and collecting. As he suggests, many of your students are already collectors. The work of grouping objects and developing and describing the rules used for the grouping is also a visually-based response that can be shared with even the youngest students.

Conclusion

Literacy educator and philosopher, Paulo Friere (1970), is known for challenging educators to recognize and release control over power in the student-teacher relationship. This is not an easy thing. When you teach your class art the 'balance of power' will have a huge impact on what you and your students can accomplish together. With experience, and a commitment to your own growth as both a teacher and an art maker (yes you have to try these things yourself!) you can give up power without losing control. When those magic moments happen, your classroom will become a compelling portrait of learning with one happy, if somewhat dazed teacher.

28

1. For example: in the Health education component of the Alberta Elementary programme of studies, under the heading: 'Relationship Choices' it says "Students will develop effective interpersonal skills that demonstrate responsibility, respect and caring in order to establish and maintain healthy interactions." And further, that: "R–1.1 recognize and demonstrate various ways to express feelings, e.g. verbal and nonverbal" (Alberta Learning, 2002, p.14).

2. The Education and psychology literatures are thick with papers exploring the role that art can play in a child's developing self-concept (Alvino, 2000; Omizo & Omizo, 1989; Emerson 1994). While much of the research is empirically inconclusive (Thomas & Silk, 1990), the bulk of the literature is still strongly supportive of the affective significance of art making in children's lives.

3. Rather than buying a letter line at the teacher store, I invite my students early in the year to use a page that is blank except for a model letter as an opportunity to portray themselves. They can choose a simple I.D portrait, or depict a favourite activity. One way or another they have a place in the classroom culture that a 'merely' bought letter line can't provide.

4. For a detailed study of elementary preservice teacher's interpretations of images from a variety of context's based on a Visual Culture' approach, see Pauly (2003).

References

British Columbia Ministry of Education. (2002). *Elementary art curriculum guides.* Retrieved March 25, 2003, from the British Columbia Ministry of Education Web site under the search descriptor 'art': http://www.gov.bc.ca/bced/Alberta Learning. (2002). *Health and life skills K-9*. Edmonton, AB: Alberta Learning 2002.

Alvino, F. (2000). *Art improves the quality of life: A look at art in early childhood settings.* East Lansing, MI: National Center for Research on Teacher Learning. (ERIC Document Reproduction Service No. ED447936).

Blandy, D., & Congdon, K. (1991). *Pluralistic approaches to art criticism.* Bowling Green, OH: Bowling Green State University Popular Press.

Brooks, M. (2002). *Drawing to learn.* Unpublished doctoral dissertation, University of Alberta, Edmonton.

Bruffee, K. (1999). *Collaborative learning: Higher education, interdependence and the authority of knowledge* (2nd Ed.). Baltimore, MA: Johns Hopkins University Press.

Bullard, S. (1998). Why does the Buddha have long ears? A North Carolina museum educator invites students to explore religious diversity through art. *Teaching Tolerance*, 7(2) 28-33.

Collado, F. (1999). *The Role of spontaneous drawing in the development of children in the early childhood settings.* East Lansing, MI: National Center for Research on Teacher Learning. (ERIC Document Reproduction Service No. ED438898).

Duncum, P. (1989). Children's unsolicited drawings of violence as a site of social contradiction. *Studies in Art Education*, 30(4), 249-56.

Emerson, A. (1994). *Building Self-Esteem through Visual Art: A Curriculum for Middle School Girls.* East Lansing, MI: National Center forResearch on Teacher Learning. (ERIC Document Reproduction Service No. ED423173).

Fehr, D. (1993). Dogs playing cards: Powerbrokers of prejudice in education, art and culture. Counterpoints. *Studies in the Postmodern Theory of Education.* (Volume V). New York: Peter Lang Publishing.

Feldman, E. (1972). *Varieties of visual experience.* Englewood Cliffs, NJ: Prentice-Hall.

Freire, P. (1970). *Pedagogy of the oppressed.* Myra Bergman Ramos. (Trans.) New York: Herder and Herder.

Goleman, D. (1995). *Emotional intelligence.* New York: Bantam Books.

Heywood, I., & Sandywell, B. (1999). *Interpreting visual culture: Explorations in the hermeneutics of the visual.* London, UK: Routledge.

Holt, D. (1997). Problems in primary art education: Some reflections on the need for a new approach in the early years. *International Journal of Early Years Education*, 5(2), 93-100.

jagodzinski, j.(1999). Reading hollywood's post-racism: Lessons for art education. *Journal of Multicultural and Cross-Cultural Research in Art Education*, 17, 74-90.

Lampela, L. (2001). Daring to be different: A look at three lesbian artists. *Art Education*, 54(2), 45-51.

Omizo, M., &. Omizo, S. (1989). Art activities to improve self-esteem among native Hawaiian children. *Journal of Humanistic Education & Development*, 27(4), 167-76.

Pauly, N. (2003). Interpreting visual culture as cultural narratives in teacher education. *Studies in Art Education*, 44(3), 265-284.

Pazienza, J. (1997). Edgar Degas--Misogynist, voyeur, or feminist: What do we tell the kids? *Canadian Social Studies*, 31(4), 181-85.

Shiffman, C. B. (1994). Ethnovisual and sociovisual elements of design: Visual dialect as a basis for creativity in public service graphic design. *Journal of Visual Literacy*, 14(2), 23-39.

Smith, A. (1993). *Getting into art history.* Toronto, ON: Barn P.

Smith, N. (1998). *Observation drawing with children: A framework for teachers.* New York, NY: Teachers College Press.

Steele, B. (1998). *Draw me a story: An illustrated exploration of drawing-as-language.* Winnipeg, MB: Peguis.

Szekely, G. (2002). The art teacher as collector. *The Canadian Art Teacher*, 2(2), 13-21.

Thomas, G., & Silk, A. (1990). *An introduction to the psychology of children's drawings.* New York: Harvester Wheatsheaf.

Tarr, P. (2001). *Aesthetic codes in early childhood classrooms: What art educators can learn from Reggio Emilia.* East Lansing, MI: National Center for Research on Teacher Learning. (ERIC Document Reproduction Service No. ED459590).

Wilson, M., & Wilson, B. (1982). *Teaching children to draw: A guide for teachers and parents.* Englewood Cliffs, NJ: Prentice-Hall.

CONNECTING, REFLECTING AND IMAGINING

Visual Thinking Journals

Belidson Dias and Kit Grauer

Recording, documenting and reflecting

In the elementary classroom it is important to move students beyond the sketchbook into forms of representation that echo the thinking strategies of our greatest thinkers. Leonardo da Vinci is a famous example of an artist/scientist who used what could be called a visual journal.

Why are journals valuable?

- They are records of process; we can see how our thinking changes and develops over time.

- They act as a visual/linguistic record of our thinking.

- The visual can provide an immediacy, that may not be as accessible as the linguistic.

ve used journals for:

a wide range of disciplines.

Between 1490 and 1495, Leonardo developed his habit of recording his studies in meticulously illustrated journals. These studies and sketches were collected into various codices and manuscripts, which are now collected by museums and individuals.

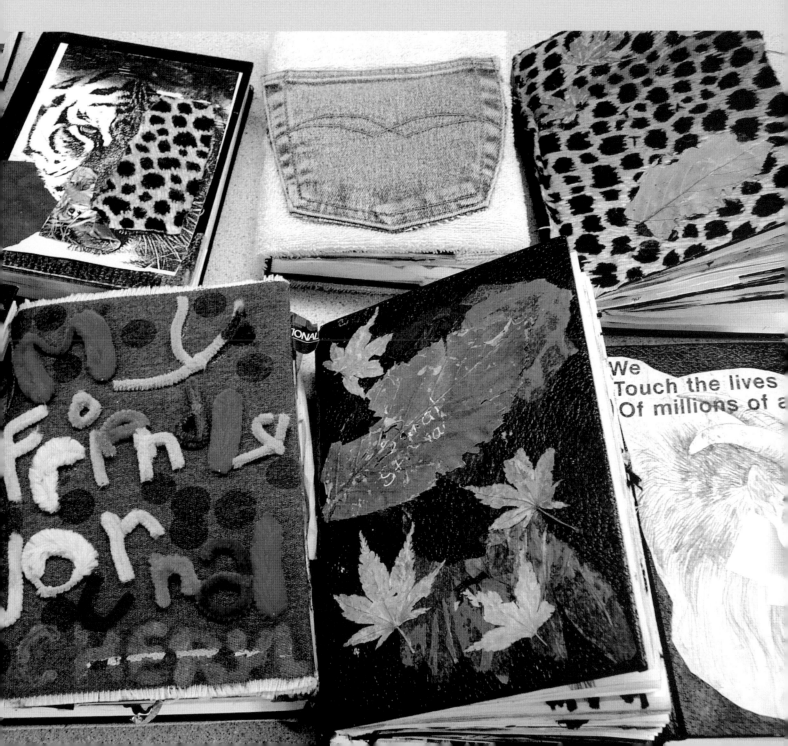

Visual Journals have been created by other more contemporary artists such as:

Peter Beard's *Beyond the End of the World*
Dan Eldon's *The Journey is the Destination*
Frida Kahlo's journals
Keith Haring's Journals
Sara Midda's Sketchbooks
Evidence: The Art of Candy Jernigan

There is also a collaborative web site called 1000 journals.
"1000 journals are traveling from hand to hand around the world. Those who find them add their stories, drawings, and pictures, and then pass them along in an ongoing collaboration"(they have 24 hours in order to complete their page). Contributors scan in what they add and email it to www.1000 journals.com.-http://www.1000journals.com. you can look and see the range of thinking possible.

Visual thinking journals may also be known as:

Visual Journals

Visual Diaries

Drawing Files

Sketchbooks

Workmates

The name is not important . It's what's in it that matters. Jour in images and text.

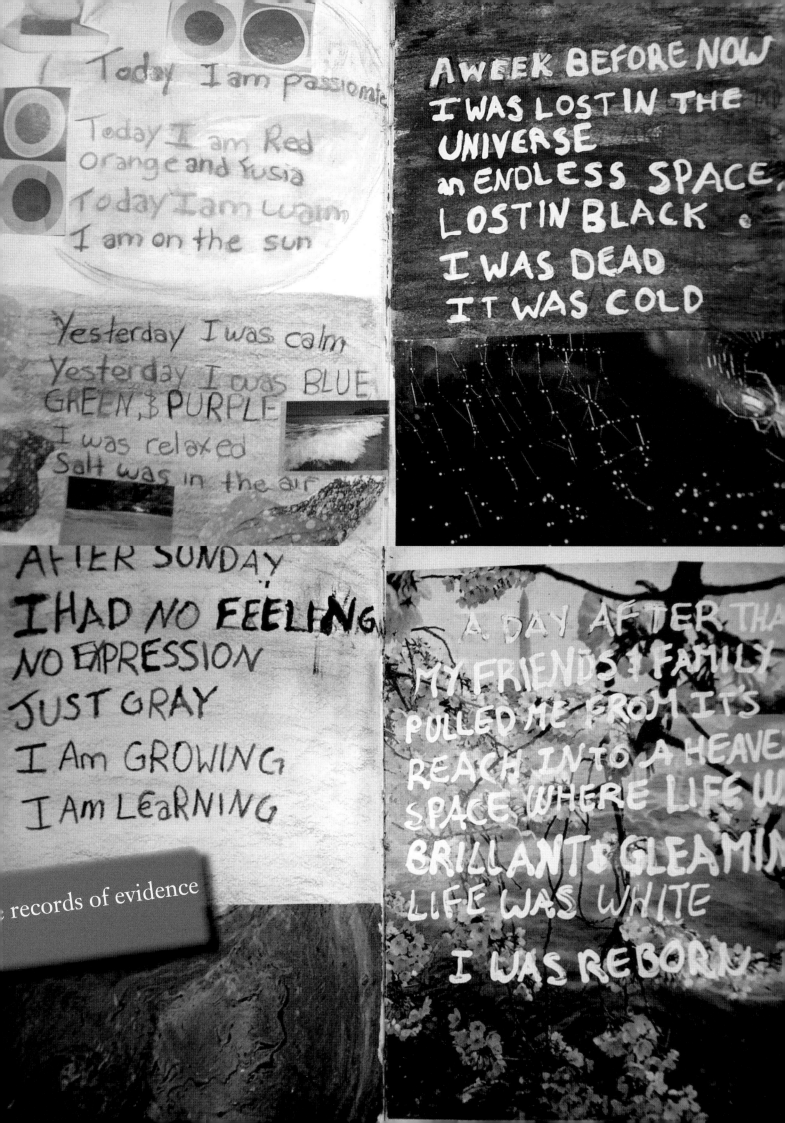

Today I am passionate
Today I am Red
Orange and Fusia
Today I am warm
I am on the sun

A WEEK BEFORE NOW
I WAS LOST IN THE
UNIVERSE
an ENDLESS SPACE,
LOST IN BLACK.
I WAS DEAD
IT WAS COLD

Yesterday I was calm
Yesterday I was BLUE,
GREEN, & PURPLE
I was relaxed
Salt was in the air

AFTER SUNDAY
I HAD NO FEELING
NO EXPRESSION
JUST GRAY
I Am GROWING
I Am LeaRNING

A DAY AFTER THAT
MY FRIENDS & FAMILY
PULLED ME FROM ITS
REACH INTO A HEAVEN
SPACE WHERE LIFE W
BRILLANT & GLEAMIN
LIFE WAS WHITE
I WAS REBORN

records of evidence

Journals are used to:

- describe

- elaborate

- summarize

- state

- extend

- express

- complicate

- highlight

- voice

- suppose

- narrate

- imagine

- critique and

- dialogue

Visual Journals can include:

- articles

- web information

- drawings, paintings, prints, ideas for various media

- photos, digital prints, fabrics

- found items

- poems, quotes, found text, narratives

- minute and major

- now, then, tomorrow

- the imaginary or real

- best bets and disappointments

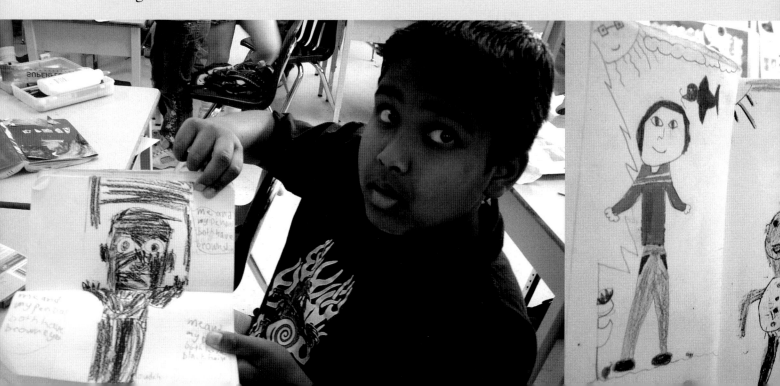

They can be focused collections of visual and material culture that allow space to contemplate and manipulate images for our own purposes or to enhance our learning.

They are focused
collections of visual and material culture that allow space to
contemplate and manipulate images for our own purposes or to enhance our
learning.

Visual journals can be created out of many different materials from discarded books, atlas, coloring books, handmade books, ready-made journals or even digitized.

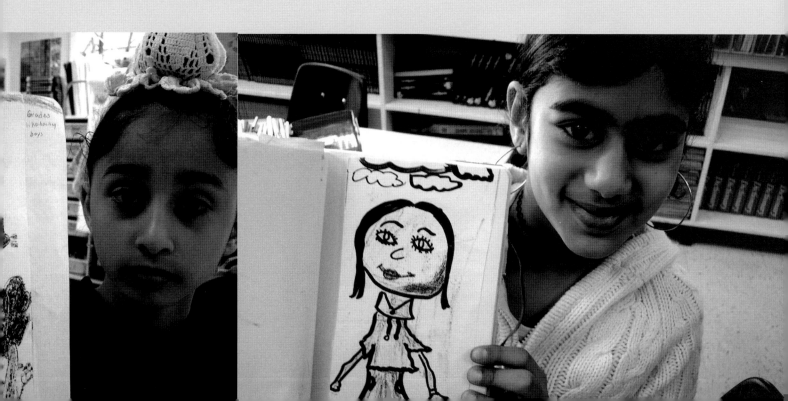

Each journal can vary in size, format, and contents.

Visual journaling let's us personalize our meaning-making much more than just taking notes from a lecture.

Learning is a complex, dynamic, and socially constructed activity that is not always logical, often unpredictable, and invariably difficult to describe.

Visual journals allow for the contextual, nonlinear, and multimodal nature of our understanding to be represented, tracked, and re-viewed.

The visual journal allows individuals to access, assess, and lead their personal learning journey in a way that is rarely attained through activities directed and owned by others

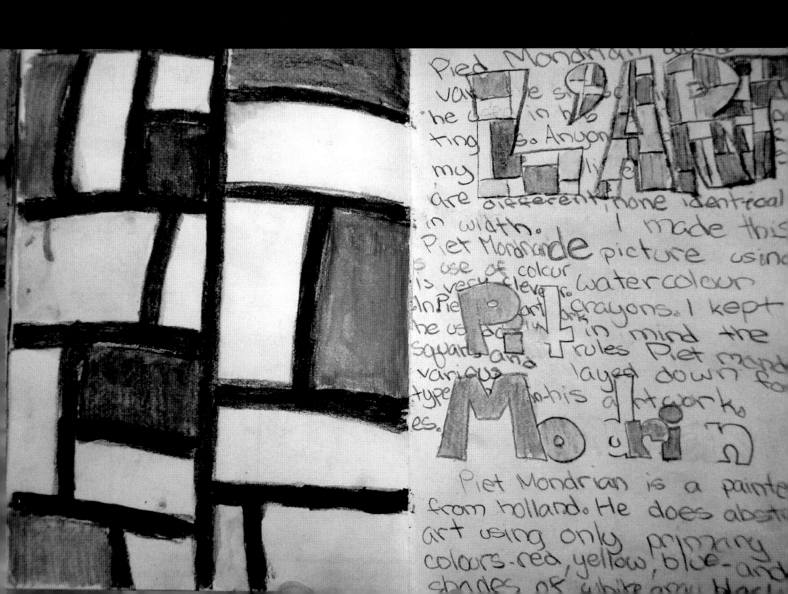

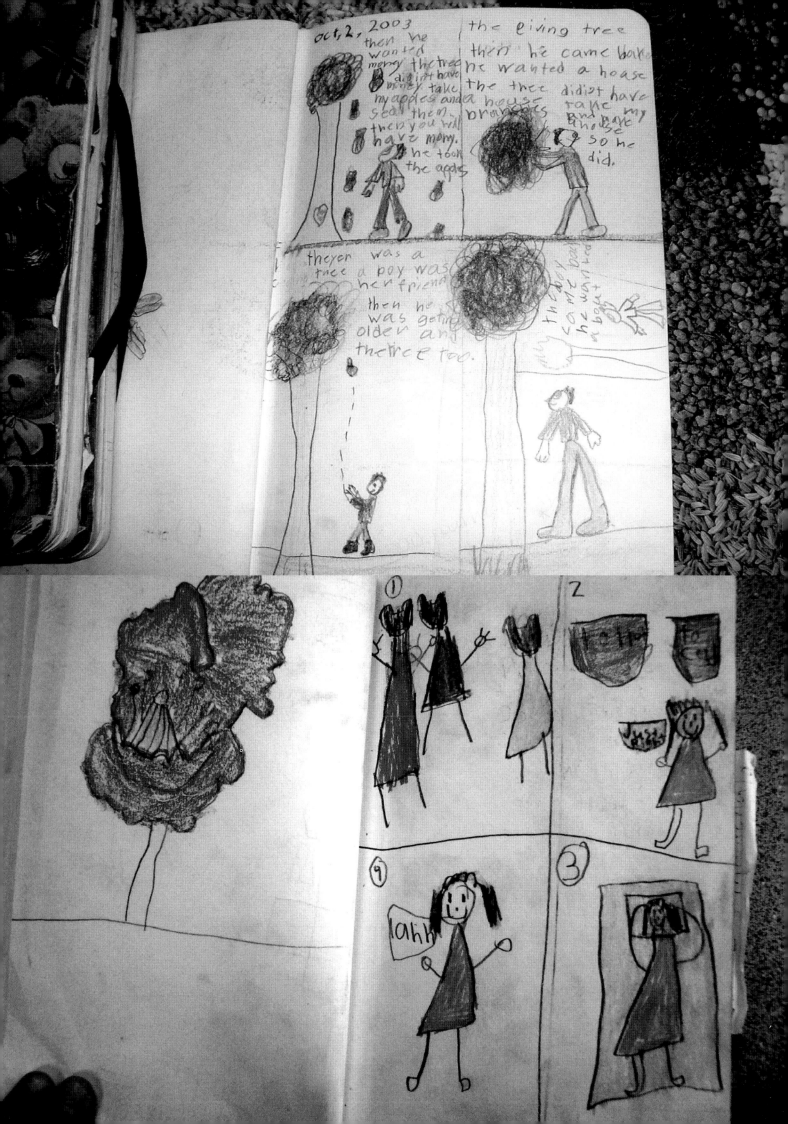

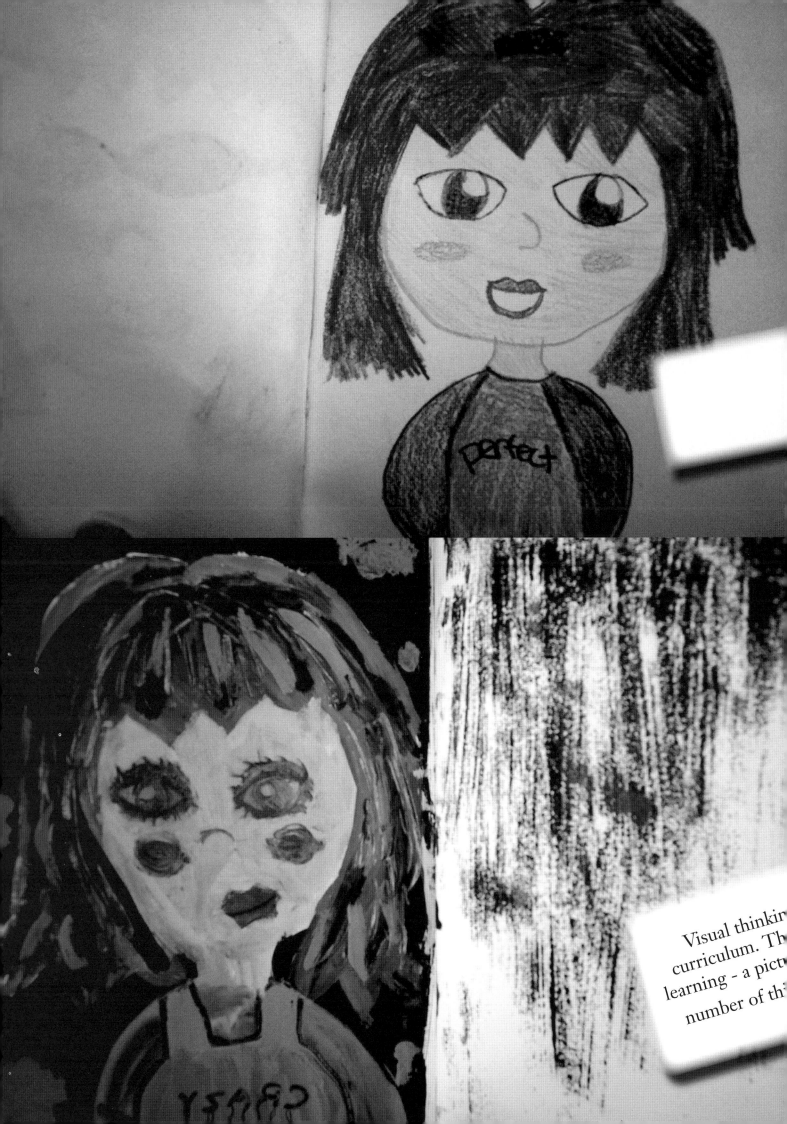

Visual thinkin[g]
curriculum. Th[e]
learning - a pict[ure]
number of th[...]

In this elementary class students were asked to represent themselves feeling different emotions.

When asked to reflect on experiences in art class, one student in this program shared that "my visual journal is my favorite piece that I have done because it describes me and I feel that I can draw and write everything I feel."

So this student portrayed as 'perfect' and 'crazy' - ote that crazy is written backwards.

The visual journal really allows students to explore visual culture and their place within it.

Perhaps more importantly it allows them to manipulate visual culture for their own purposes.

Another quote from a student using a visual journal in this class is: "my favorite example of my learning is my visual journal because it is a continuing piece of art. I am constantly working in it and going back and adding more depth."

s allow students to represent their learning across the ation of visual and text is very appropriate as a record of th a thousand words - students can effectively encapsulate a they have learned within the immediacy of a visual format.

References

Beard, P. (1998). *Beyond the End of the World*. New York: Universe.

Eldon, D; Eldon, K. (1997). *The Journey is the Destination: The Journals of Dan Eldon*. San Francisco: Chronicle Books.

Haring, K. (1996). *Keith Haring Journals*. Forth State: London

Jernigan, C., Taylor, J. B. (1999). *Evidence: The Art of Candy Jernigan*. San Francisco: Chronicle Books.

Kahlo, F. (1995). *Diary of Frida Kahlo*. (Carlos Fuentes, Trans.). City of Mexico: Banco de México.

Midda, S. (1990). *Sara Midda's South of France: A Sketch Book*. New York: Workman Publishing.

Other resources
Peter Beard at: http://sundbergassociates.com/peterbeard/publications.htm
Dan Eldon at: http://photoarts.com/journal/SABA/eldon/eldonintro.html http://www.daneldon.org/
My favorite art/visual journal books at: http://www.dealazon.com/list/1I3BJF018M2WR

CONNECTING, REFLECTING AND IMAGINING

Breaking the Grip: Drawing Beyond Anxiety and Visual Realism

Nadine Kalin

I vividly remember a 10-year-old student approaching me on the first day of school after the other students had left the classroom for recess. "Ms. Kalin, I know you are into art, so I just want to let you know, I don't draw and I won't draw, ever. I'll do anything else, but don't ask me to draw." This self-proclaimed non-drawer took a brave stand by letting his 'artsy' teacher know that he would not be drawing in my class. I was in shock. I wondered how he had learned that he was a non-drawer. What had happened? Why was he comfortable with our painting, sculpting, and collaging, but unwilling to draw?

Angst around drawing and the belief that we are not able to draw can originate in our early school experiences (as was the case with my 10-year-old student) and steadfastly remain beyond our youth. While drawing may be the media and technique we have the most experience with, compared to other processes, such as printmaking, papier-mache, and collage, drawing creates the most anxiety in potential elementary school teachers and adults in general. Some common reflections shared by pre-service teachers during their Art Methods course include: "I have dreaded the class devoted to drawing ever since I first saw it in the syllabus, because I can't draw;" and "I am not artistic; I can't draw a straight line." What do these comments say about the art experiences we encounter throughout our lives? How are our feelings reflective of cultural and societal values and views about what drawing is and good drawings are? What are you going to do to ensure these apprehensions are not the result of your future teaching? This chapter invites you to explore

how you can embrace your anxieties and previous experiences in order to transform your conceptions around drawing and the teaching of drawing.

Knowing Your Art History

During Art Methods courses, perspective elementary teachers are grappling with two related issues: 1) their own relationships with art making, and 2) how they will teach their future students. In a range of studio sessions, I ask pre-service teachers to take risks, to push beyond their comfort zones, while reflecting on their likes and dislikes related to particular media, techniques, and methods. I encourage them to value exploring the possibilities of art processes, beyond their satisfaction with final products. This is easier said than done. Time after time I am amazed at how students take a leap of faith and go with it. But there is always a ghost in the room, a hesitation, a preconception, a self-doubt lingering from the past that many adult students are grappling with and that should not be ignored.

Through various art and writing activities, education students are asked to return to their own history with art. Invariably, some education students remember teachers telling them "You are not doing that the right way" or "That is wrong." These words continue to sting and motivate pre-service teachers to never say these words, or never make students feel the way they have felt and may continue to feel about their own art making. But how can beginning teachers achieve this goal unless their views of drawing and art making are expanded beyond "the one right way" or limited notions of what constitutes acceptable child or

school art? By not determining and enlarging your "right ways" (your ideas, conceptions, notions, and feelings), you may communicate that there is one right way without actually verbalizing it. You might relay it through assessment, the reliance on particular activities that funnel student output, your choice of exemplar artists, how a project is described, or the directions given.

Do We Have to Teach the Way We Were Taught?

Maxine Greene (1995) contends that "it is simply not enough for us to reproduce the way things are (p. 1)," and I would add that it is also not enough for us to reproduce the way things were. Emerging teachers and those currently in the field, often imagine their curriculum within the methods, style, and content of their earlier education, rather than reflecting contemporary art and culture (Gude, 2000). We understand now through our memories of experience in the past (Greene). We develop tacit theories of teaching, drawing, assessment, development, artistic endeavour, learning, interpretation, and childhood based on our previous encounters, both positive and negative. We take these theories into our classrooms and then we teach how we were taught or we recreate these environments and expectations with similar, sometimes unwanted results.

It is, in part, through the acknowledgment and scrutiny of how your personal journey with art has informed your current beliefs and practices around drawing that you can revise your own art teaching practices. By engaging with earlier experiences, you can reflect on what these encounters

have to teach you about your role as a teacher of art today so that you are not doomed to versions of teaching that you may not wish to replicate. You need to consider how your previous experiences will be replicated, transformed, ignored, and negotiated with your future students' experiences, anxieties, interests, and capabilities. Recognizing and reclaiming the aspects of our earlier selves that were not understood, acknowledged, or cultivated, also allows us to recognize and cultivate the insight of our own students (Gude, n.d.).

Learning Anxiety

While our past can impact on current beliefs and practices, Kind also points out (in this volume) that "art making is both a personally and socially constructed act" that "cannot be separated from the culture and society" in which it is created. The meaning made around an activity, how it is interpreted and received is socially constructed. Instead of viewing children's art making as an individual's impulse to represent and express, we need to appreciate the intricate context out of which a child's social performance takes place and how this affects the meaning, value, and product of that performance.

In relation to drawing, the public nature of the display and creation of art within a classroom/ school environment adds to the anxiety of "performing" drawing. Within our Art Methods class, many pre-service educators feel this quite poignantly when asked to create drawings in front of their peers. Works that are shared, displayed, and evaluated are often divorced from the context and process of creation, while the products are simultaneously measured

against a particular standard of representational skill. Drawing viewed in this way is a high-risk endeavour. Children learn quickly what is favoured and acceptable as school art. This may be quite apart from how they represent outside of school-mandated activities and within a number of different social contexts such as home or lunch break. These educational experiences are further solidified by a society that overwhelmingly equates artistic talent with the ability to draw realistically. Eventually, by the time many of us get to university, my one ten-year old non-drawer has multiplied to an overwhelming and anxious majority in my post-secondary teacher education classes.

Peter London (1989) maintains that very few people endeavor to create images beyond childhood. Many children do seem to start off drawing with an ease that more often than not erodes to an awkwardness and discomfort that remains through adulthood. Some claim that this is a natural stage in our development around adolescence, to compare our output with others that are more skilled. Finding our products do not meet our expectations for realism, we abandon our efforts, declaring that we "just don't have the talent." Others wonder if it is the education, or lack of education, that throws our self-concept as drawers into doubt.

It would seem
that a major
contributing factor
must be how we
have been taught
to make images.
We have learned
to be embarrassed
by our efforts. We
have learned to

feel so inept and
disenfranchised
from our own
visual expressions
that we simply
cease doing
it altogether.
(London, p. xiii)

Sylvia Kind's (in this volume) aesthetic orientation to children's artmaking primarily focuses on the product or final appearance of an art activity. The aesthetics of an art project is one of the many reasons children draw. While the skills and techniques used to create surface and visual qualities are a valued part of art making and instruction, the singular focus on a product looking a certain way can have a harmful impact on students' artwork and self-concepts as drawers. Valuing representational skills alone can establish a lack of confidence in the use of drawing to create images. This often leads to an abandonment of drawing and a developing self-concept in students as non-drawers. For the most part, drawings are measured against a standard of realism not often expected in other media, nor necessarily valued in the contemporary artworld.

The idea that students are learning that they cannot draw brings to the surface greater questions around art and teaching. Are educators failing to teach representational skills? Are we failing to see the possibilities of using drawing for purposes beyond truth, skill, beauty, and realism? Can drawing be used by students to speak about their worlds, to explore, define, and expand themselves without the talent or technical skill to reach representational competency? How does our understanding of drawing affect

how we teach drawing? What are the goals when we ask youngsters to draw? What other conceptions and uses of drawing are available beyond realism and representational accuracy?

Drawing as a Foundational Skill

The valuing of visual realism in drawing is linked to what many in our society, including many teachers, believe to be the foundational skills required to be a "good" artist. "I'm not artistic; I can't draw a straight line," is a common refrain in our society. It reveals that there is high worth placed on skill and exactness in art, or at the very least that students learn that drawing a straight line is crucial to even being artistic, let alone an artist. The perceived inability to draw realistically is grounds for considering someone to be artistic, and it is also a rationale for why many people give up pursuing art. Without that foundational ability, why bother?

Although persistent, the concept of a foundation of drawing skills is no longer regarded as the only prerequisite for artistic development. According to Olivia Gude (2000), building skills for perceiving, analyzing, and manipulating art forms are not what are absolutely required as the starting point for exploring contemporary visual art practices, moreover, in this postmodern period, nothing can be considered truly foundational. Studio art activities are now integrating with art history, aesthetics, socio-cultural issues, and multicultural studies. The process and the meanings behind art has all but replaced a concentration on how well the final product represents beauty, skill, truth, and the world around us. Awareness of these changes in the field of art and art education provide great potential for changing classroom practices and the planning of art activities.

Tried and True Practices?

I encourage teachers to consider what they require of their students in regards to drawing. Their relationship with drawing and their goals for their students' drawings needs to be upfront whenever they ask students to draw. In many classrooms drawing is the one medium that is used across the curriculum in science, social studies, language arts, math, among other subjects to represent and extend understanding. Sensitively reflecting about what teachers are silently, or not so silently, approving, acknowledging, and privileging allows us a better appreciation of how our practices are limiting and supporting artistic activity.

Gude (2000) requires that teachers ruthlessly examine how 'tried and true' projects commonly occurring in schools can affect students encountering them for the first time. She advises educators to ask themselves if a particular lesson promotes ideas or values that they no longer believe in. Elementary school teachers will often draw a generic tree or face or pumpkin to get students started on an art project or to illustrate vocabulary words. How is this communicating a teacher's preferences for rendition? How is it limiting and/or supporting children's own versions of the trees or faces or pumpkins they may have encountered or the way they view their worlds, their systems of knowing, their voices? Will students assume that your way of drawing is the one right way or the only style you value? I would be more inclined to ask for a broad sampling of student examples of trees or faces or pumpkins and acknowledge their

insights or ways of representing, while also providing visuals created by artists exhibiting a variety of styles.

Contextualizing Drawing

Whenever we plan an art activity we are making decisions about what we consider fitting subjects for artistic inquiry (Gude, 2000). There are no practices that are universally applicable, value free, or foundational approaches to artmaking. The hidden curriculum is what is transmitted without conscious intention. In order to uncover the unintentional messages being sent, Gude suggests that teachers attempt to contextualize their curricular choices within personal, historical, and cultural settings.

For example, if you choose to include perspective drawing in your art curriculum, recall your experiences with perspective drawing, analyze why you believe this activity is important for your students, and consider when perspective was used to create illusions of space within particular cultural and historical periods of art (such as Italian Renaissance drawing and painting). Then investigate other methods of representing space in art so that this is not presented as the best and only method across time and cultures. With perspective in particular, it is key to look at the depiction of space and place multi-culturally, allowing for artistic ways of being and knowing beyond the European masters (for instance, ancient Egyptian drawing systems, the Mexican muralist, Siqueiros, or Inuit drawings and prints). Such depictions need to be presented and valued in order for students to be freed from the fixation that competency in the European tradition of perspective drawing is required to effectively communicate space in two-dimensions (Gude, 2000). Furthermore, a majority of folk (e.g., Grandma Moses), modern (e.g., the Cubists), and contemporary artists (e.g., Jason McLean) have rejected or not felt the need to employ the linear perspective of traditional European drawing.

Breaking the Grip

A consideration of how drawing is and has been used beyond realistically illustrating our world in two dimensions opens up possibilities for school drawing programs. To "break the grip" of visual realism as the sole criteria of quality in art, Gude (n.d.) proposes the consideration of various styles of contemporary and modern artmaking. In Gude's spiral art project *Elementary* I, it is recommended that artists such as Horace Pippin, Jacob Lawrence, Hollis Sigler, and Harry Lieberman be studied in order to learn about non-perspectival methods of creating space and representing through art. Gude also suggests introducing students to the drawings and paintings of people by Paul Klee and Xul Solar that eschew naturalistic styles of the human figure . By exposing children to artists and practices for imaging space, humans, and representing their experiences that are not based solely on visual realism and traditional European linear perspective, we can ease the tensions experienced in attempting to create a mirror image of our world.

Moreover, breaking the grip of visual realism over our conceptions of drawing involves expanding criteria that favour representational accuracy in drawing to also value, engage, and incorporate the communicative, social, fictional, private, narrative, gestural, multicultural, reflective, embodied, metaphoric, sensory, autobiographical kinesthetic, critical, and evocative possibilities inherent in the processes and products of drawing. The focus becomes content and meaning in addition to, or over, end product. If drawing is not a medium that is undertaken to simply represent visual realism, but a tool with the potential to create meaning, make sense of existence, and investigate issues of personal or social significance, then educators need to find ways to assist children in their construction and performance of deeper, richer, more life-informed representations of meaning (Kind, in this volume) while undertaking

drawing activities. As children begin to realize that not all artists are focused on visual realism and that their teachers embrace alternatives, students are freed up from these constraints and permitted to develop the visual means to tell and represent their own realities and experiences. Furthermore, by devising activities that permit students to analyze, observe, and be influenced by artists and artworks that have shunned a focus on conventional realistic drawing techniques, teachers send a clear message that there are innumerable "right ways" to represent within drawing.

Contemporary Drawing Practices

Part of my mission with adult students is to consider the many ways you can approach drawing in order to widen a rather fixed notion of what constitutes drawing and "good" drawing. A starting point for this is to get at definitions of drawing. What practices do you include under drawing? How would your students define drawing? Do you draw when you trace, cut out something, copy an outline with your finger, doodle, draw out a map, and/or move your pencil beyond a point into a line? Can you draw with materials other than a pencil or pen and paper?

Contemporary artists use drawing in a myriad of ways that reconsider the boundaries of drawing media, subjects, techniques, processes, and definitions. The curator of the Vancouver Art Gallery, Daiana Augaitis (2003), has broadly defined drawing as the image obtained through marking a surface. In the exhibition *Drawing for the record: Drawing contemporary life*, marking a surface often went beyond the traditional drawing with a pen or pencil on paper. Artists in this exhibit drew on vases, video screens, and cars. They used garbage and computers in the execution of their drawings. Other artists drew mind maps, signs, zines, the night sky, and personal receipts. Some copied, traced, doodled, collaborated, and constructed their drawings. Although the artworks were representational (referring to recognizable subject matter) and standard conventions of line, perspective, tone, and contour were evident, the focus of these works was on content and meaning over form (Augaitis) and realism. Drawing was used to comment on and record contemporary life using realistic, fictional, autobiographical, narrative, and critical approaches.

The American artist Vik Muniz further breaks down the traditional definition of drawing. In many of his works he recreates famous artworks such as the Mona Lisa, by drawing with paradoxical materials like chocolate syrup. He has drawn clouds with vapor trials from a plane, a large bone with a bulldozer in the dirt, the Medusa with spaghetti on a plate, Impressionist landscapes with thread, monkeys with wire, children with sugar, as well as Rembrandt etchings with pins and nails.

An annual event over the past few years celebrating drawing in Britain is known as the Big Draw. On this day, activities are organized for children and the community to draw at an assortment of facilities all over the country including railway stations, museums, beaches, art galleries, public squares, botanical gardens, and various historical sites. The incredible array of activities takes strides towards breaking the traditional view of drawing as simply involving paper and pencil. Drawing is undertaken with unicycles, dancers' feet, drawing implements attached to long sticks or goggles, fingers through dirt, thread, tape, wool, wire, seeds, ink, sand, clay, dust, and fabric. Participants have had the rare opportunity to draw on floors, walls, bodies, balloons, windows, shirts, plates, plexiglass, and on the sides of dirty trucks (with permission).

Some Further Ideas for Drawing

Beyond the suggestions and ideas put forward above, in this section of the chapter I share some further ideas for your consideration when implementing drawing in your art program. Along with Harold Pearse (in this volume), I encourage teachers to consider multiple sources for drawing. Students can use observation, description, memory, imagination, selection, elaboration, magnification, point of view, and metamorphosis, among others.

Sketchbooks and/or visual journals (see Grauer this volume) can contain and explore all forms of image development strategies that can be used to develop drawing projects of personal significance to children. Pearse's chapter in this volume recommends that practice, persistence, and time are what are required to increase in fluency, skill, and personal approach or style to a medium such as drawing. Pearse suggests the use of daily drawing in sketchbooks or visual journals around an ongoing theme or topic.

Field trips to the neighborhood around the school, parks, waterfront, forest, gardens, museums, art galleries, farms, markets, and aquariums, just to name a few, allow students to have first-hand experiences where they can gather sketches, textures, outlines, colours, shapes, details, ideas, and patterns from the world around them. Conversely, you can bring the world outside into your classroom. Contacting museums and other facilities that have artifacts they are willing to lend out to schools, such as artworks, skeletons, and preserved insects, provide unique opportunities to examine the world up

close and personal. It is very hard to adequately relay the scale, form, texture, and even exact colour of objects without experiencing them firsthand.

Drawing can be used as an entry point for learning in other subjects. The Private Eye Curriculum encompasses artmaking, language arts, and science. The program gets students to use jewelers' loupes and magnifying glasses to frame sections of objects such as finger prints, winged maple seeds, and dusty miller plants. Students attend to these objects, select parts of a whole, magnify, and draw what they see through the frame. At the same time they are answering the question "What does this remind me of?" and writing down their connections. This analogous thinking through drawing and questioning is elaborated on to create metaphors, poetry, and research questions. Drawing close up sections of larger items such as fingerprints can relieve some of the pressure of creating a drawing that looks like a whole thumb or hand. Through careful looking, a lot can be learned, perceptions can change, and things can be seen anew.

I encourage you to try some collaborative drawing techniques. Again this partner or group creation takes some pressure off of individual students who do not feel as comfortable with their own work. Students learn from each other as they draw. The Royal Art Lodge is comprised of a group of Canadian artists who collaboratively work on drawings. Sharing these works with students helps them to appreciate that working together and learning from one another is what real artists do.

Guided imagery has been effective at relaxing and focusing my students before attempting to draw from memory. Here you can ask students to close their eyes, get a picture in their mind's eye of what they are going to draw, and then outline in the air what they see before drawing. Bob Steele's (1998) book, Draw me a story: An illustrated exploration of drawing-as-language, provides several ways to use this technique along with continuous contour line drawings within a daily drawing program at the elementary level.

Conclusion

I have outlined how anxieties around drawing are the result of educational experiences and limited conceptions of what drawing can be within a larger social and cultural backdrop. By contextualizing and expanding our notions of drawing, we may be able to break the disabling grip of visual realism and enable innumerable "right ways" for children to represent through drawing. As our new teachers of art the choices and the power will rest with you.

Resources

Some Contemporary Artists Who Expand the Definition(s) of Drawing

Jason McLean (www.jasonmclean.com/) – a young Vancouver artist who creates cartoons that reflect his daily thoughts and environment.

Vik Muniz (www.vikmuniz.net - Watch video clips, look at his gallery of artworks, listen to interviews, and read articles about artist Vik Muniz).

Royal Art Lodge artists - Marcel Dzama, Michael Dumontier, Hollie Dzama, Neil Farber, Drue Langlois, and Myles Langois (www3.mb.sympatico. ca/~mondmann/ - Royal Art Lodge's website).

Books About Teaching Drawing

Edwards, B. (1999). *Drawing on the right side of the brain: A course in enhancing creativity and artistic confidence* (3rd ed.). New York: J.P. Tarcher.

London, P. (1989). *No more secondhand art: Awakening the artist within*. Boston: Shambhala.

Steele, B. (1998). *Draw me a story: An illustrated exploration of drawing-as-language*. Winnipeg, MN: Peguis Publishers.

Wilson, B., Hurwitz, A. & Wilson, M. (1987). *Teaching drawing from art*. Worcester, MA: Davis.

Related Websites

http://www.pbs.org/art21/education/studentartprojects/index.html - Check out sections on abstraction and realism, Trenton Doyle Hancock's painting of mythical creatures and Raymond Pettibon's drawings.

www.uic.edu/classes/ad/ad382/sites/Projects/ - UIC Spiral Art Education's website has unit plans for the Elementary I Project and a great unit on Autobiographical Comics.

www.accessart.org.uk/drawing/index.htm - Check it out for information, lessons, and examples to help with the

learning of drawing.

www.drawingpower.org.uk/menu2.htm - This website documents the various events of the Big Draw.

www.accessart.org.uk/drawingtogether/ - The Drawing Together website is designed to help children aged eight upwards to make storyboards and animate their drawings.

www.drawright.com/ - The website for Betty Edwards' Drawing on the Right Side of the Brain with examples, activities, and more.

www.the-private-eye.com

References

Augaitis, D. (2003). *Drawing for the record: Drawing contemporary life*. Catalogue of an exhibition held at the Vancouver Art Gallery, June 28- Sept. 28, 2003. Vancouver Art Gallery.

Greene, M. (1995). *Releasing the imagination: Essays on education, the arts, and social change*. San Francisco: Jossey-Bass.

Gude. O. (n.d.) *Elementary I* . Retrieved December 17, 2004, from http://www.uic.edu/classes/ad/ad382/sites/Projects/P002/P002_first.html

Gude, O. (2000). Investigating the culture of curriculum. In D. E. Fehr, K. Fehr, & K. Keifer-Boyd (Eds.), *Real-world readings in art education: Things your professor never told you*. New York: Falmer. Retrieved December 17, 2004, from http://www.uic.edu/classes/ad/ad382/sites/AEA/AEA_01/AAE01a.html

London, P. (1989). *No more secondhand art: Awakening the artist within*. Boston: Shambhala.

London, P. (1994). *Step outside: Community-based art education*. Portsmouth, NH: Heinemann.

Neperud, R. W. (1995). Transitions in art education: A search for meaning. In Neperud, R. W. (Ed.) *Context, Content, and Community in Art Education: Beyond Postmodernism* (pp. 1-22). New York: Teachers College.

Steele, B. (1998). *Draw me a story: An illustrated exploration of drawing-as-language*. Winnipeg, MN: Peguis Publishers.

CONNECTING, REFLECTING AND IMAGINING

The Elements of Art

Heather A Pastro

The elements of art are as integral to the understanding of visual art as the periodic table of elements are to understanding chemistry. The elements of art serve as a framework for the structure of visual art and work together to form compositions. What are the Elements of Art?

The elements of art are:
- *Line*
- *Shape*
- *Colour*
- *Form*
- *Texture*
- *Value*
- *Space*

Most art education textbooks will have definitions for the elements of art. The following definitions adapted from *How to Teach Art to Children* (Evans, 2001), are practical for both children to understand and for teachers to explain.

Line

Lines have names that describe their place in space. They may be diagonal, vertical, or horizontal. Lines may be thick or thin, solid or broken. When two lines sit next to each other they become parallel lines. Lines can be bent into curves and broken into angles. In this way, lines can create an infinite number of configurations.

Shape

Lines create the outline of shapes. Each time a line outlines a shape, it is really creating two images: the positive one that is outlined, and the negative one that is created outside the positive shape. Some shapes, particularly those used in mathematics, fit definitions and can be given a name: circles, ovals, crescents, squares, rectangles, triangles, and trapezoids are named shapes. Some shapes are irregular and don't fit a definition. A paint spill might be an irregular shape that doesn't fit a definition.

Colour

Colour is a sensation produced by rays of light on different wavelengths. There are three primary colours: red, yellow, and blue. These colours are called primary colours because you can mix them to create all the colours of the rainbow. Colour relationships create the foundation of the colour wheel. The primary colours can be mixed to create the secondary colours of orange, green, and violet. Mixing different amounts of a colour changes the colours hue. Contrast is the degree of difference between colours or tones in a piece of artwork. Blue, green, and violet are often labeled as cool colours, while yellow, orange, and red are called warm colours (e.g. purple & yellow). Complementary colours are pairs of colours that sit opposite one another on the colour wheel. Tertiary colours are colours created by mixing secondary colours.

Value

Value is the lightness or darkness of any colour. When colours are used at full value, they appear strong and bright. When colours are mixed with white paint or water, they appear as muted, lighter tones. When colours are mixed with black paint, they appear as darker tones or shades. The creation of a light to dark value scale requires careful mixing of colours.

Space

Space in artwork makes a flat image look like it has form. There are several ways an artist adds space to artwork:

- Overlapping – placing an object in front of another object makes the object in front appear closer than the one behind.
- Changing size – an object that is smaller looks like it is in the distance while an object that is larger looks like it is closer.
- Using Perspective – utilizing perspective, objects can be drawn on a flat surface to give an impression of their relative position and size.

Form

When a flat, two-dimensional shape is bent, a third dimension is created (height, width, length). The shape becomes a form. Artists use form when they create sculptures. Some forms commonly used are cylinders, cones, spheres, cubes, pyramids, and prisms.

Texture

The world is full of a variety of textures. Students have first-hand experiences with many textures. They know about rough rocks and smooth marbles. Students investigate their world and describe what they see and touch in terms of how it looks and feels. Texture can be created in pictures by using a repetition of lines and shapes.

A Teachers Guide to Key Vocabulary Words to Help Understand the Elements of Art

It is critical for teachers to use descriptive words when teaching lessons about the elements of art. Students need to be fluent in their verbal and cognitive understanding of these terms. Also, children should be able to graphically or pictorially represent these key concepts. A strong message of understanding and awareness is sent to the student when a teacher shows the word, defines the term, and then demonstrates the concept. The student then writes the word, explains the definition, and renders a graphic or pictorial representation of the concept to further the equation. The following lists provide some examples:

Line	Shape	Colour	Form	Texture	Value	Space
Angle	Circle	Blend	Cone	Bumpy	Bright	Behind
Broken	Crescent	Blue	Cube	Feel	Infinite	Change
Curly	Flat	Complementary	Cylinder	Fluffy	Light	Composition
Curve	Geometric	Contrast	Flat	Grainy	Muted	Distance
Diagonal	Irregular	Cool	Prism	Hard	Scale	Front
Horizontal	Negative	Green	Pyramid	Repetition	Strong	Overlapping
Looped	Outline	Hue	Sculpture	Rhythm	Tint	Perspective
Salloped	Oval	Mix	Sphere	Rough	Tone	Size
Solid	Positive	Muted	Three-dimensional	Prickly		Vanishing
Straight	Rectangle	Orange	Two-dimensional	Smooth		Point
Thick	Square	Palette		Touch		
Thin	Trapezoid	Primary		Variety		
Vertical	Triangle	Prism				
Wavy		Rainbow				
Zigzag		Red				
		Secondary				
		Spectrum				
		Tertiary				
		Tone				
		Variation				
		Violet				
		Warm				
		Wheel				
		Yellow				

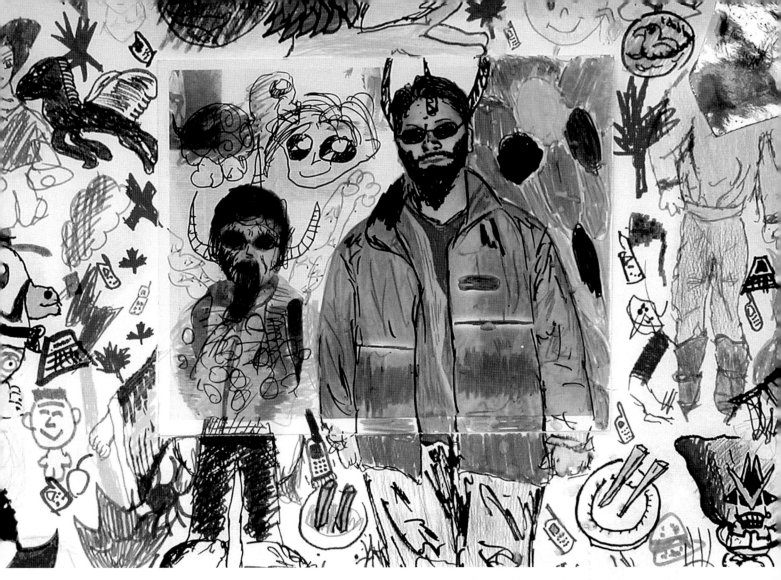

There are numerous art activities or lessons that can be used to teach the elements of art. Students need to practice a variety of techniques and processes utilizing many different materials in order to fully understand the elements. The following activities are examples of how to create an awareness of different media and approaches in the teaching of the design elements. These activities should be simplified or elaborated upon depending on the level of the learner.

Drawing Activities

Line
Abstract Lines

Listen to music. Use a variety of media to create a collection of lines on paper. Consider *overlapping* and filling up the *space*. Think of all the different kinds of lines i.e.: swirling, zigzag, jagged, dotted, etc.

Materials: manila drawing paper, crayons, chalk pastels, oil pastels, felt pens, charcoal, pencils, etc.

Shape
Six Points of View

Choose one object that interests you from the object drawing box. Observe the object from a variety of viewpoints. Divide your paper into six equal sections with a ruler. Draw the object from six different viewpoints considering shapes of interest, detail, and composition. Not all of the object needs to be shown or portrayed.

Materials: cartridge drawing paper, fine line felt pens or pencils, rulers.

Colour
Drawing – Prism Design

Use pencil crayons to create a design on paper. Draw a triangle in the center of a piece of cartridge drawing paper. Draw seven sets of lines radiating from each side of the triangle. Colour in the lines in the order that the

colours appear in the spectrum.

Materials: cartridge drawing paper, pencil crayons.

Form
Shoe Drawing

Take off your shoe. Observe it from a variety of angles. Draw it in profile showing great detail. Consider light, middle, and dark areas. Use the entire space of your paper.

Materials: cartridge drawing paper, pencil or fine liner felt, pen or charcoal.

Texture
Drawing - Scribble Image

Use a pencil to create a large loose scribble that fills the *space* of your paper. With a variety of mixed media fill in all areas with drawn or implied *textures*, i.e.: dots, solid areas, lines, cross-hatching, etc. Consider creating an animal from your scribble and place a large dot for the eye.

Materials: cartridge drawing paper, felt pens, pencils, crayons, oil/chalk pastels, etc.

Value
Landscape Drawing

Observe a landscape from a distance. Sketch a section that interests you with a pencil. Add chalk pastel to colour areas of interest (1 colour only). Remember to include a horizon line. Show value by shading areas closest darkest and areas furthest away lightest.

Materials: manilla drawing paper, pencils, chalk pastels.

Space
Vocabulary of Emotions

Think of about 7 – 10 words that describe emotions or feelings, i.e.: love, envy, rage, etc. Use mixed media materials to graphically represent the words using consideration to the materials and their ability to portray ideas and meaning. Consider filling the space, overlapping, and juxtaposition.

Materials: manilla drawing paper, crayons, oil pastels, felt pens, chalk pastels, charcoal, pencil, pencil crayons, etc.

Printmaking Activities

Line

Discover how many different kinds of lines you can make with available tools. By varying pressure and/or the speed of the stroke, you can make them thicker or thinner and darker or lighter, as you carve into styrofoam sheets. Roll paint/ink overtop with a brayer.

Materials: paper, tempera paint or water-based ink, brayer or foam roller, styrofoam sheets or meat trays, tools to incise lines such as: paper clips, ball-point pens, pencils, nails, etc.

Shape

Cut a simple organic or geometric shape from a piece of foam. Make a repetition of shapes in a row, dipping the foam in paint or ink.

Materials: paper, tempera paint or water-based ink, foam chunks, scissors.

Colour

Choose a colour grouping, i.e.: analogous, monochromatic, primary, etc. Use found objects to create an interesting pattern. Consider having borders to define edges. (Found objects might include corks, dry pasta, paper rolls, bubble wrap pieces, etc.)

Materials: paper, tempera paint or water-based ink, paint brushes, found objects, corks, pasta shells, styrofoam packing pieces, bubble-wrap pieces, paper rolls cut into pieces, straws, wood scraps, etc.

Form

Use the collograph technique to build up interesting shapes cut randomly from cardboard. Glue onto a larger cardboard plate. Roll ink/paint over top with a brayer. Lay paper on top and take prints from the collograph plate.

Materials: paper, tempera paint or printing ink, brayer or foam roller, cardboard, scissor, white glue.

Texture

Produce different textures using a collage approach of overlapping various rubbings made from wax crayons. Lay paper overtop surfaces such as brick, wood, cement, etc.

Materials: paper, wax crayons, textured surfaces, brick, cement, wood, carpet with texture, tiled flooring, ridged areas on surfaces, etc.

Value

Create a simple line drawing of mountains. Use crosshatching to define light and dark areas, (dark areas = lines overlapping very close together) As you carve into styrofoam roll paint or ink overtop with a brayer.

Materials: paper, tempera paint or water-based ink, brayer or foam roller, styrofoam sheets or meat trays, pencil or ballpoint pen.

Space

Show positive and negative space by cutting into a cardboard stencil of a simple shape. Place a sheet of paper under the stencil. Use a toothbrush dipped in paint to splatter paint in the inside (positive) area of the stencil lift off the stencil carefully.

Materials: paper, tempera paint or water-based ink, toothbrushes, cardboard, scissors.

Painting Activities

Space

Tonal Silhouette: Paint a wash of colour on 9 x 12" cartridge paper. Consider a value or intensity scale and use broad sweeping strokes in a horizontal pattern. While drying, draw tree shapes on black construction paper and glue these over dry painting. Mount on larger and compare to works by Roy H. Vicers and Ted Harrison.

Materials: paint, brushes, water, manilla paper, construction paper, scissors, glue.

Value

Monochromatic Study: Choose a subject matter of interest to you and paint the imagery in one colour mixing it with black or white for shading and highlighting.

Materials: paint, brushes, water, manilla paper.

Texture

Abstract Image: Use a variety of painting tools, i.e. brushes, sponges, toothbrushes, sticks, etc., and a variety of painting techniques, i.e. drip, wash, dry-brush, etc. Overlap and build up areas of paint and pattern on a 18 x 25"piece of cartridge paper. Once dry, cut out areas of interest in different shapes or tear strips. Arrange pieces on a large piece of black paper. Make note-cards with the remaining pieces. Encourage students to be creative and inventive. Look at art by Jackson Pollock for discussion.

Materials: brushes, sponges, toothpicks, corks, toothbrushes, paint, water, manilla paper.

Colour

Colour Matching: Cut a piece of fabric or wallpaper from a book of samples. Draw the image in an outline method. Look at the colours and mix your paints to replicate these. Create your palette and paint in the outline.

Materials: fabric samples, wall paper book samples, pencil, paint, brushes, water, manilla paper.

Shape

Distorted Image: Find a picture that interests you. Put it behind an 8" x 8" glass block or put an 8" x 8" glass block in front of a window overlooking an area of interest. Paint what you see as you look through the glass block. Look at art by Picasso.

Materials: glass building blocks, paint, brushes, water, manilla paper.

Line

Extend the Image: Look through a magazine and find a picture that interests you. Cut this out or cut away a part of the picture and glue it onto a larger piece of paper, in a place that allows you to extend this image. Draw in an outline method, then paint creating a setting that incorporates this magazine piece into your painting.

Materials: magazines, scissors, glue, pencil, paint, brushes, water, manilla paper.

Form

Edible Still Life: Draw a simple still life composition of a banana, an apple, and an orange. Paint the objects in their realistic colours. Show the forms of the shapes by shading with the complementary colour.

Materials: apple, banana, orange, paint, brushes, water, manilla paper.

Sculpture Activities

Line

Look at the art of Alexander Calder. Draw a continuous line drawing of a free form. Use wire or pipe cleaners to recreate the line. Suspend in the air with nylon string to create a mobile.

Materials: pencil, paper, wire, pipe cleaners, nylon string.

Shape

Roll out clay with a rolling pin. Use a butter knife to cut out a variety of geometric shapes in different sizes i.e. triangles, circles, squares, etc. Pierce a hole in each one and tie with nylon string to create a mobile.

Materials: clay, rolling pins, butter knives, nylon string.

Colour

Roll out a ½" slab of clay and cut into a 6" x 6" tile. Draw a Piet Mondrian like design onto the clay with

the sharp end of a pencil or carving tool (fire the clay). Use primary and secondary colours to paint in sections.

Materials: clay, rolling pin, rulers, kiln, paint, brushes, water.

Form

Look at sculptures by Henry Moore. Create an irregular shaped form by rolling and pinching a ball of clay. Encourage students to create an abstract, human or animal form.

Materials: clay.

Texture

Roll out a ½" thick by 6"x 6" square slab of clay. Using a variety of carving tools, incise at least 5 different textural patterns to fill up the entire space.

Materials: clay, rolling pin, rulers, carving tools.

Value

Use papier-mâché to cover a 9 x 12" piece of cardboard. When dry, paint a simple landscape in one colour showing at least 5 different values.

Materials: papier-mâché, cardboard, paint, brushes, water.

Space

Use a shoebox to create a setting for an imaginary dream bedroom. Paint interior walls. Construct furniture with plasticene or play-doh and arrange pieces inside.

Materials: shoebox, paint, brushes, water, play-doh or plasticene, glue.

Literature References

The use of literature as a resource for both the teacher and student alike is extremely useful for visual literacy and understanding of the art elements. We know that a picture is worth a thousand words and through the pages of books, children and teachers can make connections to reinforce the understanding of the art element. Gathering a collection of these books would be a worthy task for a teacher or librarian. The following list is a compilation of some of the many literature resources that have references to the elements of art.

Line Calder, A. (1998). *Getting to know the world's greatest artists*. New York: Children's Press.

Escher, M.C. (1992). *M.C. Escher: His life and complete work*. Boston, MA: Harry N. Abrams.

Grafton, C. (1993). *Egyptian designs (Dover Pictorial Archive)*. Mineola, NY: Dover Publications.

Johnson, C. (1955). *Harold and the purple crayon*. New York: Harper Collins Publishers.

Klee, P. & Von Schemm, J. (1997). *Dreaming pictures: Paul Klee (Adventures in Art.)* New York: Plestel USA.

Shape Anholt, L. (1998). *Picasso and the girl with a ponytail: A story about Pablo Picasso*. Hauppauge, NY: Barron's Juveniles.

Greene, R. G. (1997). *When a line bends a shape begins*. New York: Houghton Mifflin.

Mason, A., Hughes, A.S., and Green, J. (1995). *Matisse famous artists*. Hauppauge, NY: Barron's Juveniles.

Mirow ,G. (1997). *Traditional African designs*. Mineola, NY: Dover Publications.

Ringgold, F. (1991). *Tar beach*. New York: Crown Publishing.

Colour Anholt, L. (1994). *Camille and the sunflowers: A story about Vincent Van Gogh*. Hauppauge, NY: Barron's Juveniles.

Dionetti, M. (1996). *Painting the wind*. Dubuque, IA: Little, Brown & Company Inc.

Dunbabin, K.M.D. (2000). *Mosaics of the Greek and Roman world*. New York: Cambridge University Press.

Jaffe, H.L.C. (1986). *Piet Mondrian*. Boston, MA: Harry N. Abrams.

Form Anholt, L. (1996). *Degas and the little dancer: A story about Edgar Degas*. Hauppauge, NY: Barron's Juveniles.

Axsom, R H. (1997). *Printed stuff: Prints, posters, and ephemera by Claes Oldenburg: A catalogue raisonne 1958-1996*. Manchester, VT: Hudson Hills Press.

Benton, J.R. (1997). *Holy terrors: Gargoyles on medieval buildings*. New York: Abbeville Press, Inc.

Fisher, L.E. (1997). *Anasazi*. Hartford, CT: Atheneum.

Le Tord, B. (1999). *A bird or two: A story about Henri Matisse*. Grand Rapids, MI: Wm. B. Eerdmans Publishing Co.

Texture Carle, E. (1969). *The very hungry caterpillar*. New York: Philomel Books.

Ehlert, L. (1995). *Snowballs*. New York: Harcourt, Brace & Company.

Hart, T. (1994). *Picasso (Famous Children)*. Hauppauge, NY: Barron's Juveniles.

Sendak, M. (1963). *Where the wild things are*. New York: Harper Collins Publishers.

Sutton, P. (1997). *Dreamings: The art of Aboriginal Australia*. New York: George Braziller.

Value Adelman, B. (1999). *Roy Lichtenstein's ABC*. New York: Bullfinch Press.

Dunbabin, K.M.D. (2000). *Mosaics of the Greek and Roman world*. New York: Cambridge University Press.

Lisle, L. (1997). *Portrait of an artist: A biography of Georgia O'Keefe*. Washington, DC: Washington Square Press.

Venezia, M. (1997). *Andy Warhol (Getting to know the world's greatest artists)*. New York: Children's Press.

Venezia, M. (1998). *Paul Cezanne (Getting to know the world's greatest artists)*. New York: Children's Press.

Space Deicher, S. (1996). *Piet Mondrian 1872-1944: Structures in space*. New York: Taschen America Ltd.

Isom, J.S. (1998). *The First starry night*. New York: Charlesbridge Publishing.

Kelly, S. (2000). *Amazing mosaics*. Hauppauge, NY: Barron's Juveniles.

Venezia, M. (1998). *Paul Cezanne (Getting to Know the World's Greatest Artists)*. New York: Children's Press.

Winter, J. (1998). *My name is Georgia*. New York: Harcourt, Brace & Company.

Artwork References

Reproductions of master artworks can be found to represent examples of how artists use the elements of art in their work. The following is a list of artworks by artists that exemplify each of the art elements.

Line
- *Enchanted Owl* by Kenojuak, 1960.
- *Grove of Cypresses* by Vincent Van Gogh, 1889.
- *Mount Lefroy* by Lawren Harris, 1930.

Shape
- *Beachwalk* by Alan Wood, 1992.
- *Child and Dog* by Alex Colvill, 1952.
- *Guernica* by Pablo Picasso, 1937

Colour
- *The Visions After the Sermon* by Paul Gaugin, 1895.
- *Thunderbird with Inner Spirit* by Norval Morrisseau, 1978.
- *Woodland Waterfall* by Tom Thomson, 1916.

Form
- *Cabbage* by Dulcie Foo Fat, 1974.
- *Haida Grizzly Bear* by Bill Reid, 1990.
- *The Liberation of the Peon* by Diego Rivera, 1931.

Texture
- *Ecriture No. 931215* by Seo-Bo Park, 1993.
- *Red Currant Jelly* by Mary Pratt, 1972.
- *Wreck of the Nickerson* by David Blackwood, 1993.

Value
- *Indian Church* by Emily Carr, 1929.
- *Madonna of the Rocks* by Leonardo da Vinci, 1483.
- *Orange Becoming Red, series @2* by Judith Dingle, 1980.

Space
- *Edge of the Forest* by Emily Carr, 1935.
- *Man Hunting at Seal* by Niviaksiak, 1959.
- *The Studio* by Jacob Lawrence, 1977.

References

Bennett, B. & Hall, C. P. (1984). *Discovering Canadian art*. Scarborough, ON: Prentice Hall Canada Inc.

Evans J., et al (2001). *How to teach art to children*. Monterey, CA: Evan-Moor Corp.

Ocvirk, Otto G., et al. (1998). *Art fundamentals theory & practice*. Boston, MA: McGraw Hill Companies.

Ministry of Education. (1998). *The fine arts integrated resource package, Visual Arts K-7*. Victoria, BC: Ministry of Education.

CONNECTING, REFLECTING AND IMAGINING

Themes, Cross-Curricular Connections and Daily Drawing

Harold Pearse

If this chapter were to have a subtitle, it would be "Everything I Know about Art and Art Education (well, almost everything) I Learned From my Dog." Why dogs? Well, most people have a dog, want a dog or at least know someone who has a dog. Since interest in dogs and experience with them characterizes many elementary school age students, the subject seems to heighten their motivation to become actively involved in learning. Children tend to learn best when the subject, topic or theme is engaging, relevant and authentic. Artists too, tend to be attracted to certain subjects or topics and to work with themes. They draw their ideas and inspirations from their immediate environment and often in that environment, as part of it, is a dog. Many artists, from Leonardo da Vinci (Roalf, 1993) to David Hockney (2000), have drawn, painted or sculpted their dogs.

The realization of this connection between the way children learn and artists work struck me as, over the past decade, a dog became part of my family household and my prime subject for daily drawing. I have long advocated an integrated approach to curriculum planning and favoured a theme-based approach to teaching. As I drew, explored and recorded my dog's constantly changing (but somehow constant, like dogs are supposed to be) shape, lines, colours, tonality, body language and attitudes, I became impressed by the richness and depth of 'dog' as a theme for meaningful art making. This chapter explores the vital role that a theme-based approach to curriculum planning combined with daily drawing can play in teaching and art making. And since it is grounded in real life experience, it will be both theoretical and practical – ideas and actions.

Making Connections

First, let me clarify some terms I will use here. *Topics* are discrete subjects that relate to students' everyday experiences. *Themes* are broad questions that connect topics to our relationship with the world. The theme should be an overarching, general question or metaphor that ties subjects together in deep and meaningful ways (Koster, 2001). So if my topic were 'dogs' my theme could be 'dog-human interaction.' Themes can be viewed through the lenses of particular subjects or disciplines. When a topic or theme is considered from the perspective of mathematics, language arts, social studies, science or visual art, something essential is revealed about the subject matter as well as about the discipline or art form.

The theoretical basis of art's relationship with other subjects in the elementary school curriculum can be put into historical perspective. A currently fashionable term 'infusion' refers to the injection of the arts into the classroom setting in order to enrich student learning. In the arts infused scenario (a prime example is the visiting artist) the arts enter the scene from the outside in. 'Co-relation' a term popularized in the progressive era, is used when art processes or art learning are introduced into (or related to) other school subject disciplines in order to enhance presentation and instruction. A typical example of correlation is when a child is asked to illustrate a story in language arts or to draw an historical event. Illustration, rather than art, is being practiced whenever a child tries to depict an event with which he has had no personal individual relationship (Lowenfeld, 1968, p. 35). There are no doubts, occasions when illustration and correlation are appropriate and desirable educational objectives. They differ

however, from 'integration,' another term favoured by progressive educators and still a preferred strategy of many elementary school educators.

The Canadian Society for Education through Art (CSEA) defines integration as:

the making of conceptual or thematic connections between or among the visual arts and other subject areas. Providing additional attention to continuity of curricular concepts, issues, themes, or activities among subject areas, offers an interesting and meaningful exchange of disciplinary knowledge. Often, these integrative practices strengthen understanding across several disciplines. However, great care must be taken to ensure that the integrity of each subject area is maintained in the process of integration. (Irwin, 1997, p.7)

Maintaining a subject's integrity is a difficult undertaking and a large responsibility, since "integration in learning means that the single subjects lose their identity and form a new unit within the student" (Lowenfeld & Brittain, 1975, p. 106). The key point is not so much 'what' is being integrated, but 'where' or in 'whom' the integration is occurring. As Viktor Lowenfeld (1968) puts it, "whenever we engage a child in a creative process – a meaningful creative process – the child meaningfully integrates" (p. 34). He adds that this "is the most important contribution which art can make to integrative experiences, because what is integrated is man, not subjects" (p. 34).

When a theme is used, it is not a question of art being integrated with another subject or being in service of that subject. When the theme is 'dogs and people' and the student writes a poem about her dog, it is, if a label is required, poetry or language arts. If a dog's age, height and weight is being calculated, the student is 'doing math' or science. If she is painting a picture of a dog, paying attention to its shape, texture, colour, the lines and movement it makes and is trying to express its character or her feelings towards it, she is making art. She is also having an integrative experience.

Howard Gardner's theory of multiple intelligences provides strong support for an integrative or thematic approach (1983, 1993) to learning and suggests a central role for art in the school curriculum. Gardner has challenged the pre-eminence of verbal skill as the dominant method of teaching and learning by providing a more complex vision of how people think and learn. He divides intelligence into eight domains representing the biological and psychological potentials within each individual. He calls them: linguistic intelligence; logical-mathematical intelligence; visual-spatial intelligence; musical intelligence: bodily-kinesthetic intelligence; interpersonal intelligence; intrapersonal intelligence; and naturalist intelligence. By identifying distinct but interlocking intellectual capacities or 'intelligences,' Gardner has reminded us of the breadth of human potential and the many ways that people learn. He has confirmed what many art educators suspected – intelligence is a multidimensional phenomenon that is not fixed and can be enhanced. Intelligence, in the holistic sense, requires integration. It is interesting to note that Gardner does not claim an 'artistic intelligence' but believes that all the intelligences can be used for either artistic or non artistic purposes depending on combinations of individual choice and cultural factors. When an artist is engaged in the art making process, several intelligences are in play. Koster succinctly states the implications: "art crosses and links the intelligences in ways that should give it a preeminent role in our educational system" (2001, p.39).

Exploring the Human-Canine Relationship

What is common to all of these terms and ideas is the notion that both learning and art making are about making connections. In order to illustrate how a theme based approach to teaching art can generate lessons and activities rich in art learning as well as potential for cross curricular connections, lets look at one topic, 'dogs,' and related themes in detail. A good way to begin is with a brainstorming session with a group of students to create a concept web. The Student Web, p. 50, illustrates one student teacher's projection of the kind of responses a group of grade four students might generate as she prepared a unit proposal on the theme of 'the Human–Canine relationship.' [1] A true brainstorming session can start anywhere and go anywhere. With dogs at the centre and lines radiating, the teacher can name the circles or nodes. 'Dogs with jobs,' a phrase popularized by a television program, is a good place to start. A list can be made of jobs that some dogs are trained to do, including being guides for the visually impaired; helping the police; searching for bombs, drugs and lost people; guarding homes and businesses; herding sheep or cattle; pulling sleds, racing and acting in movies. Dogs have even gone to outer space! Most dogs have the job of being friend and companion. Various breeds will be called out starting with a

child's own dog. Many children will know names of breeds (Beagle, Poodle, Dachshund, Greyhound, Cocker Spaniel, Rottweiler, etc.). Many breeds are associated with various nationalities or regions, for example German Shepherd, Siberian Husky, Irish Wolfhound, Norwegian Elkhound, Australian Cattle Dog, Old English Sheepdog, Labrador Retriever and Newfoundland Dog. The potential for a geography lesson is obvious. Discussion can move to the training of dogs and terms like 'obedience' and 'agility.' Some students may have knowledge of the world of dog shows and competitions. They may be familiar with various careers involved with dogs: trainer, breeder, groomer, veterinarian. The history (evolutionary, biological and sociological) of dogs from their prehistoric predecessors to wolves to our present day domestic pets can be elaborated on by the teacher. The types and textures of coats found in various breeds (and cross breeds) of dogs – short, long, wiry, curly, coarse, silky – and the range of colour can lead to discussion of art terms and interpretation in appropriate media.

The Teacher Web is a concept web of the same theme from the teacher's perspective. It too starts with 'dogs' at the centre and leads to various subject areas: social studies (history of the dog; roles of dogs in society); language arts (dog stories, myths and fables; dog novels or expository text); science (breeding, genetics, physiology, etc.); mathematics (proportions, measurements, statistics, graphs) and even physical education (analysis of movement). The dog theme can enlighten and broaden discussions of history and multiculturalism as we uncover humankind's various and often conflicting attitudes towards these ubiquitous beasts. As Stanley Coren outlines, "in some times and places, people have viewed dogs as loyal, faithful, noble, intelligent. Courageous and sociable; in other eras and locations humans have thought dogs cowardly, unclean, disease ridden, dangerous and unreliable" (2000, p. 1). The symbolism attached to dogs by different cultures, from being guides for souls or the embodiments of the devil, is ripe and evocative material for art education. It is important to remember the negative side of dogs. Dogs can be fierce and dangerous. A black dog is a symbol of evil and menace. Some people are allergic to dogs.

When developing both the art unit and individual lessons, the "Unit Circle" model provides a useful structure. The four points on the circle: Developing images (the theme and all of its dimensions and possibilities); Elements and principles of design; Responding to art and Materials and processes constitute the major planning considerations. Each is accommodated nicely in a lesson this student teacher calls "From Picasso Pups to Cajun Canines" in which students learn about the wide ranging styles and other pertinent information of five artists who painted dogs (among other things): Pablo Picasso, Leonardo da Vinci, George Rodrigue (the Cajun), Robert Bateman and Franz Marc. The students respond to these works, learn about personal styles in art, and create a painting in their own personal style using appropriately expressive media and directly or indirectly, particular elements (colour, shape, texture) and principles (emphasis, balance, rhythm, etc.) of art and design. As she points out, this approach incorporates the three facets of art instruction: "Learning *with* art (as a vehicle for studying other

subjects), learning *through* art (using art to express ideas and emotions) and learning *about* art (gathering knowledge of media, methods, skills etc.)." [2] Art becomes truly embedded in the curriculum as an integral *learning* language. These examples demonstrate the huge potential of the dog theme and the nature and extent of the relationship between mankind and 'dogkind.'

Dogs and Art

A short survey of the history of dogs in art is in order. Dogs have had a place in art from what is generally considered to be art's beginnings, the prehistoric paintings on cave walls. The fossil record shows fourteen thousand year old evidence of a domesticated dog, similar to contemporary dogs, as cohabiting with a group of Paleolithic (Old Stone Age) humans who lived in caves in the region that is present day Iraq (Coren, 2000, p. 180). The earliest known graphic depiction of canines is from the late Paleolithic period (15,000 to10,000 years ago), in caves in the Pyrenean region of Spain (Marley, 2000). These dog-like creatures are crudely drawn and it is not known whether they were companions or competitors in the hunt for game (or the game itself). As domestication occurred, the roles for dogs

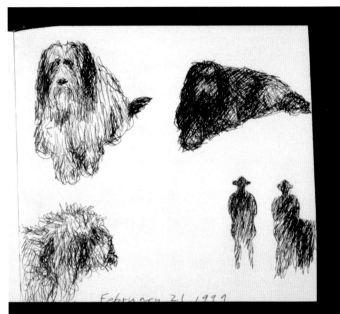

changed – from hunting, to guarding, to fighting, to herding, to hauling – each task requiring a different type. Egyptian carvings on green slate tablets from at least 4,000 BC portray both Mastiff and Greyhound type dogs, breeds that were also depicted in early Assyrian and Babylonian sculptures. By 800 BC the Egyptians were depicting a small Spitz type toy dog, most likely a pet, in household scenes. Egyptian tomb paintings from the XIXth Dynasty (c. 1350 –1115 BC) show Anubis, the dog or Jackal-headed god of the rites of death whose duty it was to guide the dead on the trip to the underworld. On jugs and urns, the Greeks often portrayed hunting dogs, guard dogs and pets. So too did the Romans. A fine example of a guard dog pulling on its leash in a mosaic excavated at Pompeii is reproduced in Howard's book, *The Illustrated Dog* (1994, p. 24).

While hunting scenes were occasionally the subject of illuminated books depicting the lives of the nobility in the early middle ages in Europe, prior to the Renaissance the major employer of artists was the Christian church and the subjects were religious ones. Consequently, few dogs are found in art from that period - Jesus didn't have a dog. When dogs were depicted it was for symbolic purposes: "A dog with a flaming torch in its mouth is a symbol of St. Dominic" (Marley, 2000, p. 23). The Dominicans, who were called 'dogs of the Lord' wore black and white habits. Black and white dogs symbolized this religious order. Dogs were also considered a symbol of faithfulness in marriage. The most famous example is Jan Van Eyck's symbol laden fifteenth century portrait, *Giovanni Arnolfini and his Bride*. The little terrier at their feet symbolizes marital faith. He is probably also just their pet.

The Renaissance, with its advancements in anatomical knowledge and draughtsmanship, along with growing private patronage and the revival of the Greek's keen interest in animals, was a rebirth of sorts for dog imagery in art. Dogs were a favorite subject of tapestry weavers. Leonardo da Vinci and Albrect Durer produced some fine studies of dogs. Venice, which boasted a wealthy merchant class which wanted their portraits painted, preferably with their favorite dogs, supported the painters Titian and Veronese. "Titian," claims Marley, "is well known for his portrayal of small children with large dogs – a device that effectively

emphasizes the contrast between vulnerability and security" (p. 22). In Northern Europe, Flemish and German artists included dogs in their commissioned paintings. Certain breeds signified rank and wealth. Eighteenth century British portrait painters such as Sir Joshua Reynolds and Thomas Gainsborough followed this example by introducing dogs into many of their paintings for this purpose, but also as compositional devices. The household pets of common people are found in the Dutch genre painting of Jan Steen, Gerard Ter Borch and others and are often central characters in paintings and illustrations from the Romantic period.

In eighteenth and nineteenth century Britain there was a proliferation of painters who specialized in animals. The best known, George Stubbs, Edward Landseer, and Rosa Bonheur, began their careers as portraitists of human subjects but became famous for their portraits of horses and dogs. Queen Victoria and her family were dog lovers and commissioned Landseer to portray her favourite pets (Howard, 1994, p. 71). The dog portrait as a genre and the dog as a subject for art had arrived. Marley attributes this phenomenon at least in part to "the developing passion for natural history on one hand, and improved printing methods and the invention of lithography on the other" which "provided an enormous incentive for dog artists to meticulously record the breeds" (2000, p. 24). The invention of photography also aided and further popularized this trend.

Dogs as a subject fared less well in modern art, perhaps as a reaction against the Victorian and romantic tendency to sentimentalize and anthropomorphize attributes such as loyalty, obedience and courage. Moreover, photography and the popular media provided ample opportunity for the spread of dog imagery. Still, one of the great landmarks of modern art, George Seurat's *A Sunday Afternoon on the Island of La Grande Jatte* prominently features two dogs and dogs appear, albeit in various degrees of abstraction, in some paintings by Franz Marc and Pablo Picasso. When the modern sensibility allows for an evocative kind of realism, as in the works of the American Edward Hopper and the Canadian Alex Colville, dogs reappear.

In postmodern and contemporary art with its urge for inclusiveness and embracing of narrative and autobiographical elements, dogs are again a popular, recurring (pun intended) subject. This is probably

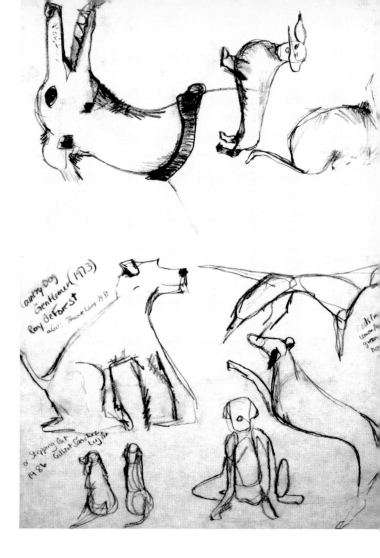

because dogs, being both a part of (and apart from) human society can serve simultaneously as a metaphor for human beings, a foil for their follies, and as particularized beings. The British-American artist David Hockney, unabashedly paints his sleeping Dachshunds in their role as specific pets – both representatives of a breed and as individuals (Hockney, 1998). William Wegman, in drawings, videos, and polaroid photographs of his Weimaraner Man Ray and his descendents, treats these dogs less as pets and more as 'co-conspirators' as they don outrageous costumes and assume elborate poses. Similarly the graffiti artist and painter, Keith Haring, often worked with and through an ironically knowing cartoon-like dog. Both artists' work exists comfortably in art galleries and in popular picture books and calendars. It is interesting to note that the postmodern dogs of William Wegman and Keith Haring do not change at all when the art is marketed to children or adults. The format may change but the dogs do not.

As long as dogs have a significant place in human society they will have a place in art. Through art, dogs help us raise questions about that society, be it ancient or post modern, and the nature of social relationships. How we treat our dogs reflects how we value our selves and how we treat other human beings and the environment.

Dog Based Art Education

In my view, the basis of an art program should be daily drawing. Daily drawing, be it practiced by professional artists, art education students, elementary teachers, or children, is like daily jogging – it keeps the 'drawing muscles' (eye, hand, brain) fit. For an adult or adolescent, the routine and discipline of a daily ritual relaxes the mind. With devotion and persistence, increased skill and fluency in drawing (and looking) can develop. For a child, daily drawing can be a kind of game, imbued with the fun that comes with spontaneous expression and the satisfaction that comes with completing a task within or in spite of certain parameters. These drawings (they could be collages or collected or 'found' images) need not be large or take long (a few minutes to half an hour). If one is to draw every day in a sketchbook or make entries in a visual journal, the process is expedited if one has an ongoing topic or theme. I have been drawing daily in a sketchbook for over 14 years and the major subject for half that time has been my dog - the other subject has been Mounties, but that's another story (See above a page from Harold Pearse's sketchbook).

The following ideas could be incorporated into daily drawings or adapted to classroom projects. How about beginning with a page of dog lines: smooth, furry, fuzzy, cuddly, strong, fierce, bumpy, squiggly, wiggley, 'as crooked as a dog's hind leg.' A page of dog textures: soft, rough, curly, shaggy, corded. A page of dog shapes: fat, thin, oblong, rounded, long, sausage-like. A page of dog colours: white, black, grey, brown, spotted, striped, banded. Dogs of course can be explored via the essential drawing modes of memory, observation, imagination and description.

Memory: Although not usually described as drawing from memory, young children draw what they remember as a 'schema' or routinized graphic

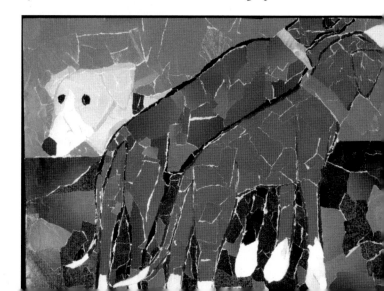

68

representation of a 'dog' - a couple of circles and a few lines that stand for 'dog.' Older children learn to personalize and particularize specific dogs, often drawing things as recalled. Drawing attention to what exactly it is that we are drawing when we draw from memory and where it is coming from (a little TV screen in our heads?) is an important kind of awareness for older children and adults to cultivate.

Observation: First you have to *really* look. At real dogs, at photographs, paintings, drawings, x-rays of dogs. Look carefully at these images. How is the dog put together? How does he move? Then put the image away and draw. Draw using a contour line, or what Steele calls the 'classical line,' the "line of early Greek ceramic decorators or classical artists such as Ingres and Picasso in his classical period" (1998, p. 91). It is the carefully observed and felt line of the contour drawing (the graceful, elegant sweep of a Greyhound or Whippet); the swift but deliberate and often playful continuous line drawing (the rapid movement of a Golden Retriever or Poodle). The aim is to achieve empathy with the subject. But as Hubbard cautions, "bringing a dog into the classroom to serve as a model may sound like a good idea and may at first appeal to students, but often can be a frustrating drawing experience because students have not learned enough about the structure of an animal and have not learned about artistic ways of portraying it" (1993, p. 30).

In other words, dogs won't keep still for long! But there is always gesture drawing, the perfect way to show a dog in motion. The value of a real dog in the classroom is not so much as a "life drawing" model but the experience of being in the presence of the real creature and the opportunity to analyze its structure and behavior. Hubbard recommends that students take Polaroid or digital photographic images in this situation which can be useful references and also give them a sense of ownership.

Imagination: Dogs can be a source for imaginative, fantasy or play inspired drawings. One group of grade six boys I observed with a fascination for collecting beanie baby dogs constructed an imaginary world of a colony of such dogs with their own families and competing armies which they portrayed in endless drawings, paintings and collages. The design process can be regarded as active imagining. De Bono's classic study, *The Dog-Exercising Machine* (1970) describes the inventive strategies employed by children when asked to 'design a machine for exercising dogs.' When learning about dog breeds, and collecting images of various breeds, students can imagine and design, draw or collage new combinations (mixed breeds and mixed media). What would a labracollie, a schnoodle, a Newfy Rotshund look like? (Lately in my sketchbook I have been drawing my puppy, which I think is a 'dwarf downhill border collie.')

Description: Drawings can be inspired from words, music, plays, films or other symbol systems or art forms. Stories and images are described in some way which can be translated to expressive visual forms. Children's books, from Lassie to Old Yeller to Snoopy contain wonderful dog characters. My current favourite is 'Walter the farting dog.' The challenge of course is to help children go beyond the sometimes stereotypical images created by adult artists (and the media) to create unique dog characters of their own.

These modes of drawing are combined and extended in a unit I do with my elementary art education students, called The Dog Collage Project. We begin by exploring various approaches to drawing including contour drawing, classical line, continuous line, drawing with empathy, drawing from memory, imagination and observation. Even upside-down drawing. We consider the notions of topics and theme, using our relationship to dogs as a model. After a variety of dog images are collected and drawn from various sources, a composition (to include at least three dogs or parts of dogs) is created and the outline transferred onto heavy paper. They are then introduced to a selection of reproductions of paintings with dogs in them by artists including Paul Gaugin, Mary Cassat, Francisco Goya, Gilbert Sanchez Lujan, Auguste Renoir and Alex Collive. These paintings provide the inspiration for the colour palette of their own composition. The colours, shades/tints/values observed in the reproduction, rather than being mixed in paint, are selected from magazines, which become a kind of paint box. The students are encouraged to pay attention also to textures, shapes, lines, mood, contrast, patterns, etc. Using this collage or "paper mosaic" material they give colour, texture, and shape to their own composition drawing such as the illustrations by elementary education student's dog drawings and collages inspired by the paintings of Alex Colville (*Child with Dog*) and Gilbert Sanchez Lujan (*Stepping Out*).

The above ideas and considerations make for a kind of 'dog based art education' (DBAE). Imagine the

possibilities using topics and themes like cats, horses, fish, trees, etc. and their place in society, the environment and art. When a theme is explored in depth in one subject, it sets the stage for in depth exploration in others and builds the potential for a truly integrated, renaissance curriculum.

Notes

1. The student and teacher webs described here and the unit concept "Exploring the Human-Canine Relationship through the Visual Arts," were developed in my Curriculum and Instruction in Elementary School Art (EDEL 302, Winter 2002) class at the University of Alberta by Willy Hankinson. Willy also breeds Standard Schnauzers.
2. Quotation by W. Hankinson. See also J. B. Koster, pp. 41-42.

This resource list of books about dogs only <u>scratches</u> the surface. Furthermore, if you <u>sit</u> at your computer and <u>stay</u> with it you can discover a lot of web sites about dogs (i.e. www.thebark.com). Who knows what you will <u>come</u> up (or <u>down</u>) with!

Books for Children

Brett, J. (1988). *The first dog*. Orlando, FL: Harcourt Brace Jovanovich Publishers.
Fanelli, S. (1998). *The doggy book*. Philadelphia, PA: Running Press.
Kotzwinkle, W. & Murray, G. (2001). *Walter the farting dog*. Illustrations by A. Colman. Berkley, CA: Frog, Ltd.
Roalf, P. (1993). *Looking at paintings: Dogs*. New York: Hyperion Books for Children.
Snow, A. (1993). *How dogs really work?* Boston, MA: Little, Brown and Company.

Books on Dogs and Art

Erwitt, E. (1998). *Dogs dogs*. London, UK: Phaidon Press.
Haring, K. (2000). *Dogs*. Boston, MA: Little Brown and Company.
Hockney, D. (1998). *David Hockney's dog days*. Boston, MA: Little Brown and Company.
Howard, T. (1994). *The illustrated dog*. London, UK: Grange Books.
Merritt, R. & Barth, M. (2000). *A Thousand hounds: The presence of the dog in the history of photography 1839 to today*. New York: Taschen.
Rodrique, G. & Freundlich, L.S. (1994). *Blue dog*. New York: Penguin Books.
Wegman, W. (Photographs and drawings) & Wieder, L. (Introduction) (1999). *Man's best friend*. New York: Harry Abrams Inc.

Books about Dogs

Coren, S. (2000) *The intelligence of dogs: A guide to the thoughts, emotions and inner lives of our canine companions.* New York: Bantam Books.

Cunliffe, J. (2001). *The Encyclopedia of dog breeds.* Bath, UK: Parragon Publishing.

McGreevy, P. (Ed.) (1999). *The little guide: Dogs.* San Francisco, CA: Fog City Press.

References

De Bono, E. (1971). *The Dog-exercising machine: A study of children as inventors.* Middlesex, UK: Penguin Books.

Gardner, H. (1983). *Frames of mind: The Theory of multiple intelligences.* New York: Basic Books.

Gardner, H. (1993). *Multiple intelligences.* New York: Basic Books.

Hubbard, G. (1993). *Canine connections, Arts & Activities,* March, pp. 28-31.

Irwin, R. L. (Ed.). (1997). *The CSEA national policy and supporting perspectives for practice guidelines.* Boucherville, QU: Canadian Society for Education through Art.

Koster, J. B. (2001). *Bringing art into the elementary classroom.* Belmont, CA: Wadsworth/Thompson Learning.

Lowenfeld, V. (1968). On integration in art and society. In Brittain, W.L. (Ed.), *Viktor Lowenfeld speaks on art and creativity,* (pp. 33-36). Reston, VA: National Art Education Association.

Lowenfeld, V. & Brittain, W. L. (1975). *Creative and mental growth.* New York: Macmillan Publishing.

Marley, B. (2000). The illustrated dog. *Dogs in Canada,* 92 (1), 22-26.

Steele, B. (1998). *Draw me a story: An illustrated exploration of drawing as language.* Winnipeg, MN: Peguis Publishers.

CONNECTING, REFLECTING AND IMAGINING

Art Education and Human Values

Boyd White

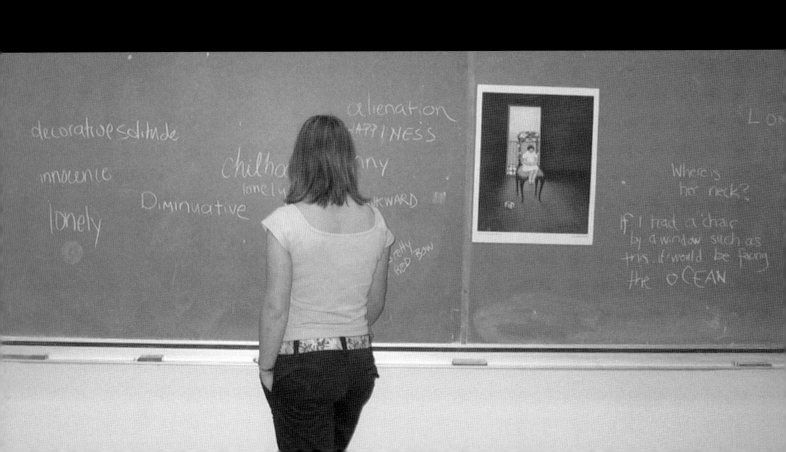

Introduction

A generation ago the late Louis Arnaud Reid (1976) stated, "... the arts have as one chief source of their importance their endlessly new revelation of new values and new relationships of values, each art having its own reservoir of resources" (p. 21). This chapter looks at Reid's assertion and its applicability to the aesthetic response component of art education. In the process I will also say a few words about the role of the elements and principles of design within aesthetic response.

My students are pre-service elementary generalist teachers, but their experiences echo what I have tried with children. Some things are consistent, no matter what our ages. So let me begin with a little anecdote about a university class exercise. Afterwards I will put the exercise into context through a discussion about its various components and their theoretical underpinnings.

An example

At the beginning of term I often show a reproduction of a painting, give students about a minute to look at the work and write down a word or phrase that the work suggests to them. I tell them that I am not looking for a factual term such as green, or dark. Rather, I want to know their response to that colour, setting, or whatever has captured their attention. When I ask the students to share their responses inevitably we find that there is substantial correspondence, although the wording might be slightly different. For example, one painting I use frequently is called *The Gift*, by Martha Teles.[1] It features, centrally in the composition, a young girl seated on a large chair. Her feet dangle well above the floor. She has on a white dress, and there are flowers entwined around the back of her chair. Behind, and therefore unseen by the child, is an open doorway, a balcony, and a suggestion of sea beyond. By one leg of the chair, well out of the reach of the child, is a small rectangular package, with a ribbon around it, apparently the gift to which the title refers.

Along with the sense of material comfort that the work portrays is a certain dissonance: The separateness between indoor and out, the colour contrast between the child and the darkness of the room's interior, the distance between the child and the gift. There are a number of other odd juxtapositions too numerous to mention here.

Responses to the work result in terms such as lonely, sad, oppressive, frightening, bizarre, trapped, waiting. As the students volunteer their words and phrases I ask them to point to something in the image that contributed to their response. It is at this point that they begin to identify specific features of the dissonance.

What quickly becomes apparent to the class is that each word means something a little, or occasionally, a lot, different from the others. But even when one student's response is quite different, the class is usually able to see why the individual responded in that way. For example, one word that is suggested occasionally is "spoiled". This response is so at odds with the others that the class is usually quite disconcerted. But when I ask the student to point to the features that prompted her response, she offers the signs of material prosperity — impeccable clothing, a somewhat overweight child, flowers; even the dominant eggplant-like colour suggests a richness. So this student can defend her choice of word. But the students also quickly realize that each term, by itself, is an over-simplification of the work; that is, when they see the combination of words they begin to grasp the potential of the image to provide multiple but related responses that coalesce into a larger, though ambiguous, meaning. This is what Swanger (1990) suggests by the phrase "open form". The work "... affords a variety of interpretations, even ones that may contradict each other, and resists unequivocal judgment" (p.95).

The next step is to get my students to understand that their responses, their spontaneous feelings about the work, are symptomatic of underlying values that they already hold. With the painting in the above example I simply ask them if this is the kind of celebration they would organize for a child of their own. Invariably the answer is, "No". As the students explain the reasons for their answer they talk about appropriate ways to treat others, especially children. Quickly they realize that they are discussing human values. Underlying and contributing to the designation of sadness, for example, is an awareness of a stance that each student takes in relation to how children should be treated.

Despite our different backgrounds, family histories and so forth, the students see that the painting enables us to share certain values; and the sharing is fairly easy because, as we have seen, the students can point to specific features of the work to back up their statements. But, keeping Reid's statement about new values in mind, one of the most intriguing outcomes of the exercise is dawning student awareness that the apparently simple image presents conflicting ideas simultaneously — material well being together

with social deprivation, for example. In fact, the image portrays layers of complex yet complementary relationships. To grasp these is to enlarge, however, slightly, one's world of values. In other words, heightened perception may lead to increased values awareness.

Aesthetics – Setting the Stage

Why do I do this exercise? What's the point of a focus on values? The questions seem justified since there is relatively little in the art education literature that addresses the issue of values explicitly. Those that do address the topic tend to fall into one of two groups. First, there are those whose writings are devoted to social issues such as multiculturalism and feminism, to name but two inter-related foci. (See, for example, Chalmers, 1996; Clark,1996; Neperud, 1995). This is the larger group.

Then there are those who address the topic from the standpoint of aesthetics. (See, for example, Bai, 1997; Curtler, 2000; Maynell, 1986; Portelli and Bailin, 1993; Shusterman, 1990; White, 1993). This chapter belongs with this latter group. This is not to say that specific social issues cannot emerge from an aesthetic orientation, but such issues are not the initial focus, which is the individual.

Let us review briefly the impetus for this orientation. The concept of aesthetics derives from early Greek usage. The word aisthetikos means of, or pertaining to, things perceptible by the senses. To grasp the full sense of the term it may be helpful to think of modern surgical practice. Anaesthetic is used to induce a deprivation of the senses during surgery. Aesthetic experience, then, is just the opposite, that is, an emphasis on sensuous perception. Thus the term is also associated with the idea of perceptiveness, which, in turn, might be considered a form of astuteness in terms of the senses. In other words, aesthetically oriented acts are not just acts of seeing; they come with a full complement of associated mental acts. As Husserl (1977) noted, every perceived form contains a mentality "intrinsically blended in" (p. 85). Or as Nelson Goodman (1968) has said, "There is no innocent eye" (p. 7).

The German philosopher, Baumgarten, in his unfinished text, *Aesthetica* (1750, 1758), digressed from this early definition, concentrating instead on the concept of beauty. Thus did he turn aesthetics into a criticism of taste. [2] An outgrowth of Baumgarten's work has been the development of a branch of philosophy that is essentially a study of the theories of art. In this chapter I am not concerning myself with the various philosophical theories, useful though they are in other educational contexts.

Baumgarten's contemporary, Kant, rejected his fellow countryman's interpretation in favour of the earlier Greek orientation. Today the legacy of the Baumgarten-Kant argument may still be seen in the confusion and general wariness (especially in many classrooms) with which the term "aesthetics" is greeted.

In what follows I adopt the early Greek/ Kantian perspective, that is, an emphasis on perception. Further, I use the specifically Aristotelian concept of perception that, as Nussbaum (1990) reminds us, is a combination of intellect, imagination and feeling. Thus, my interest in aesthetics has to do with how we respond to our visual world, especially the world of art, how values are connected to that response, and why this is an educationally valuable exercise.

Values, Feelings and Visual Distinctions

(a) <u>Values</u>:

(i) Why should values be a primary concern in art education? In order to answer the question we have to look more closely at what values are and how they operate. Rader and Jessup (1976) provide some helpful scaffolding on which to build an understanding of the nature of values. They state, "Value can be analyzed into three components, I-R-O, in which "I" is the interest of the subject, "O" is the object of the interest, and "R" is the relation between them" (p.10). Let us examine each of the components in turn. Their relation to aesthetic experience will become apparent.

The "I" in the equation suggests that values emerge only if there is interest in the object or event in question. As Frondizi (1971) has pointed out, interest is not limited to curiosity. Will, desire, aversion, in short, a "…disposition in favour of or against something…" signifies "interest" (p. 45).

Let us move on to the "O" in the I-R-O equation. It represents the object or event that is the focus of a valuational exercise. Such an apparently straightforward designation is, however, an over-simplification. Values are not simply the product of a self-centred and self-contained world (typified by the "I know what I like" attitude). Rather, values emerge as we focus on something exterior to ourselves. Values require what Frondizi (1971) calls a "carrier"; that is, if they are not entirely subjective, values are not independent entities either. Values are attached to our external world

but they need human perception in order to emerge. We can see this in the example of the Teles painting and my class's interactions with it. The painting is the value carrier, but the value, loneliness for example, is neither exclusively in the painting nor in the students looking at it. It is a quality that we distinguish as we interact with the work.

This suggests that when the term "object" is used in relation to values, it should be understood to mean "object-as-experienced". For example, when we stand before a painting or watch a movie we do not limit ourselves to the empirical presentation — the number of dots and colours on the screen, and so forth. Rather, we attempt to get beyond, or transcend, the empirical. In other words, the physical object supplies part of, but certainly not the whole meaning of the work. At best, it provides occasion to establish, spontaneously, a general categorization (This is a painting of an apple; that on the table is a real apple.). As useful as this ability is to our everyday existence, it does not fulfill the real purpose of looking with valuational intent. That purpose is to grasp the object-as-experienced; such action, in turn, entails an imaginative grasp, an Aristotelian awareness of the personal significance of the moment in all its singularity.

The term "singularity" brings us to the final letter, "R" — for relation — in the I-R-O equation. The concept is an elaboration on what I introduced in regard to meaning making in the previous paragraph. That is, personal meanings, replete with values, are established for us in our daily interactions with our world, on the basis of the particularities of our individual histories.

Meanings are evolutionary, albeit share-able. They are the product of an ongoing, lifelong process of experiencing and synthesizing, new experiences adding layers of meaning on top of, enriching, and sometimes replacing, older ones. So when Rader and Jessup speak of Relations between Interest and Object we should

keep in mind that such relationships are dependent upon the kind of lives we lead, and how experientially rich or poor they are. Suffice to say that if one's life experiences have a narrow horizon, his/her relations with the world will not be as richly layered, significant, or valuable as those of someone more broadly experienced.

(ii) Local and Regional Properties; an application of Values: As I mentioned earlier, students are able to point to specific properties of the Teles painting — the colours, proportion of child to chair, distortions in perspective, and so forth. Curtler (2000) notes that these descriptors are called "local properties". In art, these are also our elements and principles. All students can see them. They are fact-based entities.

In concert with the local properties are regional properties. It is these that, according to Cutler, define the value. The dissonance I mentioned earlier is an example of a regional quality. Unlike a local quality it cannot be pointed to directly, but the designation can be justified through reference to the local properties. As Curtler says, local properties "anchor" regional ones (p.11). This is a reciprocal relationship in which each property, local and regional, helps to support, clarify, and define the other.

The terms my students used to describe the painting — sad, oppressive, and so forth — denote the regional qualities. Curtler is correct to point out that valuations, as feelings, are not values; and words like "sad" do suggest a feeling. But it is important to keep in mind that the viewing of the image did not make my students sad. They just recognised the value quality — sadness. It was dormant in the work, awaiting recognition.

While Curtler argues that the regional properties are the values, we can go one step further. When my students point to sadness, oppression,

loneliness in the painting, I agree that they have identified a human quality. But I also suggest that these initial values point to others. The reason that the image depicts oppression or loneliness is that it also suggests what is not there, but should be — human sociability, justice and related values. Curtler insists that values must be experienced, not inferred (p.11). But the power of artworks often rests in our ability to experience what is not there as well as what is. [3]

In such instances the local features, the value-carriers, provide a dormant value-field, the potentiality for value awareness. The regional features emerge when we bring our world contexts (our understanding of, for example, loneliness) to bear on the local features. At that moment the value-field becomes no longer dormant; the field actively contains a value of which we are conscious. But it is not simply a matter of saying, for example, "The work is about loneliness." Underlying that recognition is a simultaneous acknowledgement that one values sociability. The need for human contact is the value counterpart of the value "solitude". So in our example, the student must not only empathize with the girl in the painting; the student must also be able to see the image as either metaphor or metonym — for desirable sociability, justice for children, the importance of human attention relative to material goods, or some such comparable interpretation.[4] The ability to form metaphor or metonym is a fundamentally imaginative and, as Swanger (1990) suggests, reciprocal act that requires input from both the individual participant and, in this case, the painting. "The Gift" is the title of the painting, but the real subject matter is the interpretation. And it is the value.

We can summarize this section now with the following definition: Values are qualities that acknowledge, describe, and correspond to the regional properties of objects and events. In turn, these regional properties may serve as metaphors or metonyms for larger issues. The regional properties correspond to the local properties of the thing/event itself.

(b) Feelings: Now let us look at the relation of feelings to values, and the educational implications of that relationship. Feelings are not values, but feelings are symptomatic of values. Their existence indicates values that one already holds. For example, if my students have empathy for the girl in the painting, this is the result of their value judgements, that this is not an appropriate way to treat a child. Each judgement is a result of values already formed by prior experiences that we bring to bear on the current moment in a

spontaneous, that is, non-volitional, act of comparison. Such acts of comparison result in the simultaneous experience of a particular feeling. In short, feelings are a values-laden response to a given situation.

It is for this reason that Reid (1976) can make the claim: "It is when we come to the world of values that the vital importance not only of feeling but of its cultivation and education is seen" (p.15). Reid then, not only draws attention to the essential connections between values and the arts, he also emphasizes the direct contribution of feelings to the educational equation.

We find this emphasis on feeling in more current writings too. Efland (1991) makes the point clearly: "The arts make a virtue of affective engagement and participatory learning, celebrating the life of feeling and imagination" (p.263). I will return to the essential role of imagination later. For now let us look more closely at a justification for an emphasis on feelings in education. Within the general curriculum, it is mainly within the arts that personal, particularized feelings are cultivated. Otherwise, curricular emphasis is on fact, not feeling.

It is tempting to suggest that the emphasis on feeling within art has made the discipline suspect in the eyes of many. In other words, it is not clear to many non-art and art teachers alike, not to mention students, parents and school administrators, what the educational benefits are of an emphasis on feeling. It is also obvious that an expensive school system isn't necessary to the production of feelings. Pre-school children regularly show evidence of feelings after all. What then is an educational justification for such an emphasis?

(c) Distinction making: That justification may be found in the relations between our ability to make subtle distinctions in our visual world, and the shades of feelings those distinctions engender. In other words, we are not talking about simple categories of feelings. Any pre-schooler can experience those. But our capacity for subtle nuances of feeling extend beyond our usual verbal vocabulary, even adult vocabulary, and the ability to tease out those nuances is directly proportional to our ability to make visual distinctions. This is a unique contribution that art education can make to general education; that is, a distinction-making ability, based on concrete experiences of visual stimuli, is essential to the development of an extended capacity for feeling. In turn, as authors such as Nussbaum (1990) and Bailin (1993) have argued, this capacity is crucial to the development of practical reason and education in

general, including education in regard to values.

Sokolowski (1979) argues that such abilities are frequently ignored in those parts of education that have garnered the most attention and prestige. He states,

> The bias of education and general opinion now is clearly toward explanation by decipherment rather than explanation by distinction. Astronomy, physics, economics … have inclined us to interpret what we directly experience in terms we do not directly encounter, like nuclear particles, … genes, concealed laws of money. … such hidden things are taken as the truth of what appears… This … is a bias; it overlooks a fact — that things described or constructed in science are dependent on distinctions and identifications made in the world in which we live. (p. 653, 654)

Sokolowski's cautionary words seem as relevant today as when they were first written; for, reliance upon abstraction to describe the world seems, if anything, to be on the increase. I am not advocating an abandonment of abstract thinking in education, however. It has earned its place. On the other hand, our task in art education is one of balancing such a focus with an equal emphasis on concrete experience, in the form of visual distinction-making, together with an awareness of how we feel about such distinctions; that is, what difference do the distinctions make to us as individuals experiencing them? As Sokolowski suggests, this first-hand, subjective experience provides a foundation for subsequent ideas, together with an important sense of participation and ownership. Without such a foundation, ideas remain the realm of others, and if one accepts them, one must do so on the basis of faith that those who have done the work are correct. This is a passive model of education; these days emphasis across the curriculum is inclined toward active models.

To sum up this section, visual distinction-making is a form of understanding, one that is essential to refinement of our feelings, and ultimately, expansion of our values. When we apply this idea to art education we may say that careful, distinction-making interactions with art can be identified with moments in the external world and can result in value recognition and enlargement. The identification becomes part of our ongoing growth as individuals.

Elements of Design, Principles of Organization

It is perhaps useful at this point to touch briefly on the topic of elements of design and principles of organization; for these are, metaphorically speaking, the building blocks of our visual world, without which distinction making would be impossible. They are also what make up the local properties of which Curtler speaks. But as we have seen, for students to arrive at a value designation such as loneliness or injustice, they must synthesize the impact of a number of these building blocks, or local properties. So, yes, students must recognize a colour or line and how and why it is used. More importantly, they must see how it is inter-related holistically into the meaning of the work. Meaning is seldom, if ever, dependent upon a single element acting alone. To focus on one element or organizational strategy would be to fall into the formalist trap and forego possibilities of meaning making. This does not mean that a teacher can't show a Van Gogh drawing for the sake of its line; but if she talks only about the line as line, without discussing how it contributes to the feeling of the landscape, then the teacher misses the point as to why we find the work significant. That is, it's not just about line but about a particular landscape and Van Gogh and his unique vision, his whole artistic self recorded on the paper. In short, preoccupation with physical properties alone, the elements and principles, cannot provide an aesthetic experience. What such preoccupation provides is size, shape, manner of execution, and the like. It might even provide an awareness of the unity of the whole. But without attention to feeling, synthesis and potential for meaning, then we lose the metaphoric significance. We lose the value.

Summary

My main argument has been that human values — individual, cultural and societal — may be, and should be, a central focus of art education. I have said that attention to values is an appropriate and timely concern in education today, and that art education is ideally suited to address the issues. The reasons I have cited have to do with the nature of value itself, its interconnectedness between people and things, (fundamentally an imaginative, empathic act), associated feelings, and the essentiality of concrete distinction making to current educational practice. I have suggested that all of these features can be addressed efficiently in art education, especially in that part of it that deals specifically with aesthetic response.

Notes

[1] The reproduction is from a grade one portfolio, part of a series entitled *L'image de L'art*, produced in Montreal, Quebec by Le Centre de Documentation Yvan Boulerice Inc.

[2] Further to the Baugartian influence, it is worth emphasizing that teachers have no mandate to dictate taste. But preferences in taste are culture-bound. Baumgarten's point of view is understandable insofar as his world was smaller than ours today, and Euro-centred. Our world is increasingly pluralistic and complex. To insist on a more correct taste is to place on a lower rung of the cultural-hierarchy ladder those who choose otherwise. There would appear to be little justification or need for such a stance in a democratic, pluralistic society. A more profitable line of inquiry, from an educational perspective, is to search out the distinguishable features.

[3] Darian Leader, in his text, Stealing the Mona Lisa, reinforces this point with his anecdote about the crowds who came to see where the Mona Lisa used to hang after it was stolen in 1911.

[4] Lacan's (1977) argument, that signification in art is largely metonymic rather that metaphoric, has gained wide acceptance. For our purposes, the issue is that meaning making must go beyond simple description, however that meaning is achieved.

This chapter is a revised version of an earlier article that appeared in the 2001 *Journal of the Ontario Society for Education through Art* (JOSEA), volume 27, 51 - 66.

References

Bai, H. (1997). Ethics and aesthetics are one: The case of Zen aesthetics. *Canadian Review of Art Education*, 24 (2), 37 -52.

Baumgarten, A. G. (1961). *Aesthetica*. Hildesheim: G. Olms.

Bailin, S. (1993). The bad and the beautiful: On moral and aesthetic appreciation. In Portelli, J.P. and Bailin, S. (Eds.) *Reason and values: New essays in philosophy of education*. Edmonton, Alberta: Detselig Enterprises Ltd. Pp. 93 – 103.

Chalmers, G. (1996). *Celebrating pluralism: Art education and cultural diversity*. Santa Monica, CA.: Getty Center for Education in the Arts.

Clark, R. (1996) *Art education: Issues in postmodern pedagogy*. Reston, VA.: National Art Education Association.

Curtler, H. M. (2000). In defense of values in the fine arts. *Journal of Aesthetic Education*, 34, (1), 7 – 17.

Efland, A. (1990). *A history of art education: Intellectual and social currents in teaching the visual arts*. New York and London: Teachers College, Columbia University.

Frondizi, R. (1971). *What is value?: An introduction to axiology*. (2nd ed.) Lasalle, Ill.: Open Court Publishing Co.

Goodman, N. (1968). *Languages of art*. Indianapolis: Bobs-Merrill.

Husserl, E. (1977). *Phenomenological psychology: Lectures, summer semester, 1925*. (John Scalon, Trans.). The Hague: Martinus Nijhoff.

Kant, I. (1957). *The critique of judgement*. (J.C. Meredith, Trans.). Oxford: Claredon Press.

Lacan, J. (1977). *The insistence (or agency) of the letter in the unconscious.* (Trans.: S Sheridan). New York: Norton (first published, 1957).

Leader, D. (2002). *Stealing the Mona Lisa.* New york; Counterpoint.

Maynell, H. A. (1986). *The nature of aesthetic value.* New York: State University of New York Press.

Neperud, R. W. (Ed.) (1995). *Context, content, and community in art education: beyond postmodernism.* New York: Teachers College Press.

Nussbaum, M. (1990). *Love's knowledge: Essays on philosophy and literature.* New York/Oxford: Oxford University Press.

Rader, M. and Jessup, B. (1976). *Art and human values.* Englewood Cliffs, N.J.: Prentice-Hall, Inc.

Reid, L.A. (1976). Feelings and aesthetic knowing. *Journal of Aesthetic Education,* 10, (3 -4), 11 - 28.

Sokolowski, R. (1979). Making distinctions. *The Review of Metaphysics,* 32, (4), 639 - 676.

Swanger, D. (1990). *Essays in aesthetic education.* San Francisco: Mellon Research University Press.

White B. (1993). Aesthetic judgements as a basis for value judgements. *Canadian Review of Art Education,* 20 (2), 99 - 116.

CONNECTING, REFLECTING AND IMAGINING

First Nations Art and Culture: Tradition and Innovation

Bill Zuk and Robert Dalton

First Nations

Most Canadians are relative newcomers to the land called Canada. Some are first generation Canadians and many others have parents or grandparents who came here from other countries. As Canadians, we often describe ourselves as a young country and while this may be true in one sense of the term – as a political entity – there are people who have lived here for thousands of years. The indigenous peoples or First Nations hold a special importance to Canada, our history and collective identity. When we want to tell others what makes us distinctive as a country we often turn to First Nations art. For example, the Canadian embassy in Washington D.C. features a large sculpture by Haida artist Bill Reid (1991). Visitors to Canada arriving at such places as the Vancouver airport terminal see aboriginal art prominently displayed. When the eyes of the world turned toward us during the 1994 Commonwealth Games in Victoria or the 1988 Calgary Winter Olympic Games, opening ceremonies proudly represented First Nations cultures through costume, dance, music, and art. First Nations cultures are rich and diverse with over fifty different languages still spoken in Canada. The Inuit of Nunavut, the Coast Salish of British Columbia, the Cree of Saskatchewan, the Mohawk of Quebec, and the Mi'kmaq of the Maritimes – nearly every region of this vast land has indigenous peoples with unique histories, languages, and cultures.

Traditional and Contemporary First Nations Art

Traditional art served a practical purpose. A kayak is a marvel of design; a painted buffalo hide offers visual history in narrative form – daring exploits or warfare; medicine wheels, masks, woven baskets, snow shoes, and other utilitarian articles are further examples of art's role in meeting the economic, political, social, and spiritual needs of individuals and their communities. However there are some who question whether or not this is *art*. Ellen Dissanayake (1988) provides compelling reasons why utilitarian objects should be considered as such. She took the unusual approach of looking at the function and purposes of art, finding that especially in small-scale pre-industrial societies they accomplish similar purposes to that of fine arts in contemporary western society.

Traditional arts can still be found in First Nations cultures though many examples are retained for ceremonial purposes today; items used in everyday life are generally not made by local people from local materials but have been replaced by manufactured goods. Contemporary artists, however, often make reference to these traditions in work intended for museums, galleries, and other places where fine art is displayed (Irwin, Rogers & Wan, 1998). Where traditional art tended to remain within the community and was used in daily life, fine art today is more often sold or shown outside the community to a much wider audience; it also tends to be more overtly pedagogical, a form of communication and teaching. In an era where indigenous cultures throughout the world are at risk of being eliminated through globalization, it is all the more important for artists to play a leading role in preserving key aspects of traditional life. Artists can often teach members of the dominant culture something of the beauty and wisdom of indigenous ways; reaching even further, artists may garner support for cultural preservation.

What is taught or conveyed through traditional art? Viewers may come to appreciate the genius of First Nations adaptation and survival in the harsh climate of Canada and gain insight into traditional values such as reverence for, and spiritual connection to the land, respect for the wisdom of elders, and so forth. Viewers will likely recognize the skilful working of materials evident in much of the work. In contemporary art there can also be very positive aspects but some of what is presented represents difficulties and struggle. Viewers may become more keenly aware of common concerns such as poverty, discrimination, and environmental concerns. Colonialism resulted in mistreatment of Natives. Acting in a paternalistic manner, the Canadian government authorized residential schools to remove children from their families. This action and others like it tore the social fabric of many communities. The results of these unfortunate events continue to surface in healing ceremonies and political arenas today. Through art, First Nations people often reach out to make connections with their past, reclaiming their cultural identities. They use art to communicate with one another, and they communicate with non-Natives, teaching them about their proud heritage while revealing their perspectives and concerns. First Nations were the first inhabitants of this continent, they shared their knowledge and through their art they continue to build bridges of understanding and respect.

Learning through Study and Discussion of First Nations Art

Like all living organisms, cultures adapt and change. A culture deeply rooted in the past is able to draw nourishment from its history – a sense of purpose and wisdom gained from experiences that enable it to grow and flourish. This is why many First Nations artists are helping their communities recover a past that in some instances has largely been lost due to disregard and policies of cultural assimilation. As aspects of culture are recovered, they are made relevant for the 21st century. In this respect, First Nations artists may serve as historians, elders, shamans, or others in leadership capacities, speaking *to* their people and speaking *on behalf of* their people. Tradition and innovation provide a means for understanding the past and the present. First Nations artists are normally aware of the traditions passed down to them. Studying traditional art forms and the contemporary interpretations of those forms enables viewers to recognize some of the changes that have occurred. Those changes might represent a relatively brief period of perhaps twenty years or a vast span of time involving many thousands of years. Teachers can search through books to find exemplars and after reading about the artist/culture and the work, make decisions to pair them for student study as tradition and innovation. There is great merit in examining artwork involving what the writers term a comparative picture approach (Zuk & Dalton, 2003). Learning resources are available (Zuk & Bergland, 1992; Zuk & Dalton, 1999) where research information and large format reproductions are provided, illustrating how traditions function and how they are being revitalized.

There are two principal approaches to begin understanding how tradition and innovation relate to one another. One uses a process of seeing or perceiving while the other engages the student in creating or producing innovative artwork. Perceiving can be accomplished in various ways; one commonly accepted method proposed by Feldman (1987) recommends starting with the work(s) of art and describing what can be observed. This simple and very concrete beginning teaches students to look carefully and to take account of the subject matter and media/materials used by the artist in creating it. Also included are observations about colour, form, texture, and other elements of art. Comparing the traditional and innovative works encourages careful examination and facilitates discovery. Formal analysis follows description, considering how the work is composed. Students should be guided to note relationships of scale and format, for example, or subject matter and colour. How is the viewer's eye led about the composition and what feelings are evoked by emphasis, contrast, rhythm, pattern, and balance? Description and analysis *fund* interpretation but more information is needed before students can put forward a theory about its meaning. The cultural/historical context must be considered and this requires looking outside the artwork. Information external to the work is needed to understand something of the events, beliefs, and cultural practices that may have influenced the artist in creating the work. Biographical information about the artist is often very helpful as well. From the wealth of observed and gathered information, students are then in a position to develop a theory – an explanation that seems

to adequately account for the contents and organization of the artwork. Agreement is not always necessary among students in a classroom; a lively exchange of reasoned argument is a natural and welcome part of perceiving. This prepares students for the next step, to speculate on cultural change based on the differences between the historical and contemporary works of art. Appropriately matched pairs of traditional and innovative artworks showing *old* and *new* can be very revealing.

Learning through Studio Activities

Creating is a special and significant way of knowing. Through hands-on studio activities, students benefit in ways that are different from *seeing* or *perceiving*. Those who have participated in life drawing classes know how wholly absorbing the process of creating art can be, especially when one attends to every nuance of light and shadow, and through empathy *feels* the model's energy, muscle tension, or the distribution of weight and balance of a pose or stance. Concentration on the task can be considerable, even exhausting, and at the same time deeply satisfying. When students work with their hands to create, they invest themselves physically and emotionally in a task, often entering into a metaphysical union with their artwork that leads to new ways of knowing. In some art activities, the principal aim may be to discover and record as realistically as possible but the power of creative expression adds another dimension of

be encouraged to make a personal connection with the fundamental ideas embodied in an exemplar that results in a new and unique response.

Sydney Roberts Walker (1996) took a critical look at school art projects and concluded that if the goal of art education is to develop understanding, then some of our studio projects remain at a level of skill building or experimentation and stop short of moving students to applying what they've learned. Using three hypothetical projects based on Deborah Butterfield's sculptures, she pointed to common problems. Chiefly they concern *distance* and *transfer*. A project that copies or mimics an artwork can be *too close*, failing to draw students into expressing their own ideas. It remains primarily an act of appreciation. Alternatively a project may be *too distant* or different from the exemplar with the result that there is no real transfer of knowledge; what is learned from the exemplar cannot be used or applied to the studio project. Even projects that involve the right *distance* can still fail to fulfill their potential if they involve a transfer of knowledge that is solely technical and opportunities for individual meaning making are lost.

It is relatively easy to cite examples of superficial responses to First Nations art that result in copying or appropriation. It is more productive to refer to exemplary responses. Cree artist George Littlechild worked with students in Vancouver's George T. Cunningham Elementary School; artist-in-residence Alison Diesvelt continued that initiative to create a body of artworks that were exhibited in the Surrey Art

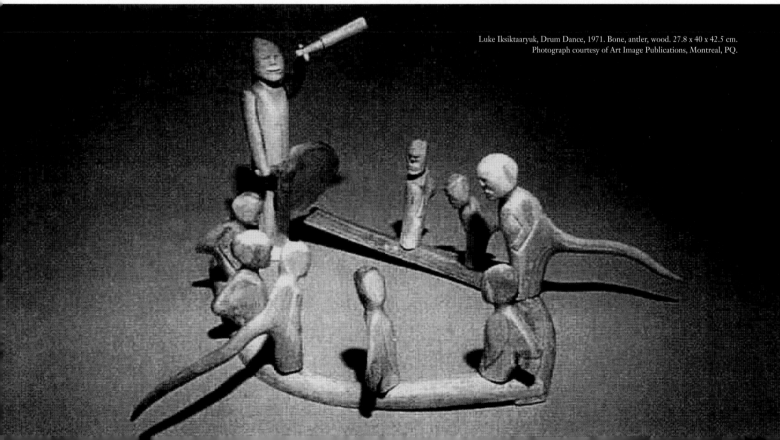

Luke Iksiktaaryuk, Drum Dance, 1971. Bone, antler, wood. 27.8 x 40 x 42.5 cm.
Photograph courtesy of Art Image Publications, Montreal, PQ.

children were able to make. Walker concluded that for understanding to emerge, key ideas must be identified so that students recognize what the master artwork is really about. Knowledge transfer must provide opportunities to extend those ideas. Personal connections must be made and problem finding or problem solving must be involved. For this, teacher guidance is invaluable.

These ingredients can be found in the Cunningham Elementary project. Students spoke with their elders – parents and grandparents – asking them to share the family photo album as a means of recalling experiences reaching back to their own childhood.

Copies of the photos were arranged to create a central composition. Students also asked family members to tell them about their cultural heritage. Colourful motifs or designs from their country or countries of origin were used to develop borders. In gathering information and creating these artworks, children discovered and expressed personal and cultural identities developed from knowledge passed down to them from elders. These values can be found in the work of First Nations artists like George Littlechild. The learning experiences in this project were substantive, not superficial, and the imagery was personal, not appropriated.

An Example from Inuit Art

Canada's far north was the last area to be settled by non-Natives. In the twentieth century change came quickly and dramatically to the culture and art of the Inuit (Zuk & Dalton, 1996). Oil and gas exploration, pipeline construction, mining, and the recent discovery of diamonds in the north brought industry and a southern way of Canadian life to the people of the Arctic. Permanent settlements were established throughout the vast region and with it, all the advantages and problems of modern culture. Along with missionaries, trading posts, R.C.M.P. stations, schools, and modern medicine came rapid transportation, mass media, fast food, and alcohol. The Inuit struggled to deal with massive changes to their way of life but like their ancestors, they have proven to be remarkably adaptive as evidenced by the formation of Nunavut, a huge semi-autonomous territory created in the eastern Arctic in 1999 (Sinclair, 1999). Some of this change can be discovered through an examination of artwork produced in communities across the Canada's far north. To illustrate how cultural change and adaptation work, we have chosen to use a traditional work and an innovative one separated by a mere twenty years. Both works deal with traditional community life and have a drum as their focal point, representing cultural continuity and leadership.

The traditional work is *Drum Dance* (Figure 1) by artist Luke Iksiktaaryuk. Knowing the approximate size of caribou antlers, viewers have a sense of how large the sculpture is. Bone and wood are the other materials used in the carving. There is a circular grouping of figures, perhaps seated and small in relation to the standing drummer whose pegged arm allows the stick to be moved up and down imitating the action of playing the drum. All figures face inward, women differentiated from men by the longer tails of their parkas. Cutting and carving these hard materials with stone tools or more recently steel or power tools often meant that traditional artists tended not to include complex details. The figures are relatively simplified; drawing by means of scratching or incising lines is a technique that has been used. The miniaturized drum is especially faithful to actual drums used by community leaders. A typical Inuit drum consists of a shallow rim with hide stretched tightly. A short handle is attached so the sound will not be dampened as it would if it were held directly by hand. Where the articulated figure would be rather stiff in its drumming action, an actual drummer uses coordinated steps and a swaying motion, turning the drum to strike the broad surfaces and also the rim. In traditional Inuit society, songs were used for many occasions including ceremonies, contests, and entertainment. If the drummer were a shaman, the booming tones would have been used to create an atmosphere conducive for summoning spirits.

The innovative sculpture is *Northern Myth, Northern Legend* , by Abraham Anghik Ruben. Probably the most striking aspect of the work is its scale; this limestone carving is almost five meters high. Traditional Inuit carving is generally quite small; nomadic people carried their possessions from place to place and many examples from past centuries are the size of amulets that would fit in the palm of the hand. Now living in permanent homes and having power tools available, Inuit artists are able to work on a larger scale than ever before. Unlike some types of soft soapstone commonly used in the north, limestone is a harder material to carve and this too, calls for tools available in the modern world. Anghik's work is organized very differently from Iksiktaaryuk's being compact and columnar with figures fused together. At the base of the sculpture are animals: a dolphin, seal, and polar bear. Among the animals is Sedna, a mermaid-like goddess. Above and supported by these creatures are humans, young and old, male and female. The viewer's eye is directed by gesturing figures

and flowing lines to the top where a drummer holds his instrument aloft, stick poised to strike. The smoothly rounded and somewhat simplified figures have eyes of inlaid semi-precious stones that make them more lifelike and perhaps magical.

.

Context and Meaning

Abraham Anghik Ruben is uniquely qualified to speak through his art about Inuit culture and change. Born in Pauletuk in 1951, his early childhood in the western Arctic introduced him to living off the land – hunting, trapping, and other aspects of a nomadic life. His grandmother and grandfather were both shamans of renown. At the age of eight he attended a residential school, like so many Inuit youths, and this separated him from his family and community for much of the year, turning his world upside down. However through his art he hopes to pass on his knowledge of customs and community life. "Individuals like ourselves have a responsibility to be the culture bearers, to carry on the stories, the legends and certain belief systems" (Schrager, 1994, p.9). In traditional Inuit society, cultural history was conveyed through song. The drummer related the myths and legends of the people, an interpretation that is supported by the title of the work. A related but slightly different interpretation grows out of another aspect of its creation. A large pharmaceutical company commissioned the huge sculpture; the drummer may well be a shaman who serves as spiritual leader of the community and practices the healing arts. Many of our modern day remedies for illness have come from folk medicines of indigenous people. This sculpture may pay tribute to that fact. Its towering scale ensures that the artwork will have a *presence* in a large commercial building but there is more to its size. In the film *Spirit of the Arctic* (1994), the artist indicated he works on a monumental scale to give viewers a lasting impression of the vastness of the Arctic. In *Northern Myth, Northern Legend*, Abraham Anghik Ruben represents the close link his people have to the land, the animals, mythological creatures that inhabit it, and perhaps ancestors who walked there before.

There are many ways in which the two sculptures are similar. Both involve carved and somewhat simplified figures; both have a drummer as the focal point. Each represents an aspect of community life in traditional Inuit culture. There are notable differences as well: The traditional work has its figures arranged in a circle while the innovative one places

figures one above the other in a vertical column. The dramatic change of scale is quite apparent. Viewers might also notice the change from local materials such as caribou antler to imported materials such as Indiana limestone. But more significant than any of this is the meaning of the works. Luke Iksiktaaryuk's *Drum Dance* appears to describe a moment of time, a ceremonial event in Inuit culture. The articulated arm invites viewers to imagine the rhythmic beat of the music in a community gathering. In contrast with this, Abraham Anghik Ruben's *Northern Myth, Northern Legend,* seems to include all living things, animals, mythological beings, community members, and perhaps ancestors – a universe bound in a block of stone. The work suggests a wide span of time and cosmology. The drummer is upheld by a throng and on their behalf, leads and mediates with the spirit world. The drum is not so much a sound as a portal – an instrument of communication from past to present, and from this world to another. Perhaps this work shows a greater sense of the passage of time because the pace of change was so evident to the artist. And perhaps the myths and legends of the Inuit should be shared with the outside world to foster respect, cultivate appreciation, and encourage cultural sensitivity. Retaining something of the past is a key to cultural survival.

Having gained a level of understanding of the works, it is possible to devise meaningful studio activities, ones in which students are encouraged to apply those perspectives to their own lives. Questions can be raised about the nature of one's own community gatherings: The role of music in focusing attention, arousing emotions, creating a sense of shared identity and purpose; our relationships with the land, animals, and ancestors; and the specialized roles of historian, politician, physician, musician, and religious leader in our own society as compared with the multiple roles of a leader in a small community. And from the sculptural methods employed by the artists, students can assemble or join natural materials, use inlaid objects, make moveable parts, incise and polish soft carving materials. They can experiment with scale and format to better understand how a visual idea changes through such important adjustments. Space does not permit a fuller discussion here but the principles, we hope, have been established for designing studio activities that enable students to make meaningful connections and enter into new understandings of themselves and their world.

A Matter of Respect

Art educators must be sensitive to the need to proceed carefully where matters of cultural appropriation are concerned. Canada's First Nations have experienced challenges in holding onto their traditional forms of art. The challenge has occurred in two opposing ways. Since first contact with Europeans, there has been misunderstanding that led to the destruction of much of the material culture and practices of the indigenous peoples of Canada. Working for museums, anthropologists, Indian Affairs agents, and others carried away many culturally significant items in order to advance knowledge and make them accessible to others. Missionaries often encouraged the destruction of items thought to be pagan. And governments banned such practices as the potlatch on the northwest coast of British Columbia in the mistaken view that they were protecting Native people from themselves. Residential schools took children away from their parents and communities, creating numerous dysfunctions in the family and community. Such paternalistic attitudes left First Nations people dissociated from their past.

More recently, there has been a cultural renaissance and reclaiming of the past. But with it a new danger has emerged, that of appropriation. With the growing popularity of the unique and beautiful creations of First Nations artists, corporations, and individuals have copied or *adopted* the style, imagery, and design motifs. This has led to revenue loss for Native artists. But more than that, imagery and visual forms of family history are sometimes blatantly used and changed in ways that are offensive and hurtful. The financial loss does not begin to compare with the harmful effects of losing control of cultural ownership.

Guidelines (Irwin, 1997) have been drawn up to assist teachers in this sensitive area. The Canadian Society for Education through Art (CSEA) has reprinted *Arts Education: A Curriculum Guide for Grade 5, 1991, Saskatchewan Education.* In those guidelines teachers are urged to contact a local First Nation, Metis, or Inuit Elder in their community. Elders are leaders and often well versed in their culture and history; asking them to recommend someone who might be willing to share their knowledge, shows respect for them as leaders. Locating an Elder is best done through a letter sent to a local Band Council, District Chief's Office, Tribal Council Office, or Friendship Centre.

The letter should also indicate the particular interests and curricular needs of the students to insure that suitable candidates are chosen. Teachers and students should be aware of cultural etiquette, completing the cycle of giving and receiving through an appropriate offering that shows appreciation for the knowledge shared by the Elder or First Nations artist. The Band Council could suggest an appropriate gift. If the School Board or its representative division normally provides an honorarium and/or expense reimbursement, this should also be offered to the guest. Richly rewarding experiences are possible through classroom activities focused upon First Nations art and culture. And where local resources are unavailable, there are films, videos, texts, and learning resources kits developed for classroom use.

References

Brown, H. (Producer). (1994). *Spirit of the Arctic*. [video]. (Available from The Canadian Broadcasting Corporation, P.O. Box 4600, Vancouver, B.C.)

Feldman, E. B. (1987). *Varieties of visual experience* (3rd Ed.). Englewood Cliffs, NJ: Prentice-Hall.

Dissanayake, E. (1988). *What is art for?* Seattle, WA: University of Washington.

George.T. Cunningham Elementary School (1996). *We are all related: A celebration of our cultural heritage.* Vancouver, BC: Author.

Irwin, R. L. (Ed.). (1997). *The CSEA national policy and supporting perspectives for practice guidelines.* Boucherville, QC: Canadian Society for Education through Art.Irwin, R. L. Rogers, T., & Wan, Y. Y. (1998). Reclamation, reconciliation and reconstruction: Art practices of contemporary Aboriginal artists from Canada, Australia, and Taiwan. *Journal of Cultural and Cross-Cultural Research in Art Education,* 16, 93-101.

Reid, B. (1991). *Spirit of the Haida Gwaii: The black canoe.* Retrieved March 4, 2003, from http://www.civilization.ca/aborig/reid04e.html.

Schrager, R. (1994). Three cousins in two worlds. *Inuit Art Quarterly,* 9(1), 4-12.

Sinclair, L. (1998). *Charting new territories.* CBC Ideas. Toronto, ON: The Canadian Broadcasting Corporation.

Walker, S. R. (1996). Designing studio instruction: Why have students make artwork? *Art Education,* 49(5), 11-17.

Zuk, W., & Bergland, D. (1992). *Art First Nations: Tradition and innovation.* Montreal, QC: Art Image Publications.

Zuk, B., & Dalton, R. (1996). Cross-currents: Tradition and innovation in circumpolar art. *Journal of Multicultural and Cross-Cultural Research in Art Education,* 14, 104-113.

Zuk, W., & Dalton, R. (1999). *Art First Nations: Tradition and innovation in the circumpolar world.* Laval, QC: Art Image.

Zuk, W., & Dalton, R. (2003). Comparative picture approach enriches study of art and culture. *BCATA Journal for Art Teachers,* 42(2), 24-27.

CONNECTING, REFLECTING AND IMAGINING

Art Is like a bowl of Fruit.
Aesthetics and art criticism in the
elementary school

Steve Elliott

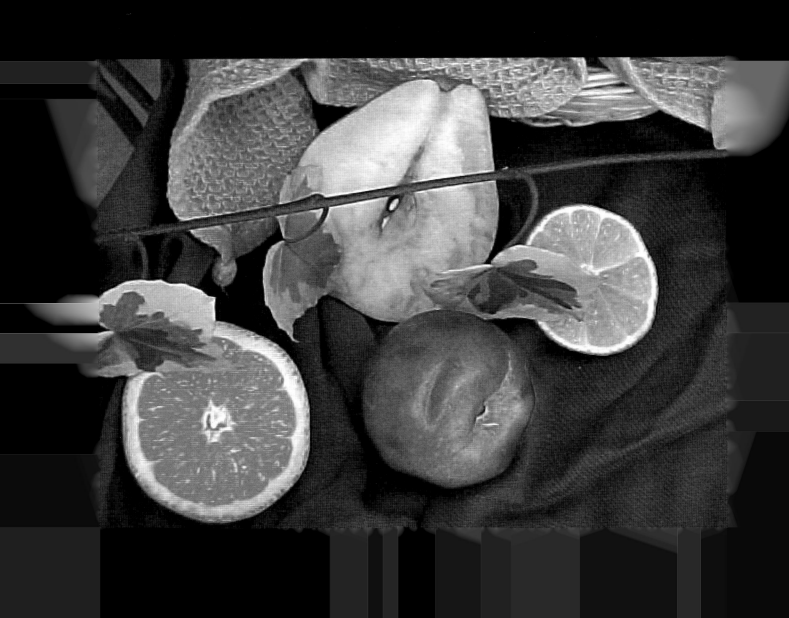

Imagine as an elementary school teacher you have gathered your students together and are sitting in the midst of the group with a painting of large bowl of fruit. You intend to introduce the idea of still life as a topic for investigation so you bring attention to the image and ask: "When you look at this bowl of fruit does anything *stand out* or *come to mind* that you that you would like to talk about?" Instantly the students (it is a good day for them) begin to comment on the presentation.

"Look at the yellow of that banana, it jumps right out at me." "The fuzz on that little brown fruit looks like it would scratch if you rubbed it on your arm, what kind of fruit is that?" "It's a kiwi." "Kiwis make me think of my grandma. She always gives me a kiwi for breakfast when I visit her. I love my grandma." "My grandma gives me fruit too." "My mom gives me an apple to bring to school, because she says that apples are school fruit." "What does school fruit mean?" "I don't know but I always see an apple on signs when they talk about schools." "My neighbour has an apple tree, he sprays poison on it to kill the bugs." "I ate a bug in an apple once." "I ate an apple with candy on it when I went to the fair last Saturday. Going to the fair makes me happy."

In school art programs, students and teachers engage in talk related to works of art. This talk can take the form of critiques or classroom discussions about art sources, student art projects, or art works of historical or cultural significance. Talk about any of these can be considered art criticism activity. Through these discussions students explore meanings, understandings, and value associated with art (Feldman, 1994). "Art criticism has become the storytelling aspect of art and aesthetics and transforms visual experiences into verbal expressions that can be shared with others" (Cromer, 1990, p.9). During these conversations students begin to discover what is interesting about what they see. This chapter introduces a few basic definitions and thinking associated with school aesthetics and art criticism. To facilitate integrating critical talk into classroom practice it concludes by identifying some relevant points of entry for teachers and students to talk about and find value in what they see.

Aesthetic Interest

If you were asked to identify your favorite colour, you would most likely form an immediate answer without much thought. If asked to defend your choice, your argument might include the statement "just because I like it." In this case there is a judgement made about the personal interest or value you hold for the colour you enjoy based on feelings of 'like' or 'dislike.' There are reasons why you like one colour more than another, but you do not have to think about those reasons before you decide which one you like. In the arts we can know things by attending to our feelings. The feelings we have when confronted with a work of art is often considered aesthetic in nature.

Individual feelings are typically subjective rather than rational. This *aesthetic subjectivity* makes it impossible to decide questions of truth. With a subjective quality at the centre of an aesthetic response, artists, philosophers, and teachers look to see if more than one person shares particular feelings or responses when confronted with a work of art. If many people are influenced in a similar way by the same experience, philosophers look for qualities in the work that might have triggered the response. Philosophers with an interest in aesthetics think deeply about, and explore the conditions that cause these feelings. When working with students there may be times when you move from personal interest to general interest (White, 1999). This validates personal experiences of each student while allowing the group to share a meaningful discussion.

Traditional *aesthetics* is the branch of philosophy that concerns itself with theories of art and forms of beauty found in nature and in art. The thinking involved in aesthetics applies to all of the arts including disciplines such as music, literature, poetry, visual art, theatre, film, dance, etc. Questions that relate to the art objects, the audience, the artists, or the experience of looking, listening, or reading, might be considered aesthetic in nature.

Philosophers typically agree that one necessary quality for something to be considered a work of visual art is that a viewer finds the experience interesting and worthy of attention over a period of time. Although they agree that those experiencing art should find the sights, textures, sounds, concepts, etc., interesting, they argue about what does, or should, cause those feelings of interest. Some claim that the feelings must be triggered by what is actually seen or heard in the work while others suggest that the feelings may also be caused by what you think about when you experience the art. Claims about what causes aesthetic

feelings, and what we might consider a work of art, have been formed into theories of art.

When you find something interesting to look at (the case with visual art) you may ask questions about what makes it interesting. The answers to such questions are typically concepts associated with aesthetic understanding. One important task of teachers of visual art is to help their students identify and clarify qualities that make art worthy of *interest* and *attention*.

What is Art?

We talk about aesthetic questions as a regular part of our daily experience. A parent asks how their teenage son or daughter can think that pink hair looks cool. A child wonders how his or her parent can wear checks and plaid together. A citizen thinks a public gallery paid too much money for a painting created by an artist with no apparent skill. As individuals and cultural groups find different things interesting to look at and question, the set of possible definitions for art increases.

What is art anyway? Is there a definition for art that will accommodate all the variety that can be considered an example of art? Early attempts to define *art* identified practical *objects*, like furniture and handicrafts, as art. As time moved on, the categories of things that could be considered examples of art were expanded to include other specific forms of expression like poetry and sculpture.[1] Things like these had no practical use except that people enjoyed them. This kind of thinking represented a refinement, or expansion, of the definition of art.

As philosophers thought deeply about the objects that were considered examples of art, they began to realize that some art objects were less interesting than others. This thinking led them to consider the reasons that objects were interesting. Thinking about why art was interesting came to dominate the field of aesthetics. As one set of qualities became popular for definitional purposes, philosophers framed a theory[2] of what makes something art.

Theories of art have traditionally outlined sets of qualities that determine if something should be called a work of art or not. Historically philosophers have used

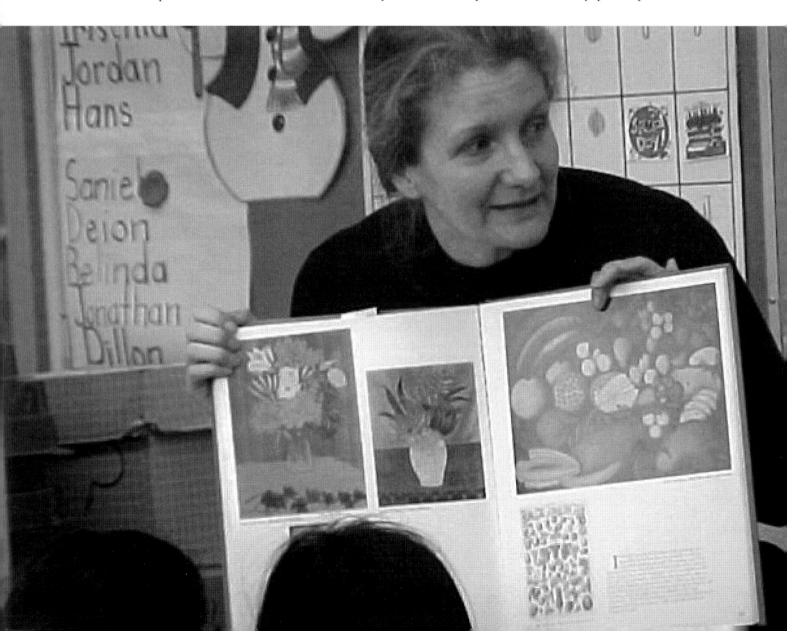

specific theories to define and judge the art that was typical in their culture and time. In current practice, if a teacher limits herself to one theory of art, she would be unable to analyze and discuss many forms of art that have existed in other times and other cultures. To enable teachers to think deeply about all art they might encounter, they must be able to consider the definitional criteria explained by various known theories and cultures. Individual theories of art represent valid ways of looking at art but if any single theory of art were used as the only explanation of art, it would be too narrow to account for the range of possible art forms. Another problem with using only one theory of art is that forms of art keep changing. As a result, any single theory of art cannot define all art forms that have been, or will be, invented.

Some authors have suggested that the definition of art is similar to the definition of *game* (Weitz, 1970). There is no single set of qualities or rules that describe all games. Art, like games, include such a variety of types that no single definition would ever be correct in all cases. As a result, no single set of possibilities will ever be identified (Bryson, Holly & Moxey, 1991). The search for a definition of art has been abandoned and replaced by the identification of art possibilities. This approach requires students and teachers to continually explore the reasons that particular art pieces might be interesting to attend to.

Art Criticism: Process and Attention

Thinking and talking about works of art, in *specific terms*, is applying philosophy and is called *art criticism*. Art criticism is the activity of analyzing and talking about specific works of art.

Students often think criticism involves saying bad things about someone's art (Barrett, 1997). The word *criticism*, when used in philosophy suggests being analytical and insightful about a work. Sometimes the result of art criticism is a judgment or evaluation of a work of art, but any observations, analysis, interpretations, as well as evaluations about art can be considered art criticism. In schools the most instructive talk about art concerns itself with observations, analysis, and interpretations.

To assist teachers in making the perceptions and ideas embedded within works of art explicit, educators in the field have proposed a variety of frameworks or processes to guide classroom art viewing practice. Variations of Feldman's (1994) practical art criticism outline and Broudy's (1987) aesthetic scanning framework probably represent the two most commonly used approaches in North American elementary and secondary schools.

These and other processes for talking about art in classrooms, share at least two common elements; looking deeply and making sense of what you see. In all viewing frameworks, slowing down the looking process gives students time to take better note of what they are actually looking at, allowing them to thoughtfully consider possible meanings or values associated with each work. An important part of putting aesthetic thinking into practice is learning to look, listen, and think carefully. This process tends to heighten student sensitivity toward things visual. Through this heightened sensibility, they begin to look at *ordinary* things in *extraordinary ways*.

The process of looking deeply, creating meaning, and assigning value requires teachers and students to consider specific things in each art work to make sense of. By considering sets of worthwhile things to attend to, teachers can more productively guide students through criticism sessions.

As mentioned earlier, individual theories of art claim that art should *be* or *do* something in particular to order to engage the audience, capture attention and sustain interest. If we analyze the definitional criteria suggested by various theories of art, we can construct a list of *specific things* about individual examples of art that make the *work* expressive, or at least *attention worthy*, presentations. These *things* could be called *qualities* of the works and, in the case of art forms, would be called *aesthetic and artistic qualities*.

Artists use *aesthetic and artistic qualities* to create their work, individuals respond to them with interest while looking, and teachers and students consider them while thinking and talking about works of art. To account for past theories, current production, and some future possibilities in art, it might be productive to consider artistic qualities under three categories, perceptual, conceptual, and cultural.

Perceptual qualities

"Look at the yellow of that banana, it jumps right out at me." "The fuzz on that little brown fruit looks like it would scratch if you rubbed it on your arm."

Individuals can experience an aesthetic response to art forms through qualities that are interesting simply because they are seen, felt, or heard. These are called *perceptual qualities* because simply perceiving them creates interest.[3] Some distinctions of perceptual interest

might include sensory, formal, expressive, and physical qualities of a work.

Sensory qualities are those attributes in works of art that directly stimulate the senses. They include all qualities that can be seen, felt, or heard. Humans find intrinsic interest in stimulation of their senses. Things to look at and discuss under the sensory category of interest might include qualities like *colours* (i.e. red, blue, orange), *tones* (i.e. light, dark, bright, dull), *textures* (i.e. rough, smooth), *lines* (i.e. thick, thin), *lights* (i.e. bright, dull), *movements* (i.e. twirling, leaping), *sounds* (i.e. tapping, rustling), etc.

Formal qualities are those attributes in works of art that expose how the parts of a presentation or work are put together or relate to each other. This *putting together* is often called the *composition* or *design* of the work. The interest and value in these qualities resides in the structures inherent in the works. Things to look at and discuss under the formal category of interest might include qualities like *form or shape*, (i.e. round, triangular, flat), *balance* (i.e. symmetrical, asymmetrical, radial), *rhythm* (i.e. repetition, pattern, disruption, connections), *emphasis* (i.e. focus, attention, contrast), *unity* (i.e. chaotic, integrated, harmonious), etc.

Expressive qualities are those attributes that make us feel a mood or emotion by the way they look. This expressiveness can be created by associations we make with facial expressions or other life experiences. Colours, lines, sounds, words, movements, performances, can each look or sound expressive. They can imitate or suggest many emotions like sad or happy, anxious or calm, warm or cool. Things to look at and discuss under the expressive category of interest might include qualities like *moods* (i.e. sombre, menacing, frivolous), *emotions* (i.e. happy, sad, angry), or *states* (i.e. warm or cool, tense, relaxed, conflicted), etc.

Physical qualities are those attributes in works of art that are physical or technical in nature. There is a different expressive quality to steel in a sculpture than that created by stone or glass. There is a different feel to acrylic paint than watercolour or oil. The audience responds in a particular way when viewing a work of installation art made up of rocks on a hillside. The physical qualities of a work of art can shape the felt experience of the work. Physical qualities of art works might include considerations like *material aspects* (i.e. paint on canvas or steel, Helvetica or Times text), *technical aspects* (i.e. watercolour wash technique or impasto,), or *environmental aspects* (i.e.

seashore or countryside), etc.

Conceptual qualities

"My mom gives me an apple to bring to school, because she says that apples are school fruit." "What does school fruit mean?" "I don't know but I always see an apple on signs when they talk about schools."

Aesthetic and artistic responses can also be created by qualities that are interesting because of what one *thinks* about when they see, hear, or read a work of art. These are called *conceptual qualities* because interest is created and shaped by thinking about what is perceived[4]. The conceptual experience of art can be meaningful to the audience if their thoughts about the work either *denote* or *exemplify* something that is connected with their lives.

A work of art *denotes* something when it reveals, stands for, or identifies it plainly. For example, the name Batman denotes a mysterious masked man with a cape and a winged car that helps people in distress. An image with two red stripes, on either side of a white stripe with a red maple leaf in the middle, denotes Canada. As works of art denote understandable symbols, they bring to our minds and our feelings, all that those things stand for and represent to us.

A work of art *exemplifies* when it serves as an example, illustrates or suggests something that we understand. Exemplification can illustrate, suggest, or represent ideas or concepts. A red circle can illustrate the features of an apple. A trapped animal can suggest an animal rights issue. A hymn can represent a religious experience.

Works of art can denote, and/or exemplify ideas that make us feel. Some qualities in the conceptual category might include *social, symbolic, contextual*, and *narrative* aspects of art works.

Social qualities are those attributes in works of art that make us feel by presenting social issues that are current, interesting, and important for us to think about. These qualities are usually connected with issues that are part of a pressing concern to a community of people. All those who experience the art might not share the same attitude about the issue, but they will understand that it is a concern that many feel requires debate and attention. Social qualities may include thoughts about *issues* (i.e. animal rights, democracy, bioengineering), *events* (i.e. man walking on the moon, bombing of the world trade towers), *beliefs* (i.e. democracy, religion), etc.

Symbolic qualities are those attributes that make us feel by presenting objects or images that have come to stand for some general notion or concept. When a group of people think of the same thing when confronted with an image, idea, sound, or word, that thing acts as a symbol. Symbolic qualities are usually connected to objects or ideas that have been associated with a particular thing over a long enough period of time that the meaning is generally understood. Symbolic qualities may be connected with representations of: *archetypes* (i.e. hearts, democracy, bioengineering), *icons* (i.e. movie star, politician), *emblems* (i.e. national flags, crosses), etc.

Contextual qualities are those attributes that shape our thinking and feeling when works of art are presented as part of a meaningful context or environment. Works of art can be presented in endless different contexts, each having the potential of shaping the way you feel about the work. When you attend to objects, sounds, or words in a gallery they are affected by the fact that you interpret them as a work of art. When you look at an ancient water pot you see it as an object of interest that also carries water. If we see a painting in a church we bring to our view of the painting, feelings and interpretations with religious considerations. Contextual qualities may be noticed in presentations associated with *environments* (i.e. galleries, churches, schools), *objects* (i.e. books, house-wares), *settings* (i.e. at night, in private), etc.

Narrative qualities are those images, sounds, words, and movements that tell a story. People intrinsically enjoy stories and find them interesting because they organize related parts of general experiences that help us create meaning. When things have meaning for us we relate to them with increased feeling and interest. Stories or narrative qualities in art offer accounts of real or fictional events, situations, or circumstances. Although literature is most often associated with narrative qualities because it tells stories with words. Artists can also tell stories with pictures, marks, sounds, and movements. Narrative qualities can be found in story and storyboard like presentations that are *personal* (i.e. my family, I am a woman), *public* (i.e. the buffalo hunt, 911), *invented* (i.e. life as an ant, 2010), etc.

Cultural qualities

"I ate an apple with candy on it when I went to the fair last Saturday. Going to the fair makes me happy."

In addition to perceptual and conceptual qualities that create inherent interest in things associated with visual presentations, we are integrally connected to a current culture that shapes our attention and interests. Concepts in this category of interest have come to be known as *visual culture* which consists of venues in our environment that occupy our attention to such a degree that we look to them to satisfy and shape our interest and need for visual stimulation. For most young people this consists primarily of the visual aspects of their popular culture as expressed through life experience, media, and worldview.[5] Because aspects of this category are so pervasive and compelling they tend to reshape in a powerful way, even the aesthetic interests and judgements that we at one time considered universally human. Some considerations in the cultural category might include qualities in *events*, *media*, and *popular culture*.

Qualities in events are those parts of events or community experiences that hold a high degree of interest for your students. The idea of "event" itself might suggest that students either attend significant happenings or *make an event* of some experience (like going to the mall). In these instances the event carries

greater impact than one might typically think the situation warrants. Here students seem to assign larger than life value to everyday life experience. Within our culture we, at times, look for qualities to help us define our visual importance. Qualities in events can be associated with *happenings* (i.e. fashion shows, concerts), *places* (i.e. the mall, amusement parks), etc.

<u>Qualities in media</u> can be observed in many forms of public communication. Due to the pervasive place it occupies within our life experience and the sophistication of the presentations, media has a powerful impact on the way we process information.

Qualities in media can be distilled from *print material* (i.e. fashion magazines, motorcycle zines), *television* (i.e. situation comedies, music stations, reality shows), *the internet* (i.e. web sites, chat rooms), etc.

<u>Qualities in popular culture</u> are those aspects of the dominant culture for any group that holds their attention and causes individual members to adopt, copy, emulate, and at times idolize observable features of the group. Discussion items in this category might help students clarify embedded messages, values, and impacts of cultural decisions. Qualities in popular culture can be found in *fads* (i.e. tattoos, piercings, border clothes), *film* (i.e. music videos, movies), *games* (i.e. Nintendo, web games), *activities* (i.e. skateboarding, parties), etc

To the Classroom: A Few Closing Thoughts

In schools, teachers might be considered leaders, facilitators, and participants in classroom activities. The main goal of art talk activities in elementary classrooms is to have the students look more carefully, think more deeply, and talk more often about the things they see (Barrett, 1997). Through art criticism, teachers and students clarify experience and find meaning and value in their art encounters. Teachers who are able to direct both the looking and the talking associated with student attention can enrich student search for visual value.

As leaders in the classroom, teachers review student and historical works to be discussed in their class. With careful attention they decide which categories of artistic and aesthetic value might represent the most productive point of entry for their students. With these qualities in mind they create leading questions that will both direct student attention and focus thinking and talking about the works they view.[6]

As a facilitator in the classroom, teachers allow time for careful looking and strategically pose questions to stimulate conversation. At Harvard, students were asked to find the thing about each work they viewed, that *carried the punch*, or generated the strongest response as their entry into critical dialogue (Perkins, 1994). By keeping the discussion moving all students will have an opportunity to look, think, and participate in worthwhile critical activity.

As a participant in the classroom, teachers talk about their own observations and give both time and consideration to all student responses as they explore the visual field together. Art is a living part of our human experience. Learn to look carefully, think deeply, feel freely, and share openly through effective critical talk in the classroom.

Notes

[1] As an example, Plato stated that art was considered good if it imitated nature well (mimesis). Using this theory of art he stated that the purpose of poetry was to accurately copy or portray the activities of the gods.

[2] Some historical theories of art include Imitationalism, Expressionism, Formalism, and Institutional definition of art.

[3] Harry S. Broudy (1973, 1984), a professor of philosophy at the University of Illinois developed a list of perceptual aesthetic qualities to guide the looking, listening, and thinking about art. For him, interpretation is based on identifying the perceptual qualities within works of art that create feeling in the audience. His set included sensory, formal, expressive, and technical (physical) aspects of art works.

[4] Nelson Goodman (1968), an American philosopher, was instrumental in explaining the conceptual side of

art expression. He was a professor of philosophy at Harvard University and, as a young man, ran an art gallery. He argued that understanding a work of art is not a matter of appreciating it or finding beauty in it, but it is a matter of interpreting it correctly. Interpretation is based on how and what the work of art symbolizes, and how that meaning relates to the individual looking, listening, or reading the work.

[5] For discussion about the place of visual culture within our schools see *Studies in Art Education* V 40-44. Also see Duncum (2001, 1999), Freedman (2000), and Giroux (1989).

[6] For suggestions about creating sets of discussion topics with your students, see Elliott (2001)

References

Barrett, T. (1997). *Talking about student art.* Worcester, MA: Davis Publications.

Bryson, N. Holly, M. & Moxey, K. (1991). *Visual theory, painting and interpretation.* Cambridge, UK: Polity Press.

Broudy, H. S. (1972). *Enlightened cherishing: An essay on aesthetic education.* Kappa Delta Phi Lecture.

Broudy, H. (1987). *The role of imagery in learning.* Los Angeles, CA: The Getty Center for Education in the Arts.

Cromer, J. (1990). *Criticism, history, theory and practice of art criticism in art education.* Reston, VA: The National Art Education Association.

Duncum, P. (2000). Visual culture: Developments, definitions, and directions for Art Education. *Studies in Art Education, 42*(2), 101-112.

Duncum, P. (1999). A case for an art education of everyday aesthetic experiences. *Studies in Art Education, 40*(2), 259-311.

Elliott, S. (2001). Some thoughts about viewing art in schools. "Building viewing art categories with students." *British Columbia Art Teachers Association Journal, 41*(2), 17-21.

Feldman, E. (1994). *Practical art criticism.* Englewood Cliffs, NJ: Prentice Hall.

Freedman, K. (2000). Social perspectives of art education in the U.S.: Teaching visual culture in a democracy. *Studies in Art Education, 41*(4), 312-329.

Giroux, H. & Simon, R. (1989). Popular culture as a pedagogy of pleasure and meaning. In Giroux, H & Simon R. (Eds.), *Popular culture: Schooling and everyday life* (pp.1-29). New York: Bergin & Garvey.

Goodman, N. (1968). *Languages of art.* New York: Bobbs-Merrill.

Perkins, D. (1994) *The intelligent eye.* Santa Monica, CA: The Getty Center for education in the arts.

Weitz, M. (1970). The role of theory in aesthetics. In Weitz, M. (Ed.), *Problems in aesthetics* (pp.169-180). New York: The Macmillan Company.

White, B. (1999). A fish tale metaphor. *CSEA Journal, 30*(2), 19-25.

CONNECTING, REFLECTING AND IMAGINING

Lights, Camera- Conversations?

Using digital media to talk with artists in our local communities

Don Krug

As an art teacher I have always been interested in knowing more about a wide range of conditions that interact with and affect community artists and their art. Talking with local people who make things can be a significant and collaborative experience for young people to piece together stories or narratives from artists and other individuals to better understand the historical and cultural complexity of a maker's social environment. In what follows, I will discuss why using digital media, (e.g., digital camcorders) can be a useful inquiry process for teachers and students to capture conversations with artists in one's local communities and to understand how some people make things and why their art is connected with particular cultural significance. But first I want to offer a brief caveat about technology.

Technologies in an Era of Information

Consider for a moment the historic development of technological communications very generally since the turn of the century. People have moved from oral and written traditions to radio, television, film, computers, and wireless telephones. Currently, we are experiencing virtual realities through digital electronic environments in an information era. Throughout this period of time, we can see an uneven progression incorporating an ever-quicker pace and relying on the reduced stimulation of a larger number of sensory perceptions.

One identifying characteristic of an information era is the use of technologies to get people directly to data without exposing them to tangentially relevant materials. Information technologies in the 1980s and 1990s focused on tailoring information to user profiles in order to avoid subjecting the user to information overload. For example families and educational and business institutions use filtering software to block access to certain advertisements, unwanted emails, and sexually explicit sites. But this approach censures activities and devalues serendipitous discovery, a valued inquiry method in the arts.

If this surveillance approach to educational computing practices becomes dominant will these controlled experiences reinforce a notion that chance encounters should be avoided? From the distribution of mass-produced goods to providing a choice of movies to watch and when to watch them, technology promises us more predictable, controllable experiences. In an era when most people feel pressed for time and fearful of chance encounters in a hostile world, they shun public spaces and turn to experiences that involve fewer unpredictable interactions.

Over time, will our experiences with technology replace public spaces and face-to-face human interactions? It is now possible to surf the web on a couch in front of a 500-channel television minimizing potentially dangerous encounters that might take place 'window-shopping' near an urban-city movie theater. Computer-based 'virtual' experiences are providing us with experiences that are more predictable, less serendipitous, and less interesting than human interactions.

Digital Media as Social Practices

We live at a time when just about everyone can learn ways to use digital media without becoming overwhelmed by the technical aspects of the equipment. It is possible for students in elementary grades to use digital cameras and camcorders to capture audio and video information and in effect become producers of their own short stories. However, this does not necessarily mean that students will become more responsible for their own learning. In order to avoid some of the negative consequences of a couch potato society, I want to suggest that we encourage a participatory, critical inquiry approach to curriculum that facilitates ways for students to use educational computing as a social practice. Let me elaborate.

Students should receive guidance from teachers on ways of using digital media for educational experiences. They should be provided with opportunities not only to acquire skills in the latest technologies, but to also write, discuss, reflect on and pose questions about how ideas are shaped and circulated in various societies. Students can represent stories about issues that affect and influence daily life experiences as well as their own personal observations, biases, and taken-for granted assumptions about their place in the world. Students need opportunities to discuss and interpret their own personal ideas, problems, and issues in relation

to the social circulation of meanings and values in society. If students are going to be able to critically place their views within larger social, historical, and cultural contexts, we will need to provide them with opportunities to voice their own interpretations publicly, discuss and reflect on their own views and the views of other people, and take specific action.

By focusing on the use of digital media as social practices in education, students and teachers can share responsibility for classroom computing inquiry. Inquiry about the social practices of computer use should look at making learning meaningful and relevant to student's lives by addressing the interconnectedness of values, ethics, personal contexts, and life-centered issues.

For example, students can use digital camcorders to interview local artists. In all communities there are individuals who make things. Some of these people are considered to be artists, while other individuals are not provided this social and historical distinction. The things people make come in a variety of shapes, sizes, and aesthetic sensibilities. Many people use what they have, and what they have are the products of industries. The creativity of peoples ways of living or 'popular culture' lies not in the production of commodities so much as in the productive use of industrial materials. Within this culture of everyday life, lies the creative and discriminating use of resources available in societies.

By employing digital media within the contexts of our everyday lives teachers can also help familiarize students with not only the skills and components of technology, but also how we can use it safely, responsibly, and effectively. For example using technology as a social practice means adopting an attitude, a disposition, or a set of beliefs about empowerment and diversity. Students can learn responsibility by giving back, hopefully, more than just their movie of a mutually constructed story. Interviewing local artists will provide opportunities for students to acquire respect for the people with whom they work, and hopefully these people will get as much out of the experience as the students do. Giving back might be as simple as listening. Caring might be not recording all that is told for ethical reasons. The act of interviewing poses critical, moral, and ethical questions about talking with rather than about other people. It is not simply collecting interviews. It can be a joint activity of constructing new narratives and an exchange of obligations. In the process of entering people's lives, stories are shared. Telling tales should be about taking responsibility.

As a teacher, I believe education should begin locally, with an investigation of the richness of ones own community. Talking with people is a way to begin this process, to carefully inquire and represent our own views in relationship to the voices of different and diverse people. The things people make can be both directly and indirectly connected to some of the most meaningful satisfaction they receive in their daily lives. Making things is constitutive of a person's cultural identity (Krug, 1992, 1993). It is in talking with people about the practices of making things special that teachers and students can investigate their own local communities to learn more about how art enriches the lives of people around them and around the world.

A Short Story

For example art education students at the University of British Columbia in the Winter of 2003, were asked to interview local artists about an important life-centered issue. I asked them to discuss why the issue they selected was important to teach about through art and how they would create conditions for students to conduct their own critical inquiry about it. The artist interview was a way to examine how people in our own communities are struggling with making sense of these ideas and issues on a daily basis. They selected the environment and more specifically consumerism as a life-centered issue. Dave Humphreys, a photographer from Squamish, BC was interviewed and asked to talk about some of the environmental issues represented through his artwork.

Of course, his story depicts one short episode from

his life experiences. Pieced together, his partial tale retells about personal relationships and art making practices. Partial tales are not linear, chronological events of a person's memory. They might be moments from a montage of life experiences, told and retold by someone and recorded and retold through the student's digital movie. All narratives are only partial because they are small segments of complex sets and combinations of many events happening simultaneously. Telling tales retell only small fragments of a richly woven life tapestry. How students learn to represent these story and how they understand this process is ultimately mediated through individual and social perceptual nuances conditioned by time and their own sense of place.

In the introduction to their inquiry about environmental issues, Beth Yearwood, Sara Price, and Brooke Macdonald wrote, "the environment is an important topic, especially as we learn more about our personal impact on it." They developed a unit of study for the purpose of stimulating thoughts, ideas, and questions about community-based environmental concerns. The one lesson that is presented below, while constructed specifically for critical inquiry through art, contains information that can be used for other subjects and/or interests.

Teachers as well as students should look at how different groups of people, as well as artists, convey, construct, and comment on issues about the environment. It is important as teachers to ask inquiry questions to study why any particular topic is of value for students to learn about in schools. In this case, educational activities were organized to guide student inquiry about ideas of interdependency as a life-centered issue. These issues were examined across a range of subject areas, as well as through an artist interview and the student's own personal work. Below is a section of the artist's interview as transcribed from the student's digital movie and a brief overview of some ideas for classroom inquiry about interdependency.

A Conversation with Photographer Dave Humphreys

It is Super Bowl Sunday, and we were meeting Dave Humphreys, a photographer, in The Brew Pub, in Squamish, BC. "This is the place where the more outdoorsy, artsy people hangout," Sara explains to me. We sit down to await Dave's arrival.

Sara explains that she had met Dave in Squamish, a small, scenic community, just south of Whistler. Dave, as a local photographer, has actively pursued the surrounding mountains, depicting them in his photography. The outdoors is familiar territory for Dave: from backpacking and hiking through Europe, to living in the Swiss Alps, to taking 5 1/2 months to walk from Banff to Mexico, one can say that Dave has seen, experienced and interacted with a full range of scenery.

When Dave arrives, we were met by a smiling, energetic young man, carrying samples of his commercial work.

Sara acts as the interviewer, Dave the interviewee, and I, as the recorder.

Sara begins by asking Dave, to "Please describe your art." Right from the start Dave describes his work as a blend of "photography, technology, and communication."

"What does your work tell us about you?" Sara asks.

"That I love the outdoors," he responds. Dave continues to explain that he was recently interviewed by the CBC Sunday Report, in regards to 'what makes people go into the mountains.' Dave was interviewed for his interest and photographs of the mountains. The report was in response to the recent avalanche in Revelstoke, which had tragically taken the lives of seven back-country skiers and snow boarders. Dave explains to us, that his photography reflects his respect and 'love for the mountains and the outdoors.'

"What experiences have most influenced your choice of subject matter?" we ask. Dave quickly begins to explain his interest in technology. Dave's comments make it clear that his love for the outdoors is strongly matched by his interest in technology. Dave explains that the most influential experience he had had, was when he first began purchasing technology.

'This equipment enabled me to shoot specific things... I began to learn through technology...

technology had improved and I had the availability to shoot through, manipulate, improve... I could shoot products, people, studio, outdoors... digital photography has allowed me to learn in a month, what would have taken years before..."

"How long have you been practicing photography?" we ask.

'I began when I was 16 years old... as a hobby... I started selling about 6 years ago... and I started a business 2 years ago...' Dave explains.

"How did you come to making art?"

'It was through being outdoors... I grew up outdoors...' Dave explains. 'I have many memories of camping and being outside.' Dave continues that his Father was an active photographer in his youth. 'When I played sports, my Dad was always on the sidelines with cameras...' In his mid-teens, his father encouraged him to go camping alone. Soon, Dave became interested in photographing his trips, and began to use his Dad's camera. At the age of 20, his father gave him a camera, which he could use more freely in his travels. Dave told us about when he walked from Banff to Mexico in 5 1/2 months. Afterwards, he remarked that he "thought about that trip everyday since..."

"Do you have any training as an artist?" we asked.

Dave flat out replies with: "Zero." He continued that when he finds something new, he'll "pick it up, whatever it is - and try to figure it out."

"Do you think you will continue?"

Dave hesitantly replies with, "Yes." Yet he continues, more surely, explaining that he doesn't want to declare his future, but he honestly felt that: "Yes, just with the growth that is happening... the subject matter is expanding so much... yes, I'll continue doing this."
"What does your art tell us about your community?" we asked.

"That it's incredible," Dave replies. Then as if changing his mind, he replies, "Grandiose! ... I moved from the Swiss Alps to here ... I love it here..."

"What does your art tell us about culture?"

Dave stops, and says, "Not much... maybe about the outdoor culture... about Squamish... it shows off the talents of my friends."

"Then what does your art tell us about society?" Sara continues.

"That there are adventure seekers... that are striving to get out of society," Dave states. "They're looking for something other, something different..."

Dave then turns to a different note. He explains that it is also a reflection of technology. "(Technology) allows people to push whatever they do further... gives people the ability to represent it..." Dave continues. "When I work with other artists... I help them represent their art... I ask them 'What are you looking to create?' ... I try to help them show their vision..." Dave then discussed the different forms of photography that he deals with. He is finding that he is turning more and more towards digital photography, especially for his

commercial, advertising, and fashion photography. Yet, he continues to use slide film for his gallery work, which is usually of the outdoors. As the interview came to its end, and we struggled with our own technology, Dave finished by stating 'Without certain styles of technology, I couldn't have done so much.'

Photography and the Environment

A difficult task confronting teachers is selecting areas of meaningful educational inquiry. Educators face this dilemma each day. Fenstermacher (1994) argues that conceptions of teaching should include questions about: What is known about effective teaching?; What do teachers know?; What knowledge is essential for teaching?; and Who produces knowledge about teaching? Clandinin & Connelly (1996) add that research about teachers' professional knowledge should also question the questions themselves. For instance, how is teacher knowledge shaped by professional knowledge in the field of study in which teachers work? Asking some initial inquiry questions can be helpful in getting started planning meaningful lessons. Beth, Sara and Brooke asked the following questions to begin their planning.

Inquiry Questions

1. What effects do the way we live have on the environment?
2. What do you believe could be done, if anything, to ensure that the environment is not damaged further?
3. What everyday choices can you make to carry out these beliefs

in your own life?
4. How might you be able to share this message with others through photography?

Contextual Information

Through this lesson, students can begin thinking about consumerism and it's effects on their immediate world. Photography will be explored in an economical, non-technological manner. Up until this lesson, students made a pinhole camera and experimented taking pictures with them. They looked at some work by artists who use pinhole camera and have discussed that people make choices everyday which either negatively or positively effect the environment. By understanding the consequese of one's actions students will examine they can make a difference in the world in which they live.

Integration of Subject Areas

Understanding the scientific effects of pollution and waste on the environment can strengthen student's understanding of ecological sustainability and the negative economic value of consumerism.

Preparation

Lay images out on a table at the front of the class in order for students to glance at them as they walk into class.
Set up overhead for images that will be discussed.

Procedure

Part One: Introduction (20 min)
Introduce topic through the use of images and discussion. Show images that raise different issues about human impact on the environment. As issues arise, we will discuss them as a class. The teacher will introduce the term "consumerism", and we will discuss what this means, how it relates to the images, and what affect it has on the environment. *Part Two: Small Group Discussions (15 min)*
In groups of three to four, students will discuss where they see the affects of pollution, waste, etc. in their own communities. Each person will come up with at least one place where they personally have noticed these affects, and hypothesize about the sources may be.

Part Three: Explanation of Assignment (5-10 min)

Students' will be asked to generate images for a collage, which deals in some way with the environment and consumerism over the next two weeks.
Part Four: Idea Generation (10-15 min)
During this time, students will have the opportunity to look at magazines, images, and photographs that have been brought in to class. The aim is for them to begin generating ideas for their own project. Students should be required to write a proposal for their project, which will be due at the beginning of next class.

Assessment

Since this is an introductory lesson, students will only be marked on participation (their daily participation mark); however, the proposal (to be handed in next class) is worth 15 marks.

Resources and Materials
• images dealing with environmental issues/ consumerism (including some pinhole camera images if possible)
• Adbusters magazines
• websites (written on the board for students):
 www.environmentalphotography.com;
 www.braaschphotography.com;
 www.photomediagroup.com/worldinfocus/main.html;
 www.mpimedia.com/New_Release/BARAKA/MEDIA.HTML
 www.adbusters.org

Conclusion

There are many social, cultural, and historical contexts involved with how someone comes to understand their own place in the world. By talking with local community people, students might learn that there are no simple answers to these issues. By making digital movies with community people, students can learn more about how intercultural and interactive processes are socially specific and contextually complex.
Our perceptions are also influenced and affected by time. Social, cultural, and physical environmental conditions change the landscapes we see. By creating digital movies, students can learn to not seek lofty expectations and explanations of people's

she

everyday lives. Students can learn to understand the significance of things within the everyday values of lived events. Often time art can be interconnected to a maker's expressive cultural practices, to what she/he makes, and to the environment in which she/he lives. By talking with local artists, students might learn to understand particular events and contextual conditions associated with particular forms of cultural production.

In the end, the act of making digital movies should be an effort to know more about ones self, other people, and the world in which we live. Meaning making is a dynamic act with its own gratification's that are derived from the pleasure and value people make from interpretive acts. Students are curious human beings who find understanding the different ways that people live and make things interesting. Talking with people about making things special, how they make sense of these things, and the meanings they ascribe to them, can heighten one's experience of everyday life. If teachers and students use digital media to examine how people place value on things within the contexts and community in which they live, they can learn how technology can be used for more than just a tool for surfing the web, playing video games, or making presentations.

References

Clandinin, D. & Connelly, F. (1996). Teachers' professional knowledge landscapes: Teacher stories—stories of teachers—school stories—stories of schools. *Educational Researcher*, 25(3), 24-31.

Fenstermucher, (1994). The knower and the known: The nature of knowledge in research on teaching. *Review of Research in Education*, 20, 3-56.

Krug, D. & Parker, A. (1998). "Power On!: The Fantastic Environments of Dr. Evermor," *Raw Vision: International Journal of Intuitive and Visionary Art*. 25(4), 26-31.

Stuhr, P., Krug, D., & Scott, A. (1995). "Partial Tales of Three Translators: An Essay," *Studies in Art Education: A Journal of Issues and Research in Art Education*, 37(1).

Websiteimovie Tutorial http://www.apple.com/imovie/

CONNECTING, REFLECTING AND IMAGINING

Jan. 7 /03

INSIDE OUTSIDE

ISSUE 202 THE INDIAN DESIGN MAGAZINE APRIL 2002 Rs 35

When you hear the term "Multicultural education, what does it mean to you"

It's amazing that I have to use your language to tell you how I feel

"TOURIST MULTICULTURALISM"

Multicultural education does not mean anything other than a human relations exercise. Cultural inequalities are not addressed in the curriculum.

MULTICULTURALISM HAS EVOLVED AND SOCIAL JUSTICE ISSUES (HUMAN RIGHTS ISSUES ANTI-RACIST PEDAGOGY, PROGRAMS THAT ADDRESS SYSTEMIC DISCRIMINATION (EQUITY INCLUSION ETC) NEED TO BE FIRMLY ENTRENCHED WITHIN THE SCOPE OF MULTICULTURALISM.

Diversity is not casual, liberal tolerance of anything and everything not yourself. It is not polite accomodation. Instead, diversity is in action, the sometimes painful awareness that other people, other races, other voices, other habits of mind, have as much integrity of being, as much claim on the world as you do.
William Chase

Art Education and Social Justice: An Elementary Perspective

Graeme Chalmers

Art involvement can become particularly meaningful in the lives of elementary students when we find ways to connect art learning and production to important social issues. Even small children can learn to see that art, in many different places and settings, can be used to perpetuate and to challenge the values of a society. And, children can use their own art making in the same ways. Where do they find injustice? What do they want to change? What should be affirmed?

In North America, education as social reconstruction can be traced back to George Counts (1932) who in his book *Dare the Schools Build a New Social Order?* argued that schools cannot be morally neutral and that educators need to collaborate with other groups to effect social change. Too often in elementary education, art simply serves as 'recreation.' Little or no attention is given to art-making as a political process. Students rarely talk about *why* art is made and displayed. Schools, even elementary schools, and the communities they represent, need to engage in this process; to see, feel, experience, and commit to the politics of art making. Artists make art to both sustain and challenge the status-quo. A world, a school, without art, needs to be unimaginable -- not just because the arts enrich our lives -- but also because we need art for social critique, cultural survival, and communal identity. Art education and arts involvement can

> **Even small children can learn to see that art, in many different places and settings, can be used to perpetuate and to challenge the values of a society.**

encourage self-esteem when students know that they are dealing with really important issues and that, through their work, they too can make a difference.

More than 30 years ago, educator Vincent Lanier (1969) proclaimed that "Almost all that we presently do in teaching art in . . . schools is useless" (p.314). He believed that students needed to examine "the gut issues of [their] day" - war, sex, race, drugs and poverty, and argued that

what we need . . . are new conceptions of modes of artistic behavior, new ideas of what might constitute the curricula of the art class. These new curricula must be meaningful and relevant to pupils . . . These new ideas must engage the "guts and hopes" of the youngsters and through these excitements provoke intellectual effort and growth. These new ideas must give the art class a share in the process of exploring social relationships and developing alternative models of human behavior in a quickly changing and, at this point in time quickly worsening social environment. (p.314)

Lanier was not just addressing secondary schools. Social responsibility begins in the home and then in pre-school and kindergarten. A look at current curriculum documents in many different jurisdictions indicates that teachers, at all levels, are now encouraged to give more attention to the social and personal contexts of art. In British Columbia there are teachers who have developed art 'units' focusing on identity and ethnicity, hunger, AIDS, making dolls for children in

war-torn parts of the world, racism, and homelessness. A new cross-curricular initiative termed "social responsibility" is providing some great starting points for elementary education. The arts can be harnessed as schools address issues such as bullying

Social justice themes provide avenues for cooperation between elementary and secondary school art programs. More than 10 years ago, an article in a local BC newspaper claimed that at least 40% of Canadians had racist attitudes. This claim, coupled with observed racist behavior within local schools, prompted some Burnaby, BC teachers to develop a unit "Art Against Racism" (Scarr & Paul, 1992). An exhibition "Fear of Others: Art Against Racism" had been held in Vancouver and a related slide set, video, and guide were produced. The visual arts part of the unit required students to respond to a variety of visual materials on issues of racism, to compose their own statement about racism, and to develop an original image suitable for an edition of linocut prints. Students developed complimentary written statements and were required to critique their own work and the work of others attending to both the formal and the contextual qualities of the prints. Language arts classes produced poems and short stories and a drama class wrote and staged a play about racist behavior and attitudes. A large 6 by 30 foot mural was created as a joint celebration of the awareness that had been developed. With additional funding from the

school district, the students went on tour to present their work to students in other schools, and some of their work was used for the cover and illustrations in a "multiculturalism issue" of the *British Columbia Art Teachers' Association Journal for Art Teachers.*

Some elementary schools have become the sites for citizenship ceremonies. Recently Dunsmuir Middle School (Sooke, BC), used

There are very few published curriculum projects that encourage students to explore the arts for social change. Such work must start with a deeply felt need; one that can be experienced locally.

the results of an intensive week of "Celebrating Diversity Through the Arts" to decorate the gymnasium for a culminating event of the week: a Canadian Citizenship Ceremony. It is valuable when art can be used for such a purpose.

Founded in 1996 in Vancouver, *ArtStarts* in Schools is a unique not-for-profit organization offering educators, artists, parents and students a broad range of programs, services and resources to promote art and creativity among young people. Their many activities include: innovative arts programs, services and resources for teachers and artists, funding resources, etc. Of particular interest to those wishing to promote anti-racist education

is the *Art as a Catalyst for Change* program which brings important social and community issues into the art class. In an innovative series of artist-led workshops and residencies, *Art as a Catalyst for Change* brings artists and elementary classroom teachers together to present art-based programs on curricular themes focused on social concerns including human rights, anti-racism, media education, and the environment.

ArtStarts has many services including an *Artists' Directory* which provides marketing and program information on over 225 artists and groups who work with young people throughout Western Canada. At the time of writing *ArtStarts'* booking service coordinates, schedules, negotiates and contracts 1800 arts events annually in schools and communities throughout British Columbia.

Teachers working with *Vancouver's Holocaust Centre*, which has produced a number of school programs and resources, including some very popular Discovery Kits, has also facilitated some innovative arts-based anti-racist projects. A project, which could be adapted for elementary students, was called *Building Bridges: Visual Stories and Perceptions of the Holocaust.* Other projects suitable for upper elementary grades include the *Suitcase Project* and *I never Saw Another Butterfly.* The Centre encourages teachers to submit a proposal to show work done by their students on Holocaust related, social

justice themes, for their summer exhibition schedule. Similarly the *Westcoast Coalition for Human Dignity* has produced an excellent kit for educators entitled *Choose Dignity*, and many activities are suggested that could be developed through art.

A number of theatre arts companies work with anti-racist themes in school and community centres and

the atmosphere in which such changes can occur." (n.p.)

There are very few published curriculum projects that encourage students to explore the arts for social change. Such work must start with a deeply felt need; one that can be experienced locally. Among the few published resources are *Art and Development Education* and the *Art as Social Action* video materials (Oxfam, 1990) piloted

If art education is to be meaningful, we must not shy away from controversial themes.

encourage teachers to actively explore links between drama and social justice. Often schools choose to perform plays with anti-racist themes. These experiences can be followed with related work in the visual arts.

We can also learn from what has happened elsewhere. At The New Museum of Contemporary Art in New York City, educators Susan Cahan and Zoya Kocur (1996) show that when the goals of multicultural art education include inquiry into current social conditions, contemporary art is an indispensable resource that should be brought in to the classroom. Their school art resource guide, includes themes (many related to social studies curricula) that could and should be explored in elementary education: immigration; changing definitions of the family; discrimination, racism and homophobia; mass media; war; and the roles of public art in society.

A group in New York City "Artists/Teachers Concerned" (n.d.) states:

For many of our students real choices and opportunities are few or nonexistent. In this context, the need for a meaningful art education curriculum . . . is clear. Through socially motivated art education programs and exhibits we give our students a chance to actively voice their opinions and be recognized for caring about themselves and their future. As educators, if we are going to honestly tell our students that they have the power to criticize and change their situation in society, then we have to believe that our educational system can reinforce those objectives and facilitate

in inner London (UK) schools. This project focused on addressing racism and apartheid through art-based approaches. Another London-based group, *Art and Society*, working with *Amnesty International* (1991) produced an art education teaching pack titled *Free Expression*.

Sharing the Vision, (National Symposium on Arts Education, 2001) a national framework for arts education in Canadian schools, begins with the statement that "Any parent or grandparent will tell you that from an early age, children naturally immerse themselves in drama, dance, music, and the visual arts: to play, to learn, to communicate, to celebrate, and to find out who they are." The arts are valued because they express and engage the human spirit in profound and powerful ways. *Sharing the Vision* goes on to state "We . . live at a time when violence and misunderstandings seem to be spreading in our society. The arts can be a direct way of vicariously but meaningfully encountering sensitive issues and values."

If art education is to be meaningful, we must not shy away from controversial themes. The literature in art education is increasingly addressing such issues (e.g. Albers, 1999; Bolin, 1999; Heath, 2001; Jeffers and Parth, 1996; Milbrandt, 2001). In an essay in the *New Art Examiner*, Henry Giroux (1996) pleads for pedagogical practices that help young people learn about and "understand their personal stake in struggling for a future in which social justice and political integrity become the defining principles of their lives" (p.21). Arts teachers can help, and schools, and community-based programs can dare, to build a new social order.

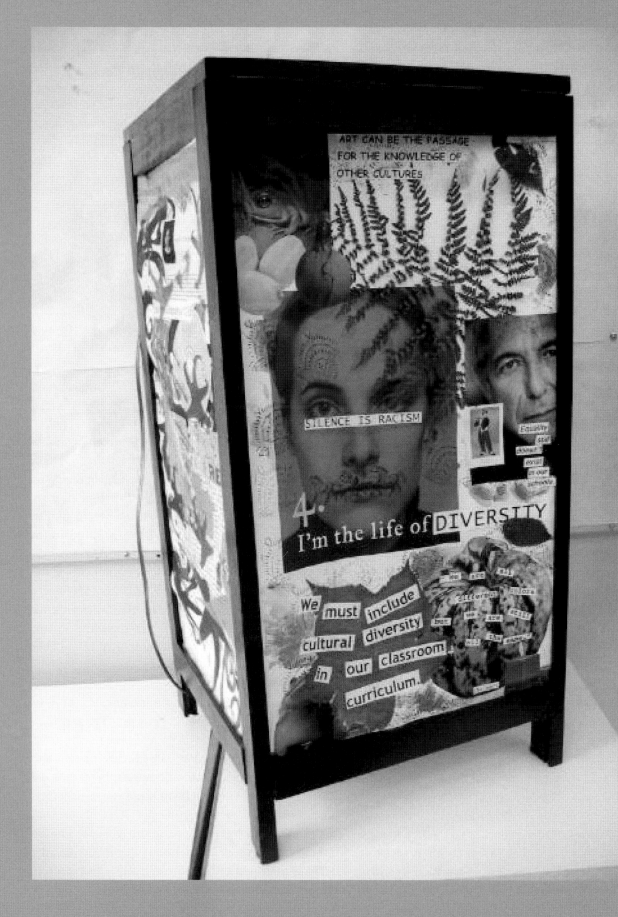

References

Albers, P.M. (1999). Art education and the possibility of social change. *Art Education*, 52(4), 6-11.

Amnesty International. (1991). *Free expressions: the Amnesty International art education pack*. London, UK: Amnesty International British Section.

Artists/Teachers Concerned. (n.d.). Brochure. New York: Artists/Teachers Concerned.

Bolin, P. (1999). Editorial: Teaching art as if the world mattered. *Art Education*, 52(4), 4-5.

Cahan, S. & Kocur, Z. (1966). *Contemporary art and multicultural education*. New York: The New Museum of Contemporary Art and Routledge Press.

Counts, G. (1932). *Dare the schools build a new social order?* New York: Day.

Giroux, H. (1996). What comes between kids and their Calvins: Youthful bodies, pedagogy, and commercialized pleasures. *The New Art Examiner*, (February), 16-21.

Heath, S.B. (2001). Three's not a crowd: Plans, roles, and focus in the arts. *Educational Researcher*, 30(7), 10-17.

Jeffers, C. & Parth, P. (1996). Relating contemporary art and school art: A problem-position. *Studies in Art Education*, 38(1), 21-33.

Lanier, V. (1969). The teaching of art as social revolution. *Phi Delta Kappan*, 50(6), 314-319.

Milbrandt, M. (2001). Addressing contemporary social issues in art education: a survey of public school art educators in Georgia. *Studies in Art Education*, 43(2), 141-152.

National Symposium on Arts and Education. (2001). *Sharing the vision*. Ottawa: NSAE.

Oxfam. (1990). *Art against apartheid and antiracism and art in Britain and South Africa*. Oxford, UK: Oxfam Education and Publications.

Scarr, M. & Paul, D. (1992). Art against racism. *British Columbia Art Teachers' Association Journal for Art Teachers*, 32(1), 32-37.

CONNECTING, REFLECTING AND IMAGINING

stARTing with Art: Relating Children's Visual And Written Expression

Kit Grauer

Alexander is drawing in his visual journal. All around him in this
wo classroom, his classmates are also concentrating over their journals
ical music plays in the background. On this day, Alex is working on
that he and Ian are writing about Jungle Boy. His drawings are the
ard for the illustrated book that they will produce later in the week.
ays, his teacher suggests a topic, "what I did last weekend", or suggests
rvation drawing of the beans that fill the window sills of the classroom,
their own paper cup with the carefully recorded children's names
on the side. Other days, like today, she allows the children to follow
vn interests. She wants their work in their visual journals to be intrinsi-
warding and so she provides structure when she thinks the children
but also places an equal amount of energy helping them develop their
:as and interests. In this school, each busy day starts with listening to
sic selection developed by the district music coordinator and journal
r the children to draw their ideas onto paper. This teacher has discov-
d many of her colleagues agree, that by starting the day with drawing
very little difficulty later in the school day when she wants to have the
1 writing. They always have lots of ideas in their visual journals and
t they want to put into words and share with their classmates. Visual
s and daily drawing are a school wide focus and the children have
fficulty understanding the close connection between expressing their

ideas in images and words. They have lots of time to 'read' back the ideas in the pages of their journals and to use some for their writing class and some as the basis for other larger art projects that they might do later in class. In the primary classroom, integration of subject areas is as common as that separation has become at high school.

At the elementary school level integration of subjects has a long history. Teachers often decide to develop their curriculum units around themes or topics. Dinosaurs and cultural events are common examples of this approach where science, social studies, math, art, language arts and music and movement are all brought in to look at the multiple ways of understanding a particular theme. In this article, I am specifically looking at the similarities in a process approach to teaching the subjects of language arts and art. By concentrating first on these two curricular areas, it is possible to make explicit the powerful associations in student's leaning that occurs when two different ways of representing our knowledge are used in combination. What teachers who use this approach have discovered is that children seem to learn with more engagement when they have a chance to combine their understanding in art and language arts. This does not mean that other subject areas are left out of any curricular decisions, it simply means that visual and verbal literacy take precedence when integrating and then the appropriate connections to other disciplines are brought into play. Most teachers at the elementary level are comfortable with their language arts instruction and less sure about the way to teach art. They appreciate that approaching art from a writer's workshop perspective and integrating the two subject areas makes pedagogical sense and also promotes a high level of accomplishment and satisfaction in their children's response to both subject areas.

The idea of linking art and language arts is not new, but a recent resurgence in interest (Cornett, 1999; Blecher & Jaffee, 1998; Steele, 1998) has prompted me to revisit several articles (Grauer, 1984, 1988, 1991, 1999) that explored the relationship between art and whole language. During the eighties, whole language instruction had started to change the way that many elementary school teachers approached teaching and learning (Willis, 1995). Teachers were discovering something called the writing process or the writer's workshop approach to teach-

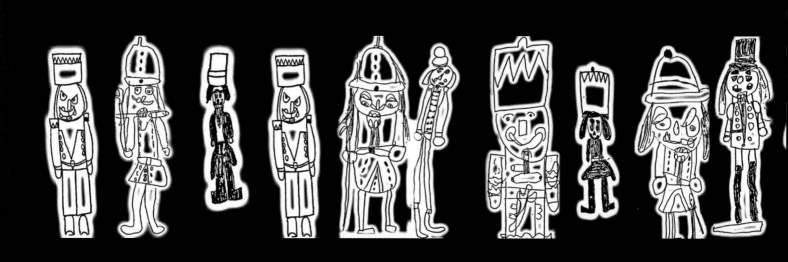

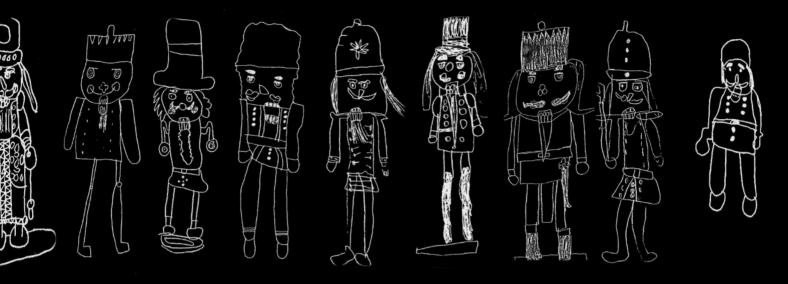

ing language arts. Writing was synonymous with thinking and expressing in words, rather than an isolated school activity to teach the skills of spelling, punctuation and grammar. Reading and writing were seen as complimentary processes instead of two different areas. Teaching process rather than products became accepted. The two sides of the brain research and early interest in Gardner's theory of multiple intelligence, (Gardner, 1983) provided teachers and administrators access to the ideas of teaching to different styles of learning and encouraging multiple forms of representation.

In art education, an awareness of the importance of including aesthetics, criticism and art history as part of a balanced making and responding art curriculum brought writing and speaking into the art classroom. As well as creators of art, children were expected to become enlightened critics and consumers of art and images. In British Columbia, we were piloting something called 'The Year 2000', built on a constructivist understanding of children's learning. With so many exciting curriculum changes, teachers were given considerable leeway to experiment with changes that made sense to our growing understanding of how children learn. One prominent innovation was the idea that there might be similarities in the way that writing and art were taught (Grauer, 1984). That concept was further expanded to suggest that using both visual and verbal modes of understanding and representing could actually enhance children's expression. By using the unique aspects of knowing represented by visual as well as verbal thinking, children have the opportunity to experience deeper and richer forms of communicating their ideas and to appreciate these capacities in others.

These ideas are continuing to evolve as our strategies for teaching become more refined. Both art and language can be thought of in terms of processes that children and adults engage in to give form to their ideas. If writing is thinking expressed in words, than art is thinking expressed in images. Images are one of our first forms of thought. Long before infants have the words necessary to speak, they have the images necessary to identify, classify

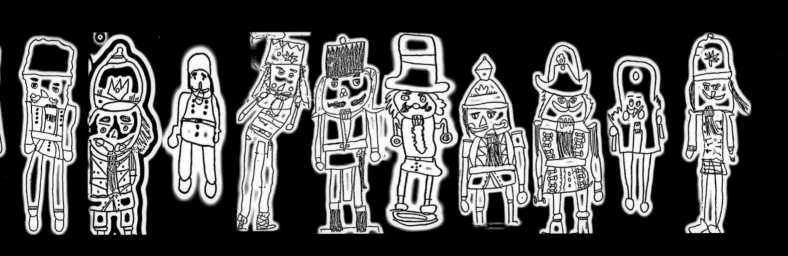

and remember important aspects of their world. Image, after all, is the root word of imagination. As children grow and develop, they engage in early scribbling and drawing, developing visual symbol systems to represent their thinking prior to mimicking the symbol system used to represent words. By the time most children come to school, they are often already engaged in talking about their pictures and picturing their thoughts. The relationship between art and language is already established.

If there have been major changes in the way that writing has been taught in the past decades, there is similar changes in our view about art education. Teaching art is not about giving children exposure to a variety of media or about teaching skills in isolation. Skills are necessary, not as the core of the curriculum, but rather in the context of problem solving and thinking within any given medium and within the wider world of images. The current interest in exploring visual culture as way of deconstructing and constructing our identity in a world saturated with media images is an example of how our understanding of the role of art education is changing. A process approach to teaching art that parallels the writing process or writers' workshop approach is a model that both teachers and students have found very useful. Although, I will discuss the various 'stages' of the process, it is important to recognize that none of the stages are wholly exclusive and stages often overlap. This is model is much more spiral than linear.

Stages in the Art Process	Stages in the Writing Process
All of the stages in the process can be ongoing, overlapping, and repeated.	All of the stages in the process can be ongoing, overlapping, and repeated.
Motivating: Getting started. Thinking about the topic or what the artist wants to express. Activities such as brainstorming ideas on a theme, webbing, guided visualization, or looking at slides, films, video or artists' work in other formats, help children generate ideas. Choose an audience for the work and a medium for the art (clay, paint, ink, etc.)	*Pre-writing*: What we do before we write. Thinking about the topic or what the writer wants to say. Pre-writing activities, such as: making a visual representation; viewing a video or a picture; talking with a friend or in a group; reading an article or a book; listening to a speaker or to music, help pupils generate ideas. Choose an audience for the finished work and the style or form of writing.
Drafting: Drawing ideas on paper. Initial attempts at composing ideas in pictures.	*Drafting*: Writing the words down on paper. Initial attempts at putting ideas into written words.
In Process Critique: Making it better. Revising the first sketches or drafts by subtracting, adding, rearranging, or substituting material to achieve the results intended. This stage is accomplished in consultation with peers and/or the teacher. Developing the ideas in a suitable medium.	*Revising or Editing*: Making it better. Revising earlier drafts by rewording, altering, adding, eliminating, and rearranging words and ideas.
Refining: Checking it. Examining the technical qualities to determine if the result is ready for matting, framing or displaying in some form.	*Proofreading*: Checking it. Examining the revised draft for errors in capitalization, punctuation, spelling, usage, and form.
Exhibiting: Sharing it. Sharing the work with others.	*Presenting/Publishing*: Sharing it. Sharing the work with others in oral or written form.

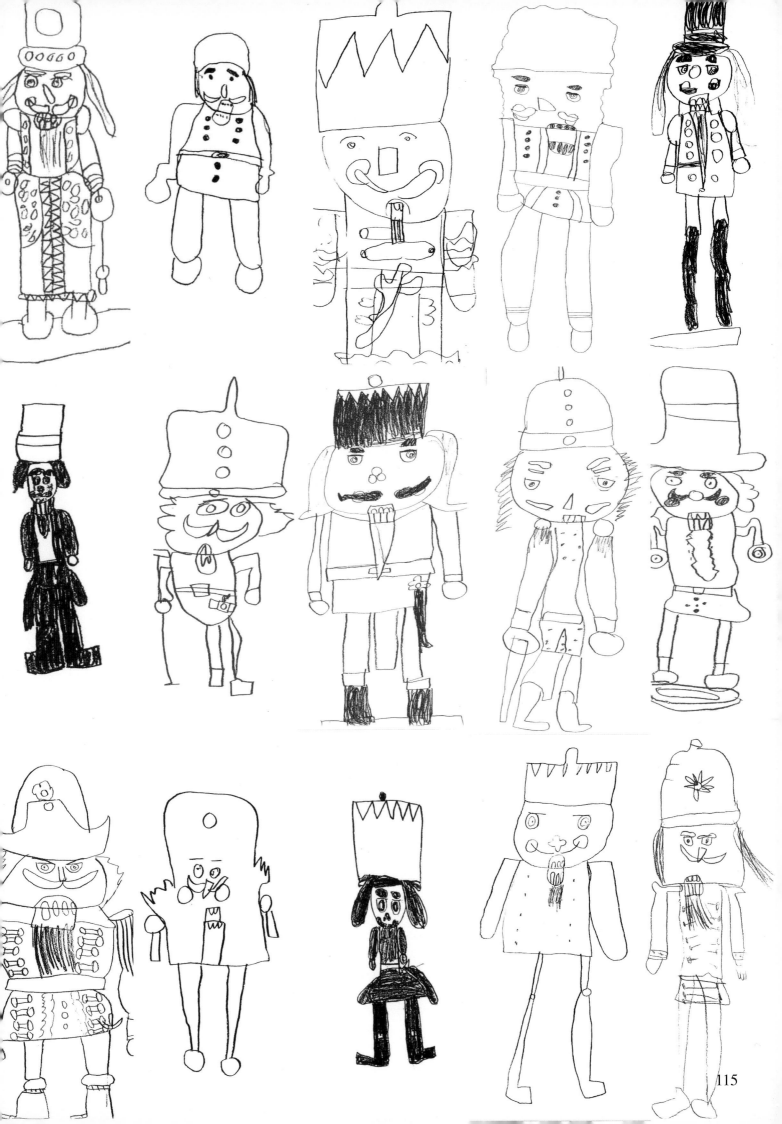

115

Before expressing ideas, artists and writers need to think about the ideas that they want to express. Teachers have learned that it is better to start with the art when combining art and writing experiences. As children think visually first, and as we are becoming more and more an image driven culture, putting the images to ideas prior to the words not only makes biological sense, it also provides a richer verbal experience as children discuss their pictures. At this first stage, visual thinking can be encouraged through any number of techniques: reading to children and having them interpret the pictures in their minds; looking at the work of adult or child artists and illustrators in pictures, photographs, illustrations, videos or children's books; guided visualization or any combination of the above. Motivating children prior to actually making art, allows them to begin to sort through the images in their world and in their minds and develop their own unique thoughts.

'Drafting' is the stage in which ideas move from pictures in the mind to images drawn on paper (or modeled in clay depending on the project). The surprise for many students is that real artists often do many drawings or models of an artwork before choosing one to make into a finished piece. It helps to show artists sketchbooks, or have an artist or illustrator visit the classroom to let children see that all drawings are not perfect the first time. Like real artists, their first images are an attempt to make thoughts public and express an idea. The use of visual journals in Alexander's class is one example of drafting ideas first in images.

'In process critique' or 'editing' is a stage that has made a huge difference to building children's confidence and competence in art. At this stage, the artist can examine the rough draft alone or in consultation with peers or the teacher. Here all the elements and principles of art and design can be contemplated for reference: colour, line, texture, shape, balance, harmony, unity, and/or rhythm. It is also a time to look at technical skills and image development strategies. Many teachers find that teaching specific skills at this stage helps children refine their ideas. What changes can the artist make to develop a finished piece so that the work expresses his/her own particular view? Help can come from other children, the teacher, and references to other artists' ideas through looking at books and pictures. Many children appreciate the feedback at the 'in process' stage rather than at the end. For many classrooms, the use of peer critiques are very useful in developing a real audience for the finished work and providing children a chance to share rather than hide, their artistic abilities. This is the stage that many intermediate teachers have found particularly useful. Older children are often particularly reluctant participants in class art critiques. However, by introducing the idea of 'critiques in process', it has taken some of the peer pressure from the critique and turned it into a peer support system. Many teachers now use this technique as an ongoing form of assessment and self-reflection that defines and builds the criteria necessary for more authentic final evaluations.
When the artwork has been completed it is ready to be finished in some type of frame or display format so that it can be properly exhibited for others to see and appreciate.

Art and writing processes are not mutually exclusive. Starting first with an art experience seems to help children discover more about what they want to write. Varying between art and writing, throughout the experience, builds on the strengths of both modes of representation. In many intermediate art classrooms, an artist statement is a requirement of any finished piece.

Later in the day, the teacher in Alexander's classroom is reading the children the story of the Nutcracker. A parent has brought in her Nutcracker collection and the children are taught a simple observation drawing technique and then draw the nutcrackers onto large sheets of paper. They are thrilled with their work and ask to do more than one drawing. These first drafts become finished drawings that the children will be proud to display. Throughout the afternoon, there is plenty of time for the children to talk about their artwork in small groups and pairs. Lots of strong descriptive language is happening as the children describe the various details on the nutcracker figures that they are drawing. "Let's add one or two sentences of really descriptive writing about your Nutcracker drawing in your draft writing books," the teacher suggests. The process between reading, drawing, talking, writing looks seamless from the outside and the finished products that are displayed at the parent open house later that week are impressive and individual.

This classroom is a good example of what children can accomplish if they are provided with an environment structured around learning. Teaching art and language arts in combination offers these children access to two ways of knowing and helps them celebrate the joy of creation and expression in both.

References

Blecher, S. & Jaffee, K. (1998). *Weaving in the arts: Widening the learning circle*. Portsmouth, NH: Heinemann.

Cornett, C. (1999). *The Arts as meaning makers: Integrating the arts throughout the curriculum*. Englewood Cliffs, NJ: Prentice Hall.

Gardner, H. (1983). *Frames of mind: The theory of multiple intelligences*. New York: Basic Books.

Grauer, K. (1999). Art and Writing Revisited. *BCATA Journal*. 39(2), pp. 28-32.

Grauer, K. (1991). Artistic knowing and the primary child. *Prime Areas*, 34(1), pp. 67-69.

Grauer, K. (1988). Art and writing: The best of friends. *Prime Areas*, 30(3), pp. 81-84.

Grauer, K. (1984). Art and writing: Enhancing expression in images and words. *Art Education*, 36(5), pp. 32-38.

Steele, B. (1998). *Draw me a story: An illustrated exploration of drawing-as-language*. Winnipeg, MB: Peguis.

Willis, S. (1995). *Whole language: Finding the surest way to literacy*. ASCD Curriculum Update, Fall, pp.1-9

CONNECTING, REFLECTING AND IMAGINING

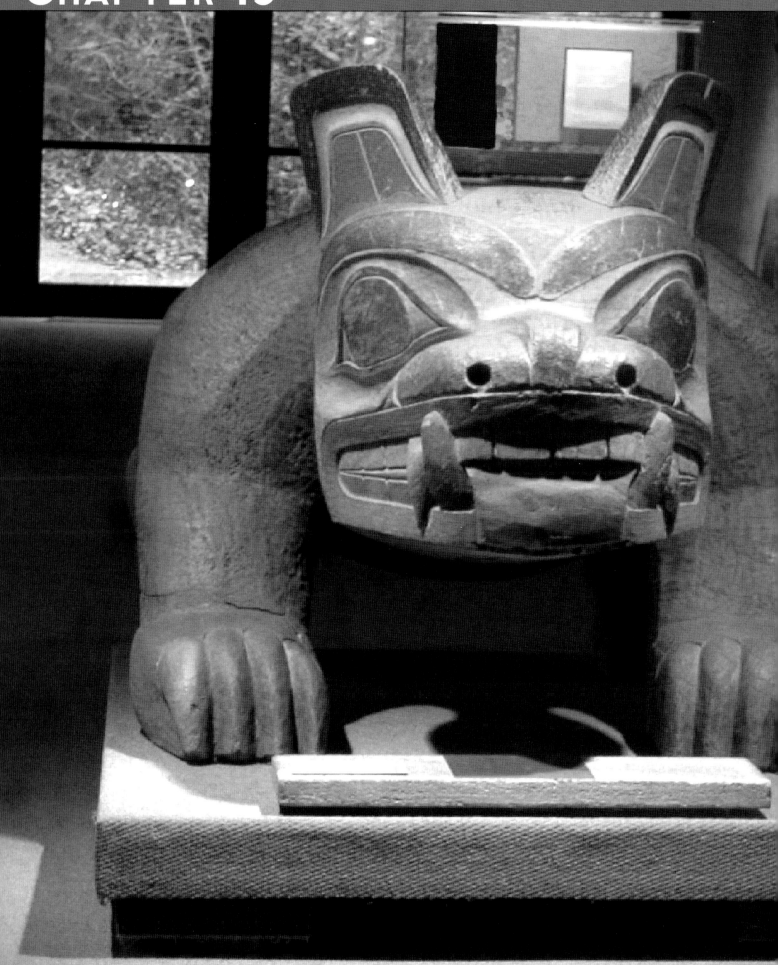

LEARNING IN THE ART GALLERY: ESSENTIAL NOT ENRICHMENT!

Jennifer Eiserman

Often we think that it would be nice to enrich our art programs through field trips to our local art galleries or museums. I would like to suggest that such experiences are not an extra activity, any more than trips to the library are enrichment to our language arts programs or that reading is an enrichment to literacy. If regular visits to the library and a regular reading program are necessary to our language literacy, then visiting an art gallery or museum and viewing original works of art are equally necessary for our visual and cultural literacy. In this chapter, I will explain how visual literacy is developed and how educators can use visits to art galleries as an integral part of an art program. Further, I will discuss alternatives to traditional art galleries that provide students a broader exposure to the arts of other cultures within our communities. Finally, I will discuss how a school can set up its own art museum, similar to the school's library, in order that original works of art be available to teachers and students on a daily basis.

Visual Literacy: Learning to 'Read' through Art

'Literacy' is one of those nebulous terms which have powerful significance yet are not well defined. Often definitions of literacy conflict and there exists much misunderstanding about how literacy functions in our everyday lives. I propose the following definition for use in this discussion: The ability to understand all the symbol systems through which our society exchanges ideas and sends information, enabling the individual to communicate effectively, think critically, and participate fully in their culture. There are several assumptions about literacy embedded in this statement. The first assumption is that definitions of literacy limited to decoding are not adequate. Statistics Canada uses this decoding definition: "the skill to use everyday printed material at home, at work, and in the community." Literacy researchers like Tuman (1987) have identified that the individual not only decodes information, but *creates meaning* which is contextually dependent. Our definition of literacy assumes that literacy education requires learning to decode

signs and to build meaning within the given context.

This leads to the second assumption that our definition makes: the 'signs' decoded in the literacy process are not restricted to printed texts. We assume, with Gardner (1985) that "there exist many kinds of symbol systems, many of which are not closely related and which can be conveyed through a multiplicity of media (p.39)." Eisner (1991) elaborates on this idea by identifying the object of the decoding process as the content of forms that are intentionally patterned, serve a purpose, have a history and a set of conventions.

By introducing notions of history and convention to the definition of literacy I propose, cultural context becomes an issue. Our definition assumes that literacy has a cultural component. Broudy (1990) defines cultural literacy as "the ability to construe the characteristics of a culture..." (p.10). This is important, for as the work of sociologist Bourdieu (1993) reveals to us, without access to the symbol systems of a culture, when one is unable to decode cultural 'forms' or 'construe the characteristics of a culture,' one is disenfranchised. Disenfranchisement means that one is unable to be proactive in determining the conditions of one's personal life or in the goals and values of one's community. Research by Johnson (1989) elaborates on the method of participation. She stresses that the learner needs to approach the cultural construction activity critically. She explains that cultural literacy requires "an active examination of the meanings, values and behaviours in a culture" (p.45). Johnson's concerns outline the final assumption on which our definition of literacy has been built: that literacy enables critical thinking and full participation in the culture.

Visual literacy focuses on the visual symbol systems of art and their role in literacy education. With Gardner and Eisner, I believe that visual art forms have an important role to play in the literacy process. With Bourdieu, I assert that the ability to participate in the symbol system is necessary for full participation

in a cultural community. When Gardner (1983) describes the way in which the different intelligences function, he stresses that 'art' is not a separate intelligence, but a way of exercising an intelligence. This is significant to the issue of whether one simply constructs and decodes signs or whether one is involved in critically exploring meaning. The aesthetic manipulation of a symbol-system means that one is literate, that one is aware of the history and conventions (the culture) of that system (Eisner, 1985). This goes beyond simply the way in which symbols can be intentionally patterned. The notion of *reading* an image thus involves an aesthetic orientation to the symbol system that constructs meaning.

Cooper, in his book *Literacy: Helping Children Construct Meaning* (2000), identifies four principles of meaning:

1. Reading, writing, speaking, listening and thinking develop simultaneously as learners grow in literacy.

2. Individuals learn to read and write by reading, writing and responding to their reading and writing.

3. Prior knowledge and background

are major elements in one's ability to construct meaning.

4. Comprehension is the process of constructing meaning by relating ideas from a text to one's prior knowledge and background.

The museum visit is vital to supporting visual literacy. Copper stresses that students need to interact with 'real' texts. By 'real' Cooper means texts as they are found in the real, lived world of the students. He believes 'real' texts support literacy in three ways:

1. They motivate, captivate and engage the students;
2. They provide a natural base to develop and expand upon; and
3. It is easier to read and understand real texts than those contrived to 'fit' the learners level of literacy.

The art museum provides 'real' experiences of both visual and language-based symbol systems to the students. Art is seen within its real, lived context. An art exhibition is the 'real' text of the western visual arts community and works of art are found primarily in art museums in our culture. Festivals, celebrations, faith acts, architecture and the home provide real contexts for the art of other cultures. Thus, in order for students to engage with 'real' visual art symbols, field trips to sites where real art is found are not just nice, but are a necessity to a child's ability to learn through art.

Visiting Your Local Art Museum

Now that I have established the necessity for children to see art in the many real contexts in which it exists, I will explore how to incorporate the museum visit into the learning activities of the classroom. The first task is to review the curriculum objectives for the year, then to survey the educational programming offered by local art galleries and museums. Museums typically have three different kinds of programmes available: guided tours; self-guided tours; self-directed tours.

Guided Tours

The first kind of programme, the guided educational tour, is developed by the museum and taught by a museum educator. Guided tours are usually between one and one and one-half hours in length. They usually combine looking with discussion, participatory and hands-on activities. Students will not only listen, but will talk, write, and draw. They might even engage in dramatic play, dance or music activities. Some museums are able to provide a studio component to the students' experience making the media and techniques of the artwork come alive.

Guided tours are usually developed in one of two ways. First, a museum may have standard programs that they offer regardless of the exhibitions on display. These programmes usually deal with basic formal, conceptual or historical concepts in art. For example, a museum programme may deal with colour, abstraction or Early Colonial art. They are excellent opportunities to explore universal issues within the art of a given culture. These programmes are often developed with a sensitivity to the provincial curricula and address learning objectives for

grades one through six. Review the stated learning objectives for these programs to determine if any of the set programmes offered by an institution will meet the needs of your art programme.

Art museums also organize educational programmes specific to a temporary exhibition (an exhibition that remains at the museum for only a limited period of time). These programmes are often much more specific in their scope. The programme may introduce students to a particular artist, a particular artform or genre of work. These specific programmes are a wonderful way to explore particular concepts with which you may be less familiar or not able to explore at school. For example, an exhibition of work by Québécois sculptor and poet Gilles Mihalcean would allow students an opportunity to explore how artists use found objects to create poetic interpretations of the landscape. This understanding could be taken back to the school in a unit that develops the assemblage technique and the landscape genre in visual art. Interdisciplinary links could also be made to poetry in language arts. Although more specific to a given grade level, these programmes are also usually designed with provincial curricular requirements in mind. Teachers need to discuss this with the educator at the time of booking.

When planning a visit to an art museum, remember that the teacher and the educator are teaching partners. Teachers know their students' strengths and their limitations. They know the context into which the tour will be place within the art programme. Teachers need to discuss their expectations, teaching objectives, the concepts and skills that need to be addressed with the museum educator. Most museum education programmes will accommodate special students' needs as well. Teachers should visit the exhibition to be toured prior to the class's museum visit to ensure that the content supports the values represented by your school and community.

Self-Guided Tours

Some art museums offer tours that the teacher can lead. They can be of either standard tours or tours of temporary exhibitions. They will not, however, be taught by a museum educator. Instead, materials will be made available to teachers to enable them to teach the programme outlined. This might include written and audio/visual materials. The self-guided tour provides more flexibility for the teacher, enabling her to tailor the visit to her art programme and students' needs more closely than perhaps the guided tour would. It requires quite a bit of preparation on the teacher's part. Teachers planning a self-guided tour should plan to visit the museum before hand to familiarize themselves with the tour and to customize it as they find it necessary.

Self-Guided, Self-Directed Tour

A teacher may choose to visit a museum without the aid of a museum educator. This is appropriate when the teacher has sufficient knowledge of the work and when the art museum does not offer a pre-prepared programme that meets the needs of her art programme or the learning needs of her students. In order to develop a meaningful self-directed programme, the teacher must identify very clear learning objectives for the visit.

Open-ended wandering of the museum will accomplish very little toward evolving the students' visual literacy. First, the teacher should visit the museum herself in order to be completely familiar with the work involved. The teacher may choose to focus on a particular exhibition or on particular works in several exhibitions, depending on the concepts she wishes to teach. Next, the teacher will develop learning activities that call on different learning styles, engaging the students in research, discussion, writing, drawing and performance activities. This will provide the students with a variety of entry points to the work, it will teach them a variety of strategies for 'reading' art. Below I outline some strategies teachers can use to plan tours for their classes. The advantage of a self-directed tour is that it will fit seamlessly into your own art programme. The disadvantage is that it requires a good deal of time and commitment to develop a successful experience for your students.

Incorporating The Museum Visit Into Your Classroom Teaching

Ideally, the museum visit is a development of learning that first occurs in the classroom. Students should engage in studio, research, or other related activities that build upon the concepts explored in the museum either prior to or after the visit. Such activities will link the museum tour to the art programme at school, creating a meaningful context for the field trip. These 'pre-tour' and 'post-tour' activities weave the learning engaged in at the museum into the work in the classroom. This is why it is so important for teachers to work with the museum educator or to evolve a self-guided or self-directed tour that responds to the classroom context.

In order to make this integration effective, teachers need to be familiar with some strategies for teaching in the museum, whether you are working with an educator or developing your own tour. I will review three models that I have found useful in developing programming in the art museum. The first is a model of aesthetic development proposed by Micheal Parsons (1987). Parsons' model allows us to understand that an individual's response to a work of art is subject to their

level of development. The second is based on the research of Andrea Weltzl-Fairchild (1991) that examines the different states of aesthetic experience engaged in by viewers. It provides the understanding that viewers engage in different kinds of cognitive activities while experiencing an artwork. Finally, I will review the model of aesthetic interaction developed by Henry Birk Feldman (1981). Feldman's model is used widely by museum educators as a framework for touring. In understanding the developmental, cognitive and practical issues involved in interacting with works of art, teachers can confidently develop meaningful visits to art museums for their students.

Parson's Model

Parson's model of aesthetic development recognizes that different levels of sophistication exist in a viewer's response to a work of art. He identified five stages to aesthetic development, based within Piaget's model of cognitive development and Kohlberg's theory of moral development.

Stage one response is characterized by an egocentric approach to the work. The viewer is consumed by her own response and is unaware of the experience of others. That the experience of another might be different than her own is completely out of the question. The response is spontaneous and idiosyncratic; the viewer will happen upon the separate components of the work one at a time without understanding that each contributes to the creation of a whole.

Stage two responses seem to focus on the subject matter of the work. The work is about what is pictured, and that which is good is usually beautiful. Stage two viewers are aware that others are experiencing the work, but assume that everyone experiences the work as they do. The stage two viewer believes his perception to be the norm.

At stage three viewers understand that the subject matter points to the meaning of the work. They expect to find meaning in a work of art. They believe that meaning is derived from her subjective experience of the work. The stage three viewer is conscious that the

work is affecting her; she is able to reflect on that affect. Further, a third stage viewer is beginning to be aware that a work may affect others differently than it affects herself.

The stage four viewer becomes aware that the medium of the work plays an important role in its significance. Stage four viewers understand that the medium is "an active partner…a collaborator with the artist, having its own potential, bigger than [the artist], a sea in which she fishes" (Parson, 1987, p. 49). This viewer is aware that the success of the work depends on the artist's ability to balance virtuosity of technique with exploration of content.

At stage four the viewer becomes aware that the meaning of a work of art is also affected by the art world. The norms and expectations of the arts community become meaningful to the viewer. He can now understand that a work of art exists as part of a larger dialogue about concepts of art.

The stage five viewer is aware that art is an abstract concept; that its nature is subject to philosophical debate. This is the stage wherein the different philosophical definitions of art evolve: art as expression; art as communication; art as social arbitrator; etc. The stage five viewer will explore a given work within this philosophical context. She will explore how a work represents a given definition or functions within a certain philosophical context. The stage five viewer may affect particular philosophical attitudes to examine the work. She may view the work through a formalist, feminist, or Marxist lens. She may examine the work through each of these and compare the meanings achieved through this exercise.

What this model suggests is that an educator cannot expect a coherent theory of art from a viewer who is responding within the third stage. As with all developmental theories, Parson's model suggests teachers need to be aware of the kinds of experiences possible within a given developmental stage. Further, the teacher needs to lay the foundations for the learner to move from that stage to the next. For example, it might be expected that grade three students will be situated in the second stage of Parson's model. Therefore,

the teacher can expect that the students will engage with the subject matter of the artworks. They will believe the meaning of the work is the subject matter pictured and that everyone experiences the work in a similar fashion. Grade three students will have a more successful experience with art if it is representational, with clearly articulated subject matter that points unambiguously to its content. For example, Ken Danby's work, *At The Crease* (1972), is a carefully rendered portrait of a goalie waiting expectantly to intercept a goal. The goalie, as subject matter, is also the content. *At The Crease* is a painting about the role of the goalie in hockey. In the next developmental stage, students will be able to understand that individuals may have different responses to the work, depending on their own experience. Teachers can lay the foundation for this development by exposing students to works with the same subject matters that point to obviously different meanings. For example, David Thauberger's *Niagra Falls at Night* (c.1985) and Thomas Davies's *Niagra Falls From Above* (c.1762). Although both works take the famous falls as their subject matter, the content of each work differs significantly. The former explores the notion of tourist attractions, the latter examines the sublimity of Nature. If a grade three class is visiting an exhibition the teacher might want to plan to engage in some of the following activities:

- Draw/write about what happened just before the pictured event or what will happen in just a few moments;

- Copy the picture, but change one of the pictured elements. Describe how this changes the meaning of the picture;

- Comparing the depiction of similar subject matters in different works of art and describe how the meanings of each work differ.

Weltzl-Fairchild's Model

Andrea Weltzl-Fairchild (1991) discovered that viewers engage in different kinds of cognitive activities when viewing works of art. She found that viewers will engage in activities she characterized as *dreaming, play, metaphor and concept.*

When viewers *dream* they engage in an identification with the artwork. They associate aspects of the artwork with memories or experiences they have had. They will make statements like, "This reminds me of…" or "This makes me feel sad." While in the dream state, viewers will also make initial judgments; they will either 'like' or 'dislike' works. In order to support *dreaming* activities, teachers can provide students with activities that encourage free association. Some of these kinds of activities might include: spontaneous interpretative dance, matching a sound to the work or element of the work, creating titles for the works. Teachers can validate students' initial attraction or indifference to certain works by asking them to explore why they like or dislike the work. Students can choose a work they like very much and one they dislike. By comparing and contrasting the two works, students can explore their values, realizing that these are subjective and personal.

Viewers will also *play* with the work of art. In their imaginations, viewers will wonder how the work might look if it were different colours, if objects within the work were placed differently. They will muse about the subject matter. Viewers will compare works of art within the exhibition to one another. Teachers can encourage *playfulness* by asking students to re-create the works through drawing or collage activities that change the colours, shapes or position of elements. Students can engage in dramatic play or can compare works in a guided discussion.

When viewers begin to evolve meanings from their experiences, they are engaged in the *metaphor* state. Viewers will talk about what the piece means to them, not just what it reminds them of. Perhaps the piece reveals something new to the viewer about a feeling or a person or an object. Perhaps the viewer understands a social situation or an historical event in a new way. The viewer has discovered the metaphorical function of the work for herself. Teachers can support the evolution of metaphorical

significance through activities in which students examine prior understandings and decide whether the work they are examining has led them to any new insights. Creative writing and dramatic play are often excellent ways of supporting this metaphorical activity.

During this state viewers are also re-examining what they believe art is and what museums are. Young children who entered the exhibition believing art is painting, may leave realizing that art can also be sculpture. Sophisticated viewers may leave coming to a new appreciation of the role of art in society. An important aspect of developing visual literacy is the evolution of these aesthetic concepts. Guided discussion and reflective writing can help students engage in these dreaming activities.

When viewers end their visit they will evaluate their experience. In the *concept* state, viewers will decide how and why the entire experience has been valuable to them. This is a deeper, fuller experience than the initial impressions of like or dislike elicited in the *dream* state. Teachers can lead students through an assessment of their visit by asking them to describe how the museum visit met their expectations, what they saw that they did not expect, what new things they learned during their visit. *Concept* activities will provide the teacher with an opportunity to assess the student's learning and to plan for future experiences.

Feldman's Model

In the 1980s, Feldman purposed a systematic approach to examining works of art that helps viewers focus attention and engage in meaningful looking. Felman's model is comprised of five or six major activities: *First Impressions, Description, Analysis, Interpretation and Judgment*. Some viewers might also engage in *Research* between the analysis and interpretation activities. These six activities are characterized by different questioning strategies that a teacher can use to guide the students interaction with the work of art.

First Impressions:
- What does the work sound like?
- What is the temperature of the work?
- What adjective describes the work?
- What does the work feel like?
- How does the work make you feel?

Description:
- What colours has the artist used?
- What shapes are used? Are they organic? Geometric? Representational? Abstract? Non-objective?
- What kinds of lines do you see in the work?
- What are the real textures of the work (the ones you can feel with your hand)?
- What are the implied textures of the work (the ones the artist wants to remind you of)?
- What is the range of values present in the work?
- What is the work made of?
- Is the work two or three dimensional?
- Is the work an object or a performance?
- Does the work stay the same or does it change?

Analysis
- What are the colour relationships in the work?
- What is the heaviest part of the image? What makes it that way?
- What is the lightest part of the image? What makes it that way?
- How has the artist balanced the composition?
- How has the artist arranged the parts of the image to lead our eye from one to the next?
- What parts of the image hold our attention the longest? Why?
- Does your eye move smoothly from place to place or does it jump from one place to the next? Why?
- How has the artist handled the materials?
- Are elements repeated in the work? What patterns or rhythms are created? How?

Research
- Who is the artist? When did s/he live? What other biographical details can you discover?
- Why did the artist make this work? Was it a commission? Was it a personal choice? Was it a body of work?
- What ideas about art was the artist interested in when s/he made the work?
- What inspired the artist to make this work?
- Was this work a new direction for the artist?
- Who curated this exhibition? Why was this exhibition organized? Is this a temporary or permanent exhibition? If temporary, will it go to other museums? Where has this exhibition been?
- What do the artist, curator or critics say about this work or exhibition?

Interpretation
- What is the main content of this work?
- What are the themes explored by this work?
- What stories does this work tell?
- What does this work reveal to you about its subject matter? Its content?
- What does this work reveal to you about the medium? The technique?
- What does this work reveal to you about this kind of art?
- What does this exhibition teach you about the artist? This kind of art?
- What does this exhibition teach you about artists? Art? Museums?

Judgment
- What are the successful aspects of this work? Why?
- What are the unsuccessful aspects of this work? Why?
- Do you want to see more work by this artist? Why or Why not?
- Do you want to visit this museum again? Why or Why not? *Putting It All Together*

The three models I described address different aspects of a students experience with a work of art. How does a teacher synthesize these three different approaches into a coherent museum visit? Below is an outline that teachers can use to plan a museum visit that responds to the developmental, cognitive and practical issues involved in responding to works of art

Developmental Issues:	Dream State Activities: (First Impressions And Description)	Play State Activities: (Analysis)	Research Activities:	Metaphor State Activities: (Interpretation)	Concept State Activities: (Judgment)
Stage(s) of Aesthetic Development present in my class:	Activities to address present stage(s):	Activities to address present stage(s):	Activities to address present stage(s):	Activities to address present stage(s):	Activities to address present stage(s):
Foundational Activities for next stage(s):	Activities for next stage(s):	Activities for next stage(s):	Activities for next stage(s):	Activities for next stage(s):	Activities for next stage(s):

Using Other Community Resources to Develop Your Own Program

I suggest that the teacher collects information about all the art galleries and museums, cultural centres and cultural activities within her community. Often, we are unaware of what is available for our students because we depend upon those institutions that provide educational programming to inform us of their activities. However, there are valuable resources in both the public and private sectors that can provide our students with meaningful, real 'texts' to support visual literacy.

For instance, shops that feature the work of indigenous artists and the arts of other cultures can provide the raw materials for a field trip. These sites do not usually have formal educational programs, however, the owners of these establishments are usually very knowledgeable about the work they sell. By visiting the shop beforehand and discussing the work with the owner, the teacher can learn the background information needed to develop an educational program.

Cultural centres and associations often have collections of art representative of the cultures they promote. Again, although no formal educational programming may be provided a meeting with the administrator of the collection can provide the teacher with context appropriate to her program.

Small museums and commercial art galleries often do not have educational programming either. Again, the teacher should not be put off if the site has works of art integral to students' learning. The directors and owners will be knowledgeable about the work and can provide the teacher with background that can be developed into an appropriate program.

Developing a School Art Museum

The school library is an invaluable source of materials to support learning in all the curricular areas and to promote reading. A school art museum can be equally valuable. Real works of art can provide students with source materials for visual literacy development, but also for work in all the curricular areas. A painting can be a source of information about social history, a geography lesson or even a math class. A sculpture may provide information useful within a physical education context or a science lesson. All works of art can support the language arts curricula when students talk and write about their experiences of them.

A school that wishes to establish a 'museum' will need a dark, dry space to store the works in. Light can fade sensitive pigments and too much moisture can wreck havoc on any work of art. A storage closet fitted with shelves for three-dimensional work, racks for paintings and framed drawings and drawers for works on paper, jewelry and textile works will work well.

The school can collect original works through donations from parents, staff, or others associated with the school. Particularly fine examples of student work can be collected as well. The school does not want valuable works as students need to be able to handle them, study them, use them to learn. This is called a 'Study Collection.'

The collection should be catalogued through a simple filing system. I suggest a number be assigned to the work when it is acquired. This accession number is written in pencil or white marker on the object and is recorded on a card with a description of the work. When a teacher wants to use a work, she signs it out just as she would a library book, referring to the accession number.

A school art collection also offers students an opportunity to learn to how to organize exhibitions of art themselves, how to display the works effectively, how to create useful labels and didactic support materials. Works from the school collection could be combined with student work in an exhibition.

Concluding Remarks

Just as there is no substitute for books and other printed materials when students are learning to read, there is no substitute for the experience of real works of art when students are learning to make and view art. Each community in this country has some form of original work of art available for students to see. It may be held by a museum, a cultural centre, a private gallery or 'craft' shop. There are 'artmakers' in every community. They may be professional artists, commercial photographers, amateur artists and artisans. Parents and grandparents of students may have original works of art they are willing to share, including not only paintings and sculptures, but also textiles, jewelry, carvings, embellished home accessories. I urge teachers to find real works of art for students to work with. The benefits of the experience are worth the time it takes.

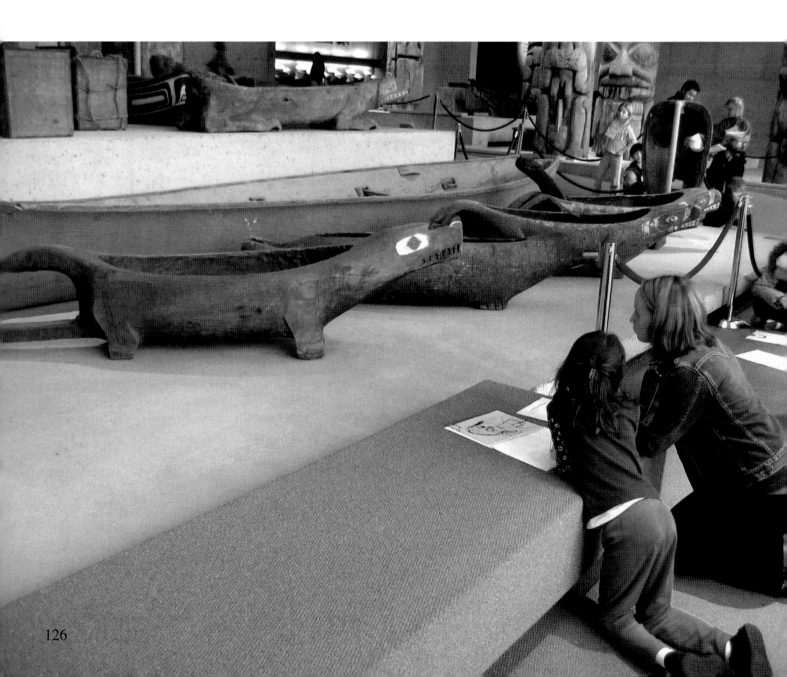

References

Bourdieu, P. (1993). *The field of cultural production: Essays on art and literature*. Randal Johnson [Editor and Introduction]. New York: Columbia University Press.

Broudy, H. (1990). Cultural literacy and general education. *Journal of Aesthetic Education, 24* (1), 7-16.

Cooper, J. D. (2000). *Literacy: Helping children construct meaning* [Fourth Edition]. Wilmington, MA: Houghton Mifflin Co
Eisner, E. (1991). *The enlightened eye: Qualitative inquiry and the enhancement of educational practice*. New York: Macmillan.

Feldman, H. (1981). *Varieties of visual experience* [Second Edition]. Englewood Cliffs, NJ: Prentice-Hall.

Gardner, H. (1985). *Frames of mind: The theory of multiple intelligences*. New York: Basic Books.

Johnson, D. & Roen, D. (Eds.). (1989). *Richness in writing: Empowering ESL students*. New York: Longman, 1989.
Parsons, M. (1987). *How we understand art: A cognitive developmental account of aesthetic*. Cambridge, GB: Cambridge University Press.

Tuman, M. (1987). *A Preface to literacy: An inquiry into pedagogy, practice, and progress*. Tuscaloosa, AL: University of Alabama Press.

Weltzl-Fairchild, A. (1991). Describing aesthetic experience: A model. *Canadian Journal of Education, 16* (3), 267-280.

CONNECTING, REFLECTING AND IMAGINING

Putting it on Show

Mary Blatherwick

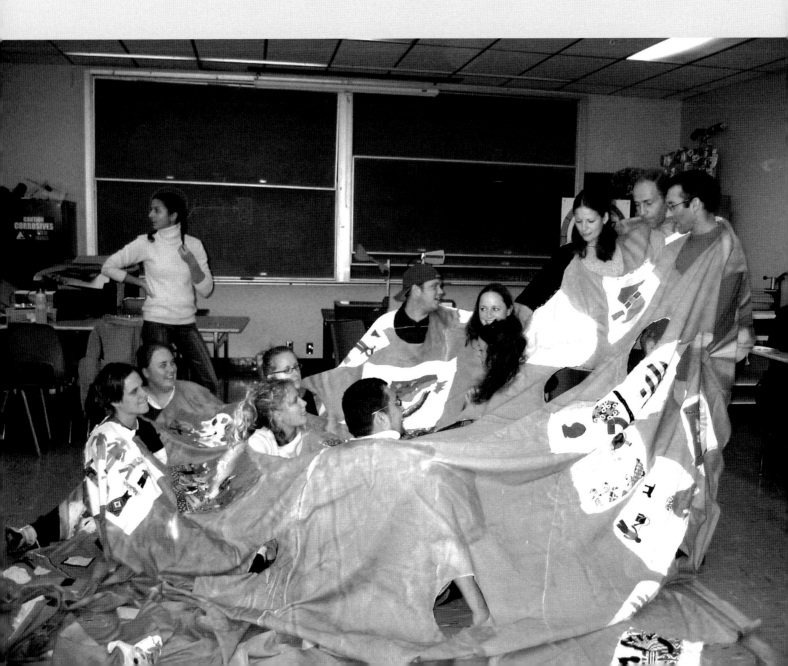

When student art is 'put on show' it sets the stage for the final and one of the most challenging aspects of the creative process. It is at this point that students have the opportunity to respond to each other's artwork and offer interpretations of what they sense and perceive. For students this event can be exhilarating but also unnerving as artwork exposes, to a certain degree, a person's inner most thoughts and feelings.

Although there has been a greater emphasis placed on the need to create more opportunities for responding to art (Barrett, 2000; Eisner,1995; Freedman, 2003; Roland, 1992; Zander, 2003), most elementary teachers still focus on art making. When work is finished, therefore, it is often displayed without discussion, placed in a portfolio for safekeeping, or sent home. As a result, the art work that students produce seldom becomes a catalyst for reflection, discussion and interpretation. Interpretation in this sense refers to responding "in thoughts, feelings and actions to what we see and experience, and to make further sense of our responses by putting them into words" (Barrett, 2000, p.7). With a greater emphasis being placed on interpretation in art programs, student art exhibitions can take on a new significance in an educational sense.

The value of 'putting work on show' is to create the opportunity for students to acknowledge their own expressive abilities and appreciate the art of others. Exhibitions of student work take place both inside and outside the classroom context. When art is presented outside of the classroom or school it can also act as a means of educating a wider audience and increasing the visibility and importance placed on student art.

Exhibitions of student art, accompanied by texts and response activities, can encourage greater interaction with viewers (Reese, 2003). When students, who create the art work, also organize and attend art exhibitions, they can stimulate discussions with other members of the school and the community. In this way student art exhibitions can become more socially and culturally relevant. According to Irwin and Kindler (1999):

> attention has been drawn in education to learning that occurs beyond the school boundaries. Understanding education in contexts broader than schooling has important implications for art education and calls for an examination of alternative venues, initiatives and strategies that facilitate artistic development, encourage aesthetic growth and promote reflection about the role and value of art in a society. (p.1)

With a growing focus on the teaching of visual culture, defined "as the objects and processes, including those created and used by students, that particularly function through visualized form to affect our lives" (Freedman, 2003, p.39), the value placed on student art exhibitions, both in a school and community context might increase significantly. Freedman comments that "from this perspective, artistic production is valued in part, because it has the power to influence, and anyone, including students, can work to initiate social and personal change through the visual culture they produce" (p.39).

For elementary teachers with little or no background in art education the idea of initiating discussions about art and encouraging students to respond to it can be overwhelming. Questions might arise for them about how to encourage students to be more observant and aware of visual detail, and in what ways can they prepare students for articulating their thoughts. Organizing exhibitions can be daunting and initiating class discussions about artwork might raise difficult questions to answer about content or meaning. Without exposure to current art education practices that address ways to exhibit art work and prepare students for the interpretative process, it is understandable that many elementary teachers focus their attention almost exclusively on art making.

Elementary teachers can prepare themselves and their students for interpreting art in exhibitions by considering how visual images convey meaning, enhancing the learning potential through explorations with art making, increasing an understanding of terminology and developing visual sensitivity. This chapter provides a brief overview of these considerations and suggests interactive approaches for interpreting and exhibiting student art in the school and community context.

Ways Images Convey Meaning

Because visual images, in their many forms, are at the heart of the creative process this chapter begins with a brief explanation of how images convey meaning. According to Messaris (1994) visual images represent the conceptions of their creators and are capable, therefore of revealing feelings, attitudes and personal experiences through various media and forms. As a mode of communication it has been noted that images share similarities

with words by conveying meaning through an understood code of symbols embodied in what is being said or visually presented (Curtiss, 1987; Dondis, 1973).

Although Arnheim (1977) connects perception with thought, he argues that there is a significant difference between these two modes of communication. He states that words reveal meaning one thought at a time whereas visual images convey layers of meaning simultaneously. The layers embodied in a visual image are not always discernable eventhough a range of interpretations exist. Art images, in particular, can be intentionally ambiguous and therefore challenge students to think in new and divergent ways. Because art images can be interpreted in numerous ways, depending upon their relevance to personal experience and cultural contexts, they present rich forms of expression for reflection. Roland (1992) explains "the purpose of reflection is to make students more aware of what they know; what is going on inside their heads; how one mental activity relates to another; and how their thinking relates to their learning" (p.34).

Visual images in all their forms can act as catalysts for reflection and discourse in the classroom setting. Student art, however embodies the personal stories and life experiences of class members, and therefore might provide a more relevant and meaningful source of images for discussion and interpretation.

Enhancing the Learning Potential

Without prior experience with art making, terminology and approaches for gaining visual sensitivity the responses students might give when responding to art work in an exhibition could be limited or superficial. Ensuring students have

previous experience with art images, both in the production and response aspects of the creative process, can also increase the appreciation they have of their own work and that of others.

Exploring Art Making

Art making represents the most central activity in the creative process. It is from the experimentation and manipulation of art materials and techniques that students begin to understand and visually articulate their inner thoughts and emotions. Understanding, in this instance, refers to the mental act of perceiving the meaning of something (Chanda & Basinger, 2000). According to Piagetian development theory elementary teachers need to be aware that children understand and think differently at certain ages or levels of intellectual development. For instance, third graders are in the concrete operational stage in which they can serialize, extend, sub-divide, differentiate, or combine existing structures into new relationships.

As a child progresses through elementary school, art making can provide a vehicle for revealing levels of awareness and understanding about self and others. Researchers in the field of artistic development (Kellogg, 1970; Kindler & Darras, 1997; Lowenfeld, 1957; Wilson & Wilson, 1982) offer different points of view on how and why children's art changes. Becoming familiar with the research on artistic development can provide a basis for determining what art materials and techniques are appropriate to introduce at certain developmental levels.

According to Bolin, once works of art are completed they become "sources for questions; issues in society and within one's self are seen as places of wonder; art making is perceived as an opportunity to wrestle with the imponderable elements of our lives and an occasion to challenge the mysteries of ourselves and our world (1996, p.10). Because art presents a particularly rich means for exploring personal thoughts and perceptions, teachers need to encourage students to express their thinking through a variety of art materials and techniques. Walker (1996) states:

Students are not only more engaged when the studio problem is personalized, but they can develop deeper understandings about the artist's creative process. If students do not have a personal investment in art making, it is difficult for them to realize why art making is about expression and not simply a technical exercise. (p.17)

It is through art making which involves:

bodily manipulations of materials, that much important learning takes

place. For as materials bring responses into focus, they simultaneously act as vehicles of reflection provoking new shades of meaning and enriching the immediate significance of the originating thought, memory, or event. (Burton, 2002, p.334)

Artwork that represents well articulated thoughts can provide rich subject matter for discussion and interpretation.

Understanding Art Terminology

According to Durant (1996) before students learn new vocabulary it is important that they use their own language in making sense of art and not terms which may be meaningless to them. She suggests they must first understand art on a basic level in terms of their own life experience. Art terminology, which describes formal qualities of art such as line, colour, and form, is also seen as important to understand but does not have to be mastered before students can respond to art work.

Graham (1990), through her research into children's picture books, found that most children need to be taught the grammar of pictures through investigative experiences in order to be able to identify, restructure and articulate, through both the visual and linguistic processes, what they have learned. Developing a fluency in the terminology of visual art is defined by Buchanan (1997) as the development of the skills necessary for eliciting and decoding meanings in art images or extracting information from them. According to Dondis (1973), in order to interpret any image it is necessary to acquire a vocabulary of terms describing basic components and compositional guidelines that govern how it was formulated. A knowledge of these terms allows for the identification, interpretation and formulation of responses.

Throughout the creative process teachers need to provide opportunities for students to examine, interact and describe the nuances of meaning embodied in visual terms such as colour, shape and line in order to fully understand and utilize them. Without experience with vocabulary students might find it difficult to articulate what they see in an artwork or want to express about it. The more familiar they are with the vocabulary of art, the more confident and articulate they can be in responding to art images.

Increasing Visual Sensitivity

Becoming more visually aware or sensitive is crucial if students are to comprehend how art images express meaning. Eyes quickly perceive what is identifiable in an art image but to observe or see on a deeper level requires spending time and looking closely for more visual information and clues. Teachers can encourage students to slow down, carefully consider the content and context of visual images and ask questions to deepen their understanding. This in-depth way of seeing instils a sense of wonder and curiosity fundamental to appreciating and understanding art.

There are several approaches teachers can take to enhance students' abilities to perceive visual details. For instance, they can create a visually stimulating classroom filled with a wide variety of art images, objects and forms thereby encouraging students to contemplate and respond to their visual surroundings. Taking students outside of the school to discover and examine visual forms in other contexts can also heighten their visual sensitivity and awareness.

Museum and art gallery educators design observation activities to help students focus on details and increase their visual sensitivity. Activities could include asking students to observe an object or form for a short period of time and then visually recall what it looks like once it is removed from sight.

Teaching upper elementary students to create contour drawings of objects and forms can also increase visual sensitivity. This drawing technique places an emphasis on eye - hand coordination, which when practised, enables students at this level, to create detailed representational drawings. This skill can be developed not only as a means of recording visual details but also to attain a level of artistic achievement which can benefit both self-esteem and confidence at this point in a students' artistic development (Edwards, 1998).

Approaches for Interpretation

Interpretation is considered a component of art criticism. In art education literature art criticism is defined as the talk, either spoken or written, about art (Geahigan, 1998). The most widely accepted approach is based on one developed by Feldman (1970) in which he proposes the use of four steps when criticizing artwork: description, analysis, interpretation and judgement. Several art educators have formulated similar steps, while others use these steps in a random order. Within visual culture the notion of following a set of steps or stages in the process of responding is often viewed as restrictive. New approaches focus on interpretation and include open-ended questioning, problem-based learning and

interactive strategies (Barrett, 1994; Durant, 1996; Freedman, 2003; Geahigan, 1998). Because students are involved in interpretation when they attend an art exhibition, gallery and museum educators in particular, develop innovative ways to engage students with artwork, and create exhibitions which reflect the new emphasis on interpretation.

Although Feldman's method also includes interpretation, these more interactive approaches have given this aspect of responding to art new importance and significance. For elementary teachers these approaches provide innovative ways to increase their students' interest and involvement in responding to artwork.

Barrett (2000) proposes encouraging students to ask questions to help them understand what they perceive, and then allowing them to express their interpretations of what they have experienced and learned. He states:
by carefully telling or writing what we see and feel and think and do when looking at a work of art, we build an understanding by articulating in language what might otherwise remain only incipient, muddled,

fragmented, and disconnected to our lives. When writing or telling about what we see and what we experience in the presence of an art work, we build meaning, we do not merely report it. (p.7)

Freedman (2002) suggests that through an inquiry approach to interpretation, where open-ended questions are encouraged, students should gain a better understanding of art from a personal and social perspective. Like Barrett she encourages the use of questions that allow students to find their own voice and express their inner thoughts and perceptions.

According to Zander (2003) classrooms should become communities of discourse. For discourse to happen however, she suggests that an open and accepting atmosphere must be established and maintained. Questions that lead to discoveries are considered particularly successful in engaging students in the interpretative process. In this approach students are given a greater opportunity to openly discuss their thoughts and reactions and teachers play a less dominant role in leading or guiding the interpretative process.

Problem-based learning approaches are used as a means of involving students in interpretation. In problem-based learning the teacher presents a problem to solve and students, usually working in groups, begin the process of finding a solution. Beyond information gathering, the students discuss and debate different notions of representation and interpretation thereby deepening their understanding of the creative process (Costantino, 2002).

Kanatani (1998) describes another approach taken in art galleries

and museums that includes open-ended questions, role-playing, improvisational activities and related sensory modes such as sound, movement, and poetry. This approach called *Contemporary Art Smart* or *CAS* encourages teachers to be innovative and spontaneously interactive with students in an exhibition setting. Instead of asking questions that lead to predetermined answers, teachers are encouraged to be receptive to the subjective responses of their students. "For students the message is that the process of observing, thinking and responding is valued over the *quick* or right solution. This acceptance of all considered reflections engenders confidence and encourages maximum participation" (p. 38). According to Kanatani, teachers note changes in their students that include an increase in their use of imagination, development of creative expression, higher self-esteem, self-confidence and keener observation skills.

These approaches for interpretation involve students in the process of looking deeply, articulating their thoughts and feelings more openly, and ultimately creating new meanings that can have personal as well as cultural significance for their lives. They offer elementary teachers choices of how to engage students in the interpretive process once their artwork is on exhibit. Whether an exhibition of student work is situated in the classroom or in some other school or community environment, these approaches for eliciting responses can be adapted for use in a variety of contexts.

Exhibiting Student Art

Exhibitions of student work can take many forms. Artwork is often hung in the classroom, in other school spaces such as libraries and hallways or public spaces in the community. When art exhibitions take place outside the classroom labels are usually mounted with the artwork providing the name and grade level of the artist. In more interactive exhibitions personal stories, additional information or questions might accompany the artwork. Students are often encouraged to take part in setting up exhibitions and invited to share their responses and interpretations with members of the community.

Whether the approach is more traditional or innovative the main objective in exhibiting student work is to honour

artistic achievements and provide a place where work can be seen, reflected on and interpreted. When exhibitions, however, are more interactive they encourage all viewers, whether they are students or members of the community, to become more engaged with the work while exploring the perceptions and realities of others.

Beetlestone (1998, p.73-74) suggests that exhibitions of student art are a vital part of the creative process because they:

- inform teaching and learning and provide children with further information;
- show that children's work is valued and enhance individual self-esteem;
- provide an audience for work to be viewed critically, developing the skills needed for appreciation;
- provide examples of aesthetically pleasing arrangements of images and artefacts;
- enable interaction so children can learn through enactive as well as iconic and symbolic modes, promoting a feeling of ownership and aesthetic discrimination;
- reflect a wide variety of styles and images presenting a culturally diverse society, and promoting positive attitudes towards diversity.

With a focus on visual culture (that encompasses a wide range of visual forms including student art work,) and new interpretative approaches incorporating the use of open-ended questioning instead of a defined path of inquiry, art exhibitions where students are able to interact and respond more freely with the art work need to be promoted. In this way exhibitions can play a more dynamic role in the creative

process. By including artwork that addresses social as well as cultural issues and offering ways for viewers to enter into a dialogue with the artwork, exhibitions might appeal to a wider and more diverse audience (Reese, 2003).

Reese also suggests expanding the size and content of exhibitions by asking students to create texts that can accompany the artwork. For instance, students might write autobiographies in which they describe how a piece of art affects them personally, socially, and historically, create stories about where art work 'transports' them or explain how other disciplines influence the creation and interpretation of the art work.

Elementary teachers can do a great deal to enhance the learning that can take place before, during and after art has been made. Each aspect of the creative process needs to be given equal consideration and be linked to the others. Planning exhibitions of student work creates an opportunity to acknowledge the abilities of students to express their thoughts and feelings through visual means. Each work of art contributes, on some level, to the experience of being human and provides an opportunity to learn about one self and others. Exhibitions of student art that encourage greater interaction also educates the public about the value and significance of student art.

In summary, this chapter provides brief overview of ways teachers can prepare their students for interpreting art in exhibitions by encouraging experimentation with art materials, learning art terminology, and increasing visual sensitivity. It outlines approaches for interpreting art and discusses ways to make exhibitions more interactive. With an emphasis on visual culture and innovative approaches for interpreting artwork, elementary teachers have more possibilities to enrich the lives of their students through the creative process

References

Arnheim, R. (1969). *Visual thinking*. Berkeley, CA: University of California Press.

Barrett, T. (1994). *Criticising art: Understanding the contemporary art*. Mountain View, CA: Mayfield.

Barrett, T. (2000). Studies invited lecture: About interpretation for art education. *Studies in Art Education, 42*(1), 5-19.

Barrett, T. (2003) Interpreting visual culture. *Art Education, 56*(2), 7-12.

Beetlestone, F. (1998). *Creative children, imagination teaching*. Buckingham, UK: Open University Press.

Bolin, P. (1996). We are what we ask. *Art Education, 49*(5), 6-10.

Buchanan, M. (1997). Reading for meaning: critical literacy. In Mason, R. (Ed.), *Reading visual texts: New directions in art education: conference proceeding* (pp. 20-30). London, UK: Centre for Educational & International Research, Roehampton Institute.

Burton, J. (2000). The configuration of meaning: Learner-centred art education revisited. *Studies in Art Education, 41*(4), 330-345.

Chanda, J. & Basinger, A. (2000). Understanding the cultural meaning of selected African Ndop statues: The use of art history constructivist inquiry methods. *Studies in Art Education, 42*(1), 67-82.

Costantino, T. (2002). Problem-based learning: A concrete approach to teaching aesthetics. *Studies in Art Education, 43*(3), 219-231.

Curtiss, D. (1987). *Introduction to visual literacy: A guide to the visual arts and communication*. Englewood Cliffs, NJ: Prentice-Hall.

Dondis, D. (1973). *A primer for visual literacy*. New York: Harcourt, Brace.

Duncum, P. (2001). Visual culture: Developments definitions and directions for art education. *Studies in Art Education, 42*(2), 101-112.

Durant, S. (1996). Reflections on museum education. *Art Education, 49*(1), 15-24.

Edwards, B. (1989). *Drawing on the right side of the brain*. Los Angeles, CA: Tarcher.

Eisner, E. (1972). *Educating artistic vision*. New York: Macmillan.

Feldman, E. B. (1970). *Becoming human through art*. Englewood Cliffs, NJ: Prentice Hall.

Freedman, K. (2003). The importance of student artistic production to teaching visual culture. *Art Education, 56*(2), 38-43.

Gardner, H. (1990). *Art education and human development*. Los Angeles, CA: The Getty Centre for Education in the Arts.

Geahigan, G. (1998). Critical inquiry: Understanding the concept and applying it in the classroom. *Art Education, 51*(5) 10-16.

Graham, J. (1990). *Pictures on the page*. London, UK: National Association for the Teaching of English.

Irwin, R.L. & Kindler, A.M. (Eds.) (1999). Art education beyond school boundaries: Identifying resources, exploring possibilities. In Irwin, R.L. & Kindler, A.M. (Eds.), *Beyond the school: Community and institutional partnerships in art education* (pp. 1-4). Reston, VA: NAEA.

Kanatani, K. (1998). Contemporary art start. *Art Education, 51*(2), 33-39.

Kellogg, R. (1970). *Analyzing children's art*. Palo Alto, CA: Mayfield.

Kindler, A. & Darras, B. (1997). Development of pictorial representation: A teleology - based model. *Journal of Art and Design Education, 16*(3), 217-222.

Lowenfeld, V. (1957). *Creative and mental growth* (3rd Ed.). New York: MacMillan.

Messaris, P. (1994). *Visual literacy: Image, mind, and reality*. Boulder, CO: Westview Press.

Reese, E. (2003). Art takes me there. *Art Education, 56*(1), 33-39.

Roland, C. (1992). Improving student thinking through elementary art instruction. In Johnson, A. (Ed.), *Art Education: Elementary* (pp. 13-42). Reston, VA: NAEA.

Walker, S. (1996). Designing studio instruction: Why have students make artwork? *Art Education, 49*(5), 11-17.

Wilson, B. & Wilson, M. (1982). *Teaching children to draw: A guide for teachers and parents*. Englewood Cliffs, NJ: Prentice Hall.

Zander, M. (2003). Talking, thinking, responding and creating: A survey on talk in art education. *Studies in Art Education, 44*(2), 117-13

CONNECTING, REFLECTING AND IMAGINING

Image Development :
The 'Mystery and the magic of
Art

Sharon McCoubrey

Defining Image

The magic and mystery of art resides in the image. Whatever materials or processes are used to make art, it is the image in the artwork that makes it distinctive and unique from any other work of art. And so, as the image carries the mystery and the magic of art, image development is a vital part of making and looking at art.

An understanding of image development is best started with an understanding of image. The term 'image' is used in many different contexts but is somewhat difficult to define. The image within artwork refers to its appearance, what it looks like. When trying to describe the appearance of a painting, a photograph, a sculpture or a video, one might refer to the colours, or perhaps the subject, style, art processes, or materials. In fact, none of these factors is an image, rather, they are all used to make an image. Perhaps, an examination of three artworks (figures 1, 2 & 3) will be helpful in defining an image. Certain factors such as materials, processes, style, subject, colour scheme, composition as well as using the design elements and principles, emotions, or special effects, could be considered when describing an artwork. All three of these artworks are mosaics that use similar colour schemes of the same subject (birds) and are stylized or simplified versions of the same artistic styles. However, figure 1 is quite different from figure 2, which is quite different from both figures 1 and 3. Each of these mosaics has a unique image as well, if one of the mosaics were reproduced, there would be a number of copies of that image, but still only one image. The interrelatedness of materials, subjects, styles, processes, purposes, or forms, is what makes it difficult to isolate an image. Although images are not limited to style, subject, or colours, these are factors used to describe images because they help define the distinctive ways images differ from one another.

When using a postmodern lens to think about art, all types of art and visual imagery would be considered: installation art, earth works, photography, performance art, conceptual art, media arts, or folk art. Further examination of the diversity of images would lead to images found within magazine advertising, interior decorating, fashion design, videos, landscaping, product design, cars, flower arranging, jewelry, fabric, wallpaper, wrapping paper, greeting cards, DC covers, book illustrations, tattoos, and many other visual features of our worlds. These images are created for many purposes: to illustrate, celebrate, advertise, give a message, provoke, adorn, challenge thinking, or to express ideas. An interesting note to remember is that the word image is found within the word imagination. An artist uses imagination to create unique images by selecting, combining, or applying the factors available to create art.

Even though we seem to deal with image and image development predominantly in the creation of art, it is also significant to deal with image and image development when viewing artworks, and when considering art in terms of art history, aesthetics, or critical analysis. As we provide opportunities for students to look at art, we need to make reference to the image, and the artists' image development decisions and processes. "The meanings of artworks can be made clearer and art appreciation can be enriched when viewers consider the strategies employed by the artist in creating or transforming images in innovative ways" (Zuk & Dalton, 1997, pp. 115-116).

With this understanding of images, it is now possible to explore image development, or in other words, the processes of creating the images found in art.

Defining Image Development

As the image is fundamental to art, image development is fundamental to creating and responding to art. Whether looking at such diverse art as carved masks of west coast First Nations artists, Abstract Expressionist paintings, or embroidered shawls from the Ukraine, all artworks consist of images created by artists.

Image development is critical yet elusive. Learning about and working with new materials, such as the latest fabric paint or learning about and applying new processes (such as non-toxic printmaking) is what generally fills art workshops and courses. Learning about image development is less common. Of course, image development processes change as materials, technologies and processes change. Monoprinting resulted from a different approach to image development than the traditional printmaking methods of etching or woodcuts. The myriad of tools available in computer graphics software lead to different image development processes than when using charcoal pencil on cartridge paper. The key to image development lies in the ways in which artists use available tools, materials, and processes to visually problem solve as they attempt to express an idea, represent a subject, portray an emotion, or present a concept. "It is the way in which ideas are translated into visual statements that is the essence of image development" (Ministry of Education Curriculum Branch, 1985, p. 28).

Art curricula varies somewhat from province to province. The Kindergarten through 12 British Columbia Art Curricula includes "Image Development" as one of four curriculum organizers, along with "Materials, Technologies and Processes," "Elements and Principles of Art and Design," and "Contexts." All the learning outcomes of the curricula are organized under these four headings. Recognizing the key role image development plays in the creation of, and responding to, art, approximately one quarter of intended learning within art courses relates to image development. Although the complexity may vary from K to grade 12, the need to be concerned with image development remains. The process of creating an image is perhaps best explored through an examination of sources and specific strategies.

Image Development Sources

As artists use materials, select processes, apply design elements and principles of art, and deal with many other factors in order to create images, their ideas for images may come from a number of different sources. Typically, the following six sources of images are used.

It is not possible to totally isolate the above sources from one another. For example, an artist may be painting an abstract image from imagination, but will be partially influenced by memories of landscape forms. Even so, one source usually dominates image development.

As teachers plan art activities for students, the source of the image should be identified. For example, if students are creating watercolour paintings about spring, or about the concept of 'belonging,' will they use their memories to create the image; create original images from their imagination; or observe a specific subject in order to create the image? Identifying the source of the image is essential to the preparation for the activity to take place.

1. *Observation*: Looking at the subject, be it a landscape, person, object or still life, before creating an image that is about the observed subject in some way.

2. *Memory*: Recalling past experiences, situations, locations and then creating images from information contained in those memories.

3. *Imagination*: Imagining and creating an entirely new image.

4. *Concepts/Ideas:* Using a specific concept, such as a social issue, as a springboard for creating an image.

5. *Sensory Experiences*: Creating images as suggested by experiences involving one or more of the senses.

6. *Feelings/Emotions*: Creating an image that emerges from the need to express emotions or respond to a feeling.

Image Development Strategies

Creating an image is often a process of editing, adjusting, reviewing, and changing before the final image is reached. As with writing, editing and refinement are important processes for image development. Artists can use a number of strategies during the creating process. The following list is not necessarily complete, as many resources and curricula will refer to various strategies and the lists will vary in number and inclusion. These strategies usually manipulate a starting image, often previously created by the artist, or some other subject or visual reference point.

1. Abstraction: To depict an idea or subject by reducing it to its basic visual properties; to depict an idea or subject with less than accurate representation.

2. Elaboration: To embellish, add pattern, detail and adornment to an image.

3. Magnification: To increase a portion of a subject or an image to larger than natural size.

4. Multiplication: To multiply parts of an image to produce a pattern or sequence in the image.

5. Reproduction: To reproduce a component of an image, altering it in some way (such as size or tone) using the reproduction in some way within the image.

6. Point of view: To depict a subject from unusual points of view, for example, a bird's eye view, an ant's point of view, eye level, aerial, profile, angled, x-ray, or through a telescope.

7. Juxtaposition: To combine two unlikely or very different elements or subjects together in an image; to create an unusual relationship or a new synthesis by placing unlike subjects together.

8. Metamorphosis: To depict objects or forms in progressive stages of growth or change in order to create new images.
9. Distortion: To bend, twist, stretch, compress, warp, melt, or deform an object or subject

10. Exaggeration: To represent some component of a subject in an exaggerated way, making that component unrealistically prominent.

11. Fragmentation: To split, fragment, insert, invert, rotate, shatter, superimpose or divide an image and then reconstruct it to create a new image.

16. Minification: Opposite of magnification: to reduce a portion of an image to a smaller size; to diminish, contract.

17. Serialization: To create a set within an image by grouping, linking, or showing progression.

18. Reversal: To reverse the laws of nature, such as the time of day, the seasons, gravity, size, age, function; to reverse components of an image, by rotating or reorienting (such as back to front or mirror image).

19. Simplification: To reduce the details of an image until it is represented in a simplified way; to eliminate, subtract, delete, remove, and erase details.

20. Superimpose: To cover, overlap, or merge some part of an image; to place one component over another component in the image.

21. Polarize To place opposites together in an image, such as beauty/beast, good/evil, life/death.

22. Substitute: To substitute a component in an image for another; to replace, exchange, switch, or swap.

23. Disguise To place almost hidden images within the image; to hide, conceal, camouflage, screen or shroud some component of the image.
24. Isolate: To separate within an image; to segregate, seclude, exclude.

25. Stylize: To simplify the subject of an image in order to achieve a stylized representation.

26. Animation: Serializing images in various stages of action in order to depict movement and progression.

Valuing Original Images

A fundamental aspect of art is the uniqueness and originality of images. Just as an author does not copy word for word the contents of a book and then publish it as a new book, visual artists do not copy another artist's image and present it as a new work of art. "Imagination and individuality are critical to successful production in art.... Individuality of outcome, not conformity to a predetermined common standard" (Eisner, 1998, p. 118) is needed.

The postmodern idea that art carries social responsibility (Albers, 1999) leads to many artists and class assignments investigating social issues, such as poverty or racism, and creating images that address the issue in some way. Once again, this way of using art to provoke reaction or to make a statement about a social issue would not be possible except through creating original images. Much of the artwork we look at from any culture, from any time, is a reflection of a life situation or a significant event. Our means of feeling the emotion of another person is communicated through images. Art must be original in order to allow for relevant and meaningful communication. "Artists are concerned with exposing aspects of reality through symbols, they are not imitators, but interpreters of reality reacting with feelings as well as thoughts" (Schinneller, 1968, p. 198).

Right answers are required for the majority of subjects taught in school. Often there is only one right answer or there is a set of expectations established for all students to reach. Fortunately, in art, a variety of answers or solutions are celebrated. Even so, there is a misconception held by some that art is only relaxing handwork using an assortment of materials. In fact, creating an original image is an extremely complex, cognitive process involving many

decisions through, often divergent rather than linear thinking. Creative thinking is intellectual. "There is no competent work of the hand that does not depend on the competent use of the mind" (Eisner, 1998, p. 23).

Creating original art results in intellectual development since "different forms of representation develop different cognitive skills" (Eisner, 1998, p. 47). Thinking skills, the essence of an educated person, are developed when creating original images. Original thinking, creative thinking, critical thinking, and problem solving are all desired and essential cognitive skills for successful learning, work, life and relationships. Every opportunity to develop and value thinking skills should be embraced by our schools.

Current practices in many schools and classrooms do not embrace such creative work by children. Unfortunately "we are far more concerned with the correct replication of what already exists than with cultivating the powers of innovation or the celebration of thinking. Perhaps a little parity among these educational goals would be appropriate" (Eisner, 1998, p. 26). Copying, tracing, and colouring stenciled pictures have nothing to do with art or education. This 'busy work' may keep their hands busy, but their thinking and feelings take time off (Gaitskell, Hurwitz & Day, 1982). School is not about busy work. School is about learning, developing, and thinking.

It is not uncommon to see elementary student art, in particular primary student art, that involves students following instructions to complete a pre-planned project. In these cases, students are not creating their own images, and as a result, are not going through the thought processes required for visual problem solving.

Unfortunately, the tremendous benefits that come from creating their own images is lost to these students. Fortunately, those non-creative projects can easily be converted into creative art activities by changing that part of the pre-planned projects that dictates what the final product is to look like, and letting students decide that part for themselves. For example, the students can use brown paper and coloured stickers to create gingerbread characters (a project that a primary teacher might want to coincide with the reading of that story) but rather than having students use a tracer to draw around in order to make the gingerbread man, let students draw their own men; rather than providing instructions for using the coloured stickers in a set way to create the face, allow students to define and decorate their own gingerbread men as they choose. Students of all ages must be allowed to create their own images. This is essential for long-term development of skills and confidence in art. This is also essential for meeting the learning outcomes of the curriculum. And, this is essential for gaining the benefits inherent in art experiences. Sometimes, pre-planned art projects are given to primary aged children because it is thought there is no choice for young children who cannot yet draw pictures or design various project themselves, and therefore, tracers and outline drawings are used. This would be a little like saying young children should not make sounds until they are able to speak. In the same way that beginning babbles lead to speaking, beginning scribbles lead to drawing and original art images. Young children's drawings and art creations are so wonderful: they are a delight that would be missed if students were not allowed to create their own images.

Art education is all about development and creativity, not about completing pre-planned projects. As Zuk and Dalton (1997) clearly state "… learning how to create and transform images for expressive purposes, should be emphasized at every opportunity in art education" (p. 119).

Developing Image Development Skills

A common misconception among teachers is that images in artworks are somehow "inspired" and magically come to the artist who then creates them. How is it possible that one can develop a skill for something that comes through inspiration? In actuality, image development is clearly a skill that can be developed. The use of various strategies, reference to existing images, manipulation of existing images, critical analysis of beginning efforts and exploration of various compositions, are all part of image development skills that can be developed.

Students who approach an art activity with reluctance, or those who stare at a blank page with anxiety, or those who say "I can't draw," will be helped tremendously with specific image development skills. They will be able to move beyond these hurdles by having a place to start, specific strategies to use, and a means to assess their efforts.

Students should be encouraged to make thoughtful decisions as they create images. This is part of skill development. Try to encourage students to clarify the idea to be represented in their image. The idea may be a straightforward record of some object, person, or place. However, the idea may be a social message or a feeling. Creators work to make their ideas known through images. The idea of the image may be made up of many interrelated parts. Students can be encouraged to create well-designed and meaningful images by stressing the need to plan ahead, think about how to put their ideas together, use the elements and principles of art to create effective images, and make their images intriguing and extraordinary (Changar, 1992).

Making working sketches of the idea is often an important part of image development. Sketches help the creator work through decision making. It helps make obvious, and therefore allow elimination of, the representations that don't work.

Teachers are able to support and facilitate students' image development skills by providing the following:

Opportunities: Provide many and varied occasions in which students are required to create images. Working with pre-drawn images, tracers, or copying images all take away such opportunities.

Encouragement: Some students need prompting and a great deal of encouragement to create their own images until they have gained confidence in their image development skills.

Acceptance: Teachers must accept the imagery that matches the age and development stage of students. The development in drawing skills and image development skills will progress only if the early efforts are accepted. "If a thing's worth doing, it's okay to do it poorly. Otherwise, you'll never give yourself permission to be a beginner at a new activity" (von Oech, 1990, p. 146).

Positive Feedback: Teachers must appropriately respond to student's

early efforts so that they will be encouraged to continue and their confidence can be built.

Enthusiasm: Students learn through modeling and will become enthusiastic about creating their own images when the teacher values art, is enthusiastic about students art.

Guidance: As students progress, particularly when they want to draw realistically, suggestions and specific instruction may be needed to help students progress with their image development skills.

Variety: Providing students with a great deal of variety of art processes, subjects and challenges will address their varying interests and preferences, and thereby provide essential motivation.

Motivation/Preparation: The challenge and anxiety of facing a blank page, of thinking of what to create, will be minimized when the teacher provides some image development preparation, such as key questions to trigger memories, or visual references for observed subjects, or intriguing scenarios for creating through imagination.

Some Activities to Strengthen Working with Images

The following suggested activities can be helpful explorations with image development for teachers and their students.

- Each person is given an assortment of coloured shapes of paper, varying shapes, sizes and colours, but the same set for each individual. Working on a blank piece of paper, arrange the paper pieces to create a picture, a composition, a design. Compare each other's images. Discuss the multitude of possible variations. Refer to the elements and principles of art and design in order to create new compositions by changing the paper pieces to create specific effects, such as a center of interest, formal balance, or movement.
- Use a viewfinder to select an image in one's environment or in another visual image, such as a landscape, at a still life arrangement. Move the viewfinder over the original image to find new, yet smaller images. Consider moving the viewfinder closer or farther away from the image in order to change the impact.
- Search magazines for pictures of jewelry before examining the range of images. Choosing one form of jewelry, such as a ring, watch, lapel pin, necklace, pendant, earrings, bracelet or hair barrette, design a new piece of the chosen type of jewelry to suit a particular generation, era, or style.
- Each student works with one of the many possible image development strategies, selected by drawing names from a hat. Students work with selected images while creating a new image by manipulating the starting image using the particular strategy.

Image Development Activities for Students

Art education involves students creating personally meaningful images. In order to provide art activities that result in personally meaningful images, students need to be given topics or challenges that require thinking as they develop their unique images. The following list provides some examples:

- Have students do a drawing or painting of this topic: "The police are coming! They are …!" Imagine what students in a class might choose to do with this topic, their varying experiences with this topic, and the kinds of events for which they might imagine the police attending.
- Ask students to recall their own experiences related to a variety of topics, before creating images from those experiences, such as the most frightening thing to me would be…; my favourite movie is…; if I could invite a famous person for dinner in would be…; my hero is…
- Provide opportunities for students to discuss, research, and then create images related to social issues, such as poverty, the environment, loneliness, or racism.
- Students give their personal interpretations for topics such as my best adventure, my ideal house,

my favourite alien friend, or my innovative vehicle.
- In a similar way, have students think about and create images from the following topics:
o Someone who is sad, and why.
o A group of people each with something different in their hands.
o People in a circle.
o People gathered but each having arrived by different means.
o A memory of cats.
o What I saw when I reached the top of the mountain.
o The strangest person I have ever seen.

Motivating for Image Development

For many students, having to create a work of art from a blank piece of paper or a pile of raw materials is an intimidating and daunting task, enough so that many are reluctant to start, and many are unhappy with what they put down. Teachers need to stimulate student's imagination to the point where they can't wait to get their hands on the materials. A major responsibility teachers have is to help students over the 'blank page' hurdle by providing experiences, inspirations, and challenges that assist the students in the creation of ideas. Some of the ways in which teachers can provide pre-image development preparation to 'fire up' student's imaginations include:
- Tell a story without showing illustrations. Students can then illustrate some aspect of the story, or create an entirely new image. The same could be done with poems, plays, and other literary work.
- The lyrics of some songs may provide a starting point for creating an image. An instrumental piece of music could also stimulate image development.
- Experiences provide great material for image development. Sometimes teachers are able to provide such experiences through field trips, special quests in the classroom, or a variety of special activities.
- Movies, pictures, films and a host of other pictoral resources may provide the basis of an image.
- Characters, whether actual people, pets, wild animals, alien creatures or any host of imaginary characters, could be represented in images.
- Collaborative image development can be an effective alternative to individual art making.
- Challenge students to create an image that shows what the characters in a chosen painting are looking at.
- Some of the preparation for image development might include a brainstorming and discussion session related to a specific topic.
- The materials or the art processes themselves might trigger ideas for creating images. Intuitive, unplanned creating may be an appropriate challenge at times. Simply working with the chosen materials and techniques to start with something, respond to the start, add to and alter until an image.
- The use of visual reference may be helpful to the students' image development. The visual reference might include photographs taken of the subject, looking directly at the subject, or more subtle influence from other artworks. Rather than directly copying the other artwork or the photograph from a magazine, the student refers to them in order to get the required visual information needed to complete a new image.
- Visualization can be prompted by providing descriptive scenarios and action.
Students' image development will be greatly facilitated and will result in richer final images when teachers provide pre-image development preparation.

Conclusion

Teachers have the opportunity to take the mystery out of image development for their students while opening up to the magic within art. Working directly with learning outcomes related to image development, planning for the image development stage of their art activities, providing opportunities for students to create their own creative images, facilitating image development skills, and providing pre-image development preparation, are all ways in which teachers can nurture their students' creativity.

References

Albers, P. (1999). Art education and the possibility of social change. *Art Education*, 52(4), 6-11.

Changar, J. (1992). *"Time…Pieces" Curriculum Resource Packet*. St. Louis, MO: Craft Alliance.

Collier, G. (1972). *Art and the creative consciousness*. Englewood Cliffs, NJ: Prentice-Hall.

Eadie, M. (1999). Image development and design strategies. BCATA Journal for Art Teachers, 39(2), 10-17.

Eisner, E. (1998). *The kind of schools we need*. Portsmouth, NH: Heinemann Press.

Eisner, E. (2002). *The arts and the creation of mind*. New Haven, CN: University Press.

Gaitskell, C., Hurwitz, A., & Day, M. (1982). *Children and their art, methods for the elementary school*. New York: Harcourt Brace Jovanovich.

Ministry of Education, (1985), *Elementary Fine Arts Curriculum Guide/Resource Book*, Victoria, BC, Curriculum Branch.

Roukes, N. (1982). *Art synectics, stimulating creativity in art*. Worcester, MA: Davis Publications.

Roukes, N. (1988). *Design synectics, stimulating creativity in design*. Worcester, MA: Davis Publications.

Shadbolt, J. (1968). *In search of form*. Toronto, ON: McClelland and Stewart.

Schinneller, J. (1968). *Art search and self-discovery*. Scranton, PE: International Textbook.

Von Oech, R. (1990). *A whack on the side of the head*. Menlo Park, CA: Warner Books.

Zuk, B., Dalton, B. (1997). Expanding our vision of image development. In Irwin, R. L., & Grauer, K. (Eds.), Readings in *Canadian art teacher education* (pp. 115-124). Boucherville, QC: Canadian Society for Education through Art.

CONNECTING, REFLECTING AND IMAGINING

Assessment of others and ourselves continually takes place. When meeting someone, we interpret our mood. Everything about how others speak, dress, behave, and what they say provides us with information as to how we might respond. Small nuances such as warmth in the tone of voice, or not making eye contact, provide us with clues.

Assessment is one of *the* most significant educational issues today. Assessment has emerged on the Canadian political stage with some provincial governments demanding teachers be more accountable: that is, teach more content and assess more rigorously. But there is the perception among parents, teachers, perhaps even you, that art is difficult to assess because it is a 'soft' subject. Problems associated with assessing art are:
•the *subjective judgement* of the assessor(s)
•the *qualitative nature* of art itself
•the problem of *method*, that is how to assess art?

Subjective Judgements and the Qualitative Nature of Art

Assessment is considered difficult to accomplish in art because of the qualitative nature of the subject. How can we grade something as ephemeral as a child's creative expression? This is a valid question. It is unfair when a child produces a piece of creative work -- say a drawing of a cat, and John gets a 'C' while Susie gets an 'A' with no other information from the teacher as to why that grade was assigned. Ash, Schofield, and Starkey (2000) state that "for many Art and Design teachers the idea of examining art work runs counter to a long-held philosophy and imbued

ideas about the nature of creativity, self-expression, and the idiosyncratic nature of Art and Design and making. Many will say you cannot assess art, it is to do with subjective opinion, it is creative" (p.145). Not being able to resolve this problem easily, and being expected to assign a grade for art, many teachers have simply relied on their own subjective opinions. However, those arguing against assessment in art would assert that the interpretation of value is so entirely subjectively mediated and defined, that any assessment in art is necessarily flawed. Best (1980) illustrates an extremist's interpretation of this view:

> ...subjectivists rarely recognise the inherent difficulties in their own position…. A dance professor, who is a convinced subjectivist, commendably recognised that it is a consequence of such a position that anyone's opinion is as good as anyone else's. Hence she was unable to raise any objection when some of her students, as their 'dance performance,' simply sat on the floor of the studio eating crisps. Despite her admirable honesty she lost her job. (p.36)

If sitting on the floor eating crisps is unacceptable, then there exists a socially and culturally defined conception of what is acceptable: What counts as art or art production is defined socio-culturally. Csikszentmihalyi (1996) explains:

> No matter how much we admire the personal insight, the subjective illumination, we cannot tell whether it is a delusion or a creative thought unless we adopt some criterion–of logic, beauty, or usefulness–and the moment we do so, we introduce a

social or cultural evaluation. Hence I was led to develop the systemic perspective on creativity, which relocates the creative process outside the individual mind (italics added). (p.403)

Cultures worldwide confer artistic merit based on socio-cultural values, beliefs, and appreciation; as Wolff (1981) asserts, art is produced in a socialized context. The same is true for the subculture of teaching and the school. If art is produced and valued within socio-cultural contexts, we must, as Csikszentmihalyi posits, necessarily adopt socio-culturally defined criteria for determining what is unacceptable, what is better, and what is best.

Learning about art and assessment in the school context is defined by socio-cultural norms and expectations. There is an important difference between valuing art and assessing art in the school setting. This is because teachers need to be concerned primarily with making educational rather than artistic judgements.

Assessing Art Qualitatively

As a teacher, you will most likely have to assess students in art. I am not talking about liking or disliking the work produced, I mean considering what educational qualities you believe to be important; thinking clearly about what you aim to teach, what you expect your students to learn, and then turning those expectations into criteria for assessment of a process or product. Thus, assessment involves delineating expectations for what and how your students will engage in learning about art and design, and a range of standards (or levels of achievement) they might attain in relation to your expectations of them. As well, assessment involves deciding

what kind of student work will best reveal the learning process. This work may be product, as well as process, or work habit based. In making educational judgements, the multiplicity of variables to be assessed might include "high standards of work; a continuous working process; an independent and responsible attitude; self assessment and evaluation" (Clements, 1986, p.239). In short, the best qualitative alternative to (indefensible) subjective judgement or simply giving a grade to a piece of artwork based on whether you like it or not is qualitative assessment by using criterion-referencing.

Criterion referencing refers to the delineation of criteria for assessment. In order to ensure content validity, you need to assess what was taught. In other words, criteria must reflect lesson expectations. Through defining criteria one can assess specifics such as understanding concepts, the work produced, work habits, skills and techniques, and classroom dialogue. Criterion referencing means that in assessing many variables, the teacher goes much further and beyond a subjective judgment on creative expression alone.

In criterion referencing each child is assessed individually: Susie's work is assessed in terms of the criteria for assessment. Thus, Susie is not compared with John, as in norm referencing where students are compared with one another competitively and in relation to bell curve norms. Rather, in criterion referencing, Susie is assessed in terms of her individual work habits, work produced, and personal potential.

Assessment can be undertaken formally, at the conclusion of a thematic project. This is known as summative assessment. Assessment undertaken formally or informally on an ongoing basis is known as formative assessment.

Essential to the assessment of art in schools is the need for dialogue based shared understandings of expectations and criteria for assessment, which will occur through conversations and art critiques between individual students and the teacher, and discussions with the whole class. This approach will facilitate students' abilities to self and peer assess, and to become reflective learners.

An important aspect of assessment in art is building up individual student portfolios of visual and written work. This activity should result in adequate bodies of material to assess, and to discuss with parents and students. Portfolios can and should include written reflective material, sketch books, and research materials.

A portfolio is a focused collection of pieces of visual art, often accompanied by reflective and explanatory written data. The contents of the portfolio and the time frame for production are specified or negotiated between teacher and students. Krueger and Wallace (1996) hold that a portfolio is:

> constructed according to an explicit purpose. This purpose provides students with a focus for the collection and organization of the evidence, informs them about what they are expected to learn, the types of evidence they can marshal as support for their learning and how they will be assessed…. A major decision relating to the purpose of a portfolio is whether it will contain students' best pieces of work or whether it will be developmental. (p.26)

There is strong support in the literature on assessment in art education for qualitative assessment of art utilizing portfolios as a significant element of formative or summative assessment, with reference to specific criteria and clearly delineated levels of achievement (Beattie, 1994, 1997; Blaikie, 1997; Boughton, 1994; Eisner, 1985; International Baccalaureate, 2000; Schonau, 1994; Steers, 1994). However, there are many ways to apply criteria.

Comparison of Curricular Approaches to Assessment and Evaluation in Ontario, British Columbia, and Nova Scotia

Barrett (1990) defines assessment as a judgement of a process or product set within a spectrum of explicitly stated criteria. Allison (1986) asserts that assessment and evaluation differ because assessment "is one of the factors upon which evaluations can be made" (p.115). Beattie's (1997) view, as well as definitions in the British Columbia Fine Arts K-7 Curriculum Guide (1998) are similar to Allison's. Beattie states that "assessment is the method or process used for gathering information about people, programs, or objects for the purpose of making an evaluation" (p.2). In an earlier publication (1997) I wrote that:

evaluation tends to be more holistic-one tends to be looking at an overall impression in evaluating; searching out themes, metaphors, patterns and general trends. With reference to criteria for assessment, assessment is specific in its focus on very particular aspects of a student's work and work habits, even though an overall grade or percentage may be the final result. (p.193)

In assessment the teacher is charged with being specific in regard to individual criteria during the lesson, as well as while providing feedback. Accountability is at issue here, as well as the teacher's ability to explain and defend grading decisions to school administration,

students, and parents. If a teacher were being asked to evaluate, s/he might assign a 'C' grade to Jane's drawing of a cat, based on an overall impression of it. But Ministries, Boards of Education, and principals require more data than this. Even when the term used is 'evaluation,' you will be expected to provide detailed information to illustrate how you came to a final grade.

In short, assessment refers to an approach in which greater external control exists, as teachers are expected or required to follow curricular expectations and criteria. In evaluation, control is internal, and rests more with individual teachers. Ideally in both approaches teachers function as respected professionals making informed educational judgements about learning in art.

Ontario

In Ontario, the term assessment is used exclusively in the Ontario Curriculum Grades 1 to 8: The Arts (1998). Teachers are expected to look at specific aspects of learning, rather than making global 'general impression' based judgements. Greater control of teachers and teaching as well as curricular and procedural rigidity are indicated. Specific curriculum content areas and related expectations for learning are organized as follows:

Knowledge of Elements or content knowledge (for example, the elements and principles of design, art history, and so on)

Creative Work or studio work (including drawing, painting, printmaking, three dimensional work)

Critical Thinking or responding to art (including art criticism utilising analysis and interpretation)

The four achievement levels outlined (p.9) are to be used "along with more traditional indicators like letter grades and percentage marks, (and) are among a number of tools that teachers will use to assess students' learning" (p.4). Level three which is the "provincial standard, identifies a high level of achievement of the provincial expectations" (p.4). Level one refers to students not meeting the provincial standard, level two refers to students almost meeting it, and level four refers to students exceeding the provincial standard.

The three curriculum content areas, Knowledge of Elements, Creative Work, and Critical Thinking, translate directly into criteria for assessment in the rubric provided, with descriptors in relation to each criterion and the four achievement levels (p.9). To illustrate how this works, an example of a unit plan for Ontario follows. The unit plan is for grade one students,1 and focuses on exploring the art of Roy Thomas, specifically his painting, Spirit of Anishnabe Art, in which primary colours, shape, and line are examined, along with the meaning of the image.

 Very brief expectations in relation to each curriculum content area are defined as follows:

Knowledge of Elements
•Students will learn about and use primary colours, shape, and line.
•Students will learn about the work of Roy Thomas, by analysing and interpreting meaning in Spirit of Anishnabe Art.

Critical Thinking
•Students will engage in Formal Analysis (description, analysis and interpretation) of Spirit of Anishnabe Art.

Creative Work
•Students will paint animals, birds, or fish using only primary colours, shape, line.
•Students will create a stuffed painted sculpture of an animal, bird or fish using shape, line, and primary colours.
•Students will respect art materials.
•Students will cooperate during clean-up time.

The Unit Plan

Lessons 1/2: Formal Analysis of Spirit of Anishnabe Art focusing on recognizing the use of primary colours, shape, and the use of line. We will conclude by discussing the meaning of the painting for each of us, as well as its cultural significance.

Lesson 3/4: Painting of birds or fish using primary colours, shapes, and lines.

Lesson 5/6: Create a stuffed painted sculpture of a bird or fish emphasising the use of shapes, lines, and primary colours.

Lesson 7: Review and reflection: Students tell one thing they liked best about one of the artworks they produced, and one thing they found difficult. An example of a criterion referenced rubric follows.

Criterion-Referenced Rubric for Knowledge of Elements

Knowledge of Elements (Understanding of concepts)	Level 1	Level 2	Level 3	Level 4
The student: - recognizes and understands the concept of primary colours	-shows understanding of few of the concepts	-shows understanding of some of the concepts sometimes	-shows understanding of most of the concepts	-shows understanding of all (or almost all) of the concepts
- identifies and understands the concept of shape	-rarely gives explanations that show understanding of the concepts	gives complete explanations	-usually gives complete or nearly complete explanations	-consistently gives complete explanations
-identifies and understands the concept of line				

Expectations have become criteria for assessment. Each criterion is assessed in terms of adjectives which describe levels of achievement (levels 1 to 4). These levels of achievement are termed anecdotal or qualitative, because they provide more descriptive information to parents and students.

It should be noted that the approach in Ontario is assessment based and provides limited information to parents on work habits or process-based art learning, and focuses heavily on understanding concepts, ability to engage in talk about art, and the quality of final art products.

British Columbia

In the British Columbia Curriculum Guide Fine Arts K-7 (1998) both terms, assessment and evaluation, are used. Four curriculum content areas are defined as:

1. Image-development and design strategies, perceiving and responding as well as creating and communicating are components of all four content areas;
2. Context;
3. Visual elements and principles of art and design; and
4. Materials, technologies and processes.

The curriculum guide provides examples of approaches to assessing student work, based on examples of unit plans. For example, in a grade 7 unit on self portraits, students are expected to do the following:

• view and discuss self portraits by other artists; examining the use of materials, elements and principles of design, and interpreting mood in each image;

- paint self portraits, including symbols, items of personal significance, and "selected use of colour to contribute to the characterization and to develop mood" (p.6), as well as experiment with using different materials to paint, including neutrals, tonal contrasts, as well as complementary colours;
- create a "personal web chart of interests, hobbies, friends, concerns, and hopes," in order to convey a sense of 'Who I Am' to the viewer" (p.6);
- paint using "one colour to convey mood" as well as neutrals, complementaries, and a variety of "brushstrokes and paint application tools to add texture and details" (p.6);
- engage in "reflection time" during painting sessions in which they discuss their paintings with a partner, who provides "constructive criticism" (p.6);
- sign and matt their works their works;
- write an artist's statement including reasons for colour choices, style idea, and using particular symbols (p.6); and
- curate a show of their works and create a catalogue of artists' statements.

Criteria for assessing and evaluating student performance are not defined explicitly in relation to the curriculum content areas: Image Development and Design Strategies, Context, Visual Elements and Principles of Art and Design and Materials, Technologies and Process. Rather, they are defined in relation to criteria created specifically for this particular project:
- self portrait
- contribution to art show
- artist's statement

A rating of 'C+' in relation to the criterion 'self portrait' is defined similarly to a level of achievement in the Ontario curriculum guide, but more variables are considered here (character, mood, technique, use of elements and principles of design): May show some inconsistencies. Some features are effective, but there may be problems in another area (e.g., colour may not convey mood; the brushstrokes and paint application may not offer variations in texture). Conveys some sense of character. Tends to reflect 'safe' choices in technique and subject matter. (p.4)

Overall, in British Columbia the strategy seems to be closer to evaluation than assessment in that there does not exist a direct connection between curriculum content areas and related expectations and criteria for assessment/evaluation. Teachers are expected to use their "insight, knowledge about learning, and experience with students, along with criteria they establish, to make judgements about student performance in relation to learning outcomes" (p.1). For the teacher, it seems that one's professional opinion in gaining an overall general impression is important, and seems to count for more than the delineation of specifics, such as how much knowledge a student might have of a very particular aspect of art theory.

Nova Scotia

In the curriculum guide for Nova Scotia Visual Arts Primary-6 (2000) both terms, assessment and evaluation, are used interchangeably. Three curricular areas are outlined:

1. Creative/Productive-Making
2. Cultural/Historical-Looking
3. Critical/Responsive-Reflecting

Several assessment strategies are suggested: collecting portfolios, learning logs and sketch journals; peer feedback through group discussion; performance assessment; student-teacher conversations; questionnaires and surveys, anecdotal records; checklists, observations and questioning (pp.95-97). Sample assessment questionnaires and rubrics are included. As in British Columbia, they do not relate specifically to the curriculum content areas defined above, but rather, the curriculum content areas are infused within each unit or lesson plan. For example, for a dream catcher's studio exercise (no grade level defined) students are asked to complete a checklist which includes questions such as:

1. I enjoyed (did not enjoy) making the dream catcher because....
2. The part I found most difficult was....
3. I was successful in completing the web design resulting in an exact pattern. (Yes or No).
4. Two things I learned about dream catchers are.... (p.99)

In peer assessment activities of overlapping line designs (p.104), the approach leans toward assessment rather than evaluation, as very specific questions are delineated and levels of achievement are defined. Again, there is no evidence of criteria defined in relation to the three curriculum content areas, Creative/Productive, Cultural/Historical, and Critical/Responsive. Rather links to the curriculum content areas are implied.

Overall though, an evaluation based approach is more evident in the Nova Scotia Guide, Visual Arts Primary - 6 (2000): "Evaluation should be based on the range of learning outcomes addressed throughout the year and should focus on general patterns of achievement in learning in and through the arts, rather than on single instances, in order that judgements be balanced" (p.93).

Conclusion

This chapter began by asserting that assessment goes on all the time, in every aspect of our lives. Three problems were delineated with assessing art in schools: making subjective judgements, the qualitative nature of art, and the problem of method or how to assess art. I defined art as socio-culturally produced. Judgements about art are linked to socio-cultural conceptions and values. I argued that in teaching art we must be concerned primarily with making educational rather than artistic judgements.

I asserted that assessment is specific and looks at particular defined aspects of learning related to specified criteria. Curriculum content areas and related learning expectations are represented in criteria for assessment. Evaluation is related more to a holistic overall impression. Often, evaluation is based on a generalized judgement derived from an initial assessment of learning. In assessment there tends to exist greater external control over teachers, while in evaluation teachers have more internal grassroots control.

In examining three curriculum guides, Ontario, British Columbia, and Nova Scotia, I compared approaches to defined curriculum content areas, assessment and evaluation (See below for summary).

Comparison of Approaches to Curriculum and Assessment in Nova Scotia, Ontario, and British Columbia

	Nova Scotia	*Ontario*	*British Columbia*
Making Art	Creative/Productive	Creative Work	Image Development and Design; Materials, Techniques and Processes; Creating and Communicating; Perceiving and Responding
Theories of/Learning About Art	Cultural/Historical	Knowledge of Elements	Elements and Principles of Design; Context; Creating and Communicating; Perceiving and Responding
Reflecting Responding Art Criticism	Critical/Responsive	Critical Thinking	Creating and Communicating; Perceiving and Responding
Assessment and Evaluation Approaches	Assessment and evaluation; evaluation dominates; criteria for assessment not related explicitly to curriculum content areas defined above	Assessment dominates; criteria related to curriculum content areas defined above	Assessment and evaluation; evaluation dominates; criteria for assessment not related explicitly to curriculum content areas defined above

Similarities between the provinces lie in definitions of curriculum content: Each identifies studio production, (creative work or image development) as a specific area of curricular focus. Theories of art or concepts are defined as well, although in Nova Scotia the focus is on the historical/cultural, while in British Columbia and Ontario historical and contextual studies are combined with a focus on elements and principles of design. All three include a curricular component focusing on art criticism or responding to art. In British Columbia "perceiving and responding" is a sub theme of all four curriculum content areas.

In Ontario, assessment is linked specifically to the three defined curriculum content areas. Overall levels of achievement are outlined, with an emphasis on criterion referenced assessment of finished products. In British Columbia and Nova Scotia, assessment is not linked explicitly to defined curriculum content areas. Rather, links are implied within new criteria defined for each project. Although both terms, assessment and evaluation, are used, the teacher's overall evaluative impression seems to dominate in British Columbia and Nova Scotia.

Finally, effective assessment and evaluation of learning in art is dependent on the following principles: Teachers need to determine what it is they value about teaching art. What aspects of art learning are most important, and how do these relate to provincial curriculum guidelines? Next, goals for art learning based on curriculum guide expectations (as well as one's own) need to be defined for, or with students, along with related criteria for assessment. It is important also to define at least three levels of achievement, for example ranging from 'needs improvement' through to 'good.'

It is imperative that there exists between teachers and students shared dialogue based understanding of expectations and criteria for assessment. Teachers may utilize portfolios, reflective journals, sketch books, learning logs, and so on, in order to assess both final products as well as ideas and works in process/progress.

Art critiques in which constructive thoughtful responses are encouraged will facilitate self and peer assessment, and reflection. The development of good oral and written skills in responding to art will bring forth enhanced understanding of all aspects of learning in art, providing linkages between theory, studio work, and critical reflection. Reflective self assessment is the ultimate goal of assessment and evaluation, and is achievable when it is based on socio-culturally and communally defined conceptions of value, creativity, and what counts as good work in learning about art.

References

Allison, B. (1986). Some aspects of assessment in art and design education. In Ross, M. (Ed.) *Assessment in arts education* (pp. 113-133). Oxford, UK: Pergamon Press.

Ash, A., Schofield, K., & Starkey, A. (2000). Assessment and Examinations in Art and Design. In Addison, N. & Burgess, L. (Eds.), *Learning to teach art and design in the secondary school* (pp. 134-162). London, UK: Routledge Falmer.

Barrett, M. (1990). Guidelines for evaluation and assessment in art and design education 5 - 18 years. *Journal of Art and Design Education*, 9(3), 299-313.

Beattie, D. K. (1997). *Assessment in art education.* Worcester, MA: Davis Publications.

Beattie, D. K. (1994). The mini-portfolio: Locus of a successful performance examination. *Art Education*, 47(2), 14-18.

Best, D. (1980). Accountability: Objective assessment in arts education. In Smith, R. & Best, D. (Eds.), *The function and assessment of art in education* (pp. 27-58). Leeds, UK: Association of Art Advisors: Leeds City Council Department of Education, Printed Resource Unit.

Blaikie, F. M. (1997). Strategies for studio art assessment in Canada: Lana, Brenda, Sharon and Mark. In Irwin, R. L., & Grauer, K. (Eds.), *Readings in Canadian art teacher education* (pp. 193-212). Toronto, ON: Canadian Society for Education through Art.

Blaikie, F. M. & Clark, J. (2000). *Art kits including lesson plans and visual resources for Thunder Bay's elementary schools, grades 1-8.* Thunder Bay, ON: Lakehead University.

Boughton, D. (1994). *Evaluation and assessment in visual arts education.* Selong, Victoria, Australia: Deakin University Press.

British Columbia Ministry of Education. (1998). *Fine Arts K - 7.* Victoria, BC: The Queen's Printer for British Columbia, or at .

Clement, R. (1986). *The art teacher's handbook.* Avon, UK: The Bath Press.

Csikszentmihalyi, M. (1996). *Creativity: Flow and the psychology of discovery and invention.* New York: Harper Collins.

Eisner, E., (1985). *The art of educational evaluation: A personal view.* Philadelphia, PN: The Falmer Press.

International Baccalaureate Organization. (2000). *Diploma programme visual arts guide.* Geneva, Switzerland: International Baccaluareate Organization.

Krueger, B., & Wallace, J. (1996). Portfolio assessment: Possibilities and pointers for practice. *Australian Science Teachers' Journal*, 42(1), 26-29.

Nova Scotia Department of Education. (2000). *Visual Arts Primary - 6.* Halifax, NS: Department of Education.

Ontario Ministry of Education and Training. (1998). *The Ontario Curriculum Grades 1 - 8: The Arts.* Toronto, ON: The Queen's Printer for Ontario, or at

Schonau, D. (1994). Final examinations in the visual arts in the Netherlands. *Art Education*, 47(2), 34-49.

Steers, J. (1994). Art and Design: Assessment and Public Examinations. JOURNAL OF ART AND DESIGN EDUCATION, 13(3), 287-298.

Wolff, J. (1981). *The Social production of art.* New York: New York University Press.

(Footnotes)

1 This unit plan idea is taken from Art Kits (Blaikie & Clark, 2000) developed for grades one to eight for schools in the Thunder Bay region. Roy Thomas is one of sixteen artists who participated in this project.

CONNECTING, REFLECTING AND IMAGINING

Don't Run With the Scissors

Nadine Kalin

"Are there art materials I should avoid?" "How is classroom management different for an art activity?" These are questions pre-service teachers ask in anticipation of tackling two of the challenges associated with good art instruction, that of management and safety. When teaching art there are indeed specific issues which teachers need to address in order to provide safe working conditions. This chapter outlines how to address in order to provide a safe and secure environment during art activities. Topics covered include: classroom management techniques for art activities, alternatives to potentially hazardous art materials, use of appropriate products for elementary-aged children, as well as adequate instruction in the use of tools and handling of art materials.

Classroom Management

Behaviour management confronts every teacher. There are no easy solutions to gaining students' cooperation and running an orderly classroom. What works well in one classroom may not be effective for another teacher, because management style reflects the individual teacher's preferences and values in relation to the students and overall educational goals (Susi, 1996). It is only through testing methods with particular students during specific activities that teachers begin to develop a repertoire of strategies that can be adapted to different situations. Some of the suggestions contained in this chapter may work for you while others may not, nonetheless, becoming familiar with options for managing student behaviour is helpful for building your own strategies.

Discipline and Art Activities

Susi (1995) defines effective discipline as "an outcome that results from an artful combination of instructional and interpersonal practices which serve to focus student attention on positive and productive educational activities" (p. 6). Most of what is written in the area of discipline examines classrooms where academic tasks are predictable and routine. Learning in art involves distinct physical and intellectual activities associated with various forms of studio production and response to artworks. While these endeavours can be multi-faceted and complex, you still need to establish an atmosphere in which art can be created safely and confidently within the classroom. Reviewing the points made in this chapter can assist teachers in developing, refining, and expanding their discipline strategies while undertaking art activities with their students.

Student - Teacher Relationships

Teachers themselves have the responsibility to build what Belvel and Jordan (2003) have called the "foundations for positive student-teacher relationships" in order to setup an environment of physical and emotional security that supports learning and risk taking. Positive interactions between teacher and student, as well as among students, requires teachers to:

- Establish a sense of security through consistently dealing with students in a fair and balanced way using persuasion rather than power or threat to solve problems.
- Set up parameters for class interaction and limits on behaviour.

- Allow students adequate time and instruction so that they can have the opportunity to develop a sense of competence in particular art activities.
- Provide immediate and meaningful feedback during the formative stages of learning so that students know what they can do well and how they can improve.
- Strive for a sense of connectedness within the class.
- Show respect for individual differences across cultures, religions, learning styles, race, gender, and thinking by using activities, language, and visuals that support student diversity.
- Develop a feeling of belonging by letting students collaborate and bond with a variety of peers under various circumstances.
- Focus on the positive and build on students' unique strengths so that students will persevere in their artistic endeavours.
- Be caring, respectful, and nurturing at all times.

All of these strategies will not only enhance relations within the class, they will also facilitate student self-esteem, which is a key component in students' willingness to take risks and creatively explore with confidence during art-making activities.

Expectations Across the Curriculum

Beyond the foundations for positive student-teacher relationships, there are certain core expectations for behaviour that elementary teachers have to establish. These core expectations set the stage for learning across the curriculum and, over time, become routine. Core expectations underline any activity and provide structure that reduces the uncertainty and, ambiguity of new activities, procedures, materials, and tools associated with art classes. These expectations enhance learning by making the classroom an environment that students understand, and feel secure in, both psychologically and physically. Example expectations could include: listen to someone when they are talking, respect each other at all times, and keep your desk tidy.

Procedures Specific to Art Activities

It is important to establish safe, respectful behaviour by creating guidelines for how students move and work during art activities. When developing procedures specifically for an art activity, one needs to address the following areas:

- Setup of materials
 - How will students get materials? How will students protect surfaces and themselves from hazards?

- Getting students' attention
 - Do you have a safety signal, such as putting up your arm or turning off the lights? What do you expect students to do when they see the signal?

- Noise level
 - How do you want students to communicate? What noise level will you be comfortable with? Can the students listen to music while completing activities?

- Movement
 - When can students get up? Who can get up? Where can students go?

- Space
 - Do you have areas for storage, drying, demonstration, work, and cleanup?

- Early finishers
 - What should students do when they are finished? Should they select another activity, begin the next task, read silently, draw in a sketchbook, or something else?

- Cleanup
 - What is each student responsible for during cleanup? Where do materials get put away? How will you monitor cleanup?

Developing Rules for Art Activities

Teachers have ultimate control over what materials and activities will be part of their art program, yet a well-managed class can be democratic in some important ways. Students value rules more if students themselves are involved in formulating the expectations they will have to follow. Koster (2001) recommends asking students in what kind of place they would like to create art and then writing a list based on what students have shared. Next, ask if they have ever been hurt or felt bad while creating art. Then explain to the class why "it is important to have guidelines in place so that they can have the kind of place they described in the first list and so that they can work safely" (p. 320). With the students, develop concise rules for creating art phrased in positive terms. Make sure to post the list in the classroom and make reference to it whenever a transgression occurs. Furthermore, while demonstrating with a new material or technique point out how students are to use a material or behave during an activity in relation to class rules.

Consequences

Along with establishing parameters for appropriate behaviour, there needs to be recognition that if students do not fulfil their obligations there will be consequences to bear. Again with the class, determine what compensatory actions should follow individual infractions of the class rules. These consequences should be reasonable and match the behaviour. For example, if a student creates a mess and therefore, an unsafe condition, the logical consequence is for that student to clean it up (Koster, 2001). Once rules are in place, remember to remind students of expected behaviours before starting activities.

Teacher Reflection

Susi (1995) states, "when a discipline problem occurs, teachers must look at their own personal behaviours, instructional practices, and management systems for clues leading to the sources of that problem" (p. 6). Through this reflection, all instruction-related variables are eliminated as contributing factors to discipline problems before looking to outside factors, such as the offending student, for explanations of what might have caused the situation (Susi, 1995; 1996). Teachers need to determine if they have done everything possible to make their activities and lessons challenging, relevant, and clear so that inappropriate behaviour is unappealing to students (Susi, 1995).

Response to Misbehaviour

Quick (1996) recommends catching misbehaviour early and addressing it right away in order to avoid simple misbehaviours escalating to more serious confrontations. The way in which you choose to react to misbehaviour will be long remembered by your students, so carefully consider your actions. One possible response to inappropriate behaviour might include using body language such as making eye contact with the student or physically moving to where the disturbance is coming from. A look or the close proximity of the teacher can often deter further negative behaviour. Try and avoid confronting students in front of the class, since this only draws unwanted attention to the student or the behaviour. Preferably, the teacher should calmly intervene using a low-profile approach to communicate displeasure with the behaviour, not the student. In this same manner, privately request that the student switch seats, or remain after class.

Prevention of Inappropriate Behaviour

Apart from establishing classroom rules, techniques such as monitoring behaviour, reinforcing positive behaviour, and thorough instruction, also assist in preventing inappropriate behaviour during art activities. Keeping constant check on student behaviour through monitoring is an effective way to detect minor problems before they become major disturbances or harmful situations. Constantly scanning the room makes students aware that they are being watched at all times. Additionally, by carefully observing behaviours, noting adherence to procedures, and by looking for unusually slow progress, confusion, or frustration, the teacher can respond to potential difficulties and take steps to clarify any confusion immediately (Susi, 1995).

Although it is valuable to recognize when students are not performing correctly, it is arguably more important to recognize when students are performing properly. Koster (2001) claims that statements addressing the entire class, rather than an individual, and that statements focusing on an observed positive behaviour, will instantly improve every student's behaviour. When proper behaviour occurs, highlight the action by saying something such as "I see that you are…" This type of positive statement will reinforce expected actions.

According to Susi (1995), "the effective implementation of an art program depends as much on instructional thoroughness as on skill in control and monitoring" (p. 34). Many educators believe that good behaviour is the natural outcome of effective teaching.

The combination of well-planned instructional strategies and lessons can go a long way in preventing discipline problems. Susi recommends that teachers demonstrate and provide instruction to the class as a whole, because monitoring behaviour will be easier than when small group or individual instruction is provided. During group instruction, the teacher must insist on having each student's undivided attention before proceeding with demonstrations or instructions to make sure all students are attending.

Art Materials Safety

In elementary classrooms, teachers spend time modelling respect for their individual students, nourishing respect amongst their students, as well as encouraging respect amongst students for their shared classroom environment. Pertaining to art activities, teachers need to also devote some attention to cultivating respect for the materials and processes used in creating art. It is the teacher's responsibility to provide safe art materials as well as clear instruction pertaining to the use of these materials in order for students to experiment and create with confidence (Koster, 2001). This requires that teachers be informed about potential hazards and take precautions to ensure that working with particular art materials does not lead to student injury or illness (Qualley, 1986). This second part of the chapter covers issues around exposure to art materials, risk factors for children, handling of hazardous materials, and safe alternatives for the elementary classroom.

Risk Factors

Elementary-aged children are at an elevated risk from exposure to hazardous art materials and activities because of the following developmental factors:
Behaviour
o Children may misuse tools and materials during creative explorations. They are more likely to put harmful art materials in their mouths than older students. For this reason, children should not use materials that might be hazardous if swallowed or inhaled.
Muscular Control
o Children are still developing their fine motor skills and physical strength. Certain tools and processes may be difficult for them.
Body Size
o Because children are smaller than older students, the same amount of a hazardous substance will be more concentrated in a child's body (Health Canada, 1994) and therefore, be more harmful.

Health Canada (1994) advises that the point to remember here is "the younger the child, the greater the risk" (p. 8). Therefore, a teacher's knowledge and choice of materials is crucial.

Exposure: Ingestion, Skin Contact, and Inhalation

Certain art materials contain toxic and harmful chemicals that children in your care should not be exposed to, especially through ingestion, contact with skin, or inhalation. The harmful effects can be minimised by a suitable choice of materials and precautions. To protect against contamination through ingestion, do not allow eating in the art area and have children wash their hands after art activities. Exposure to harmful chemicals may result in harm to the skin therefore, require students to wear protective clothing such as aprons, long sleeves, or gloves. The inhalation of airborne substances such as smoke, dusts, spray mists, or fumes, can damage the lining of children's lungs and airways. Provide adequate ventilation, conduct activities outdoors, or refrain from art activities that produce potentially harmful vapours.

Storage, Handling, and Labelling

Correct storage and handling of art materials is an important responsibility of the teacher. When not in use, collect and store art materials and tools in a safe place such as a locked closet. Keep art materials tightly closed in their original containers so that any colleague can read the label or directions for correct use. It is imperative that you carefully read and follow the safety instructions for every art material, each time you use the material. Discard old art supplies because there may have been deterioration or the supplies themselves may be considered unsafe by current standards. Be sure to check the product label and the Material Safety Data Sheet (MSDS) provided by the manufacturer for information regarding its possible hazards and any precautions that should be taken. In Canada, potentially hazardous arts materials will be labelled with health and usage warnings in accordance with labelling requirements as determined by the Hazardous Products Act (Health Canada, 1994).

Hazardous Materials and Safe Alternatives

While it is impossible to list all of the potential hazards involved in every art material or process, the examples found in figure 1 (adapted from a chart found in Koster, 2001, p. 319) highlight some common materials that could be harmful along with suggestions for safer

alternatives to use in elementary art classes.

Toxic Ingredients

When choosing art materials, avoid adult materials that could have toxic ingredients. Instead look for materials specifically designed for children or those materials identified as safe for children's use. Artist-quality oil paint, watercolours, acrylic paint, and pastels may contain hazardous pigments and should not be used with elementary-aged students. Some glazes may contain lead. Glazes labelled "lead-free" or "leadless" are safer alternatives for student use.

Fumes

You should steer clear of projects that create fumes or require special ventilation. Qualley (1986) states, "poor ventilation is one of the most important health problems in schools" (p. 4). The opening of doors or windows alone is not adequate ventilation in most cases. When melting wax, take care to not let the liquid wax get so hot that is smokes because these fumes can be hazardous. Appropriate ventilation for this process could include open windows and fans to assist the flow of air. Kiln firings take several hours to complete, during which time various fumes, that can be dangerous or poisonous to the lungs, are produced. In order to prevent students from breathing in these gases, kilns need to be vented through a canopy hood.

Hazardous Materials and Methods	Safer Alternatives
Toxic Pigments	
Artist-quality oil, watercolour, and acrylic paints	Use student watercolours, tempera paint, and water-soluble acrylics.
Artist-quality pastels	Use student pastels.
Glazes for firing clay	Use lead-free glazes.
Fumes and Toxic Gases	
Waxes	Melt over hot water, not over direct heat. Don't let it smoke. Provide ventilation.
Kiln firing	Make sure there is the proper ventilation (canopy hood).
Solvent-Based Products	**Water-Based Products (Washable)**
Varnish, or shellac	Use gloss polymer medium
Rubber cement, or other solvent-based adhesives	Use white glues.
Permanent markers	Use water-based markers.
Oil paint	Use watercolours, tempera paint, and water-soluble acrylics.
Oil-based printmaking inks	Use water-based inks
Dusts	
Clay	Use only moist, premixed clay. Wipe surfaces and mop the floor after use.
Powdered glazes	Use liquid, lead-free glazes.
Chalk, chalk pastels, and charcoal	Use dustless chalk and conte crayons.
Powdered tempera paint	Use liquid paint.
Aerosol Sprays	**Nonaerosols**
Spray paint	Use sponging, brushing, or dipping techniques.
Spray adhesives	Use liquid white glues.
Spray fixative	Cover chalk and/or charcoal drawings with paper and gently rub off extra.

Figure 1
Adapted from: J.B. Koster. (2001). *Bringing art into the elementary classroom*. (p. 319). Belmont, CA: Wadsworth.

Solvent-Based Products

Oil-based products emit harmful vapours and need adequate ventilation. They can also contaminate unprotected skin. Moreover, oil or solvent-based products are flammable. To keep health hazards to a minimum, use water-based products, such as water-based printmaking ink, watercolour, tempera, or acrylic paint, that are washable and solvent-free in place of solvent-based products, such as oil paint or oil-based printmaking ink, that require solvents, like turpentine, to clean-up. When a sealant or a high sheen is desired use water-based gloss polymer medium instead of varnish or shellac. Rubber cement is not only flammable, but also contains fast evaporating solvents that are hazardous when inhaled. White liquid glue, glue sticks, and double-sided tape are relatively risk-free adhesives to use with elementary-aged children. Furthermore, permanent felt-tip makers can be very toxic, and should never be used in elementary classrooms. Water-based makers are a safe alternative.

Powders

Any materials in a dry powdered state or that create dust can be inhaled and get into children's eyes. Instead choose projects that will not cause harm. For instance, it is safer to buy supplies such as glazes, clay, and paint in premixed, paste, or liquid form. Additionally, charcoal and chalk pastels can create quantities of dust in the classroom that can irritate students. Dustless chalk and conté crayons are safer alternatives, because they create less respirable-sized dust particles.

Aerosol Spray

Finally, teachers should refrain from using aerosol sprays because of the dangerous fine mists of chemical compounds that teachers and children can inhale. As a replacement technique for spray painting, use sponging, brushing, dipping, or splattering with water-based paints. Teachers may choose to spray paint outdoors on their own away from students. Spray adhesives are similar to rubber cement, but they are more problematic because the particles are "forcefully airborne" (Qualley, 1986, p. 35). Spray fixatives should only be used by teachers outdoors or not at all. In lieu of spray fixatives, paper can be placed over chalk or charcoal drawings and excess dust can be rubbed off gently (Koster, 2001).

Choosing Age-Appropriate Supplies and Tools

You must select supplies and tools that match the age and physical development of the students you are teaching (Koster, 2001). If you have to spend too much time preparing art project materials so that your students can then work with them, it is probably not an appropriate activity for your class. Students should do most of their own work in order to learn. Moreover, Susi (1996) contends that gearing your art program to the developmental level of your students is crucial for maintaining student motivation and interest as well as minimizing disruptive or harmful behaviour.

Providing Instruction

Even though an art material may be age-appropriate and meet all the safely guidelines, it may not be used in a particularly safe way by students and could therefore prove harmful. Koster (2001) reminds us "tools such as scissors, paintbrushes, and pencils can cause injury if handled improperly" (p. 318). In general, students do not come to the art class with understanding of the proper methods for handling materials and working with tools they will use. It is up to the teacher to provide clear instruction to enable students to successfully learn how to use equipment correctly and safely.

According to Qualley (1986), the purpose of hazards instruction in the art class "is to call attention to the fact that art materials and processes, like many other things encountered in daily living, can be harmful if we are careless" (p. 9). Therefore, an appreciation of the potential hazards of working with art materials and tools, as well as an awareness of safety precautions should be fostered in elementary students. These basic precautions learned in using school materials can promote safe work habits for any student who goes on to use these materials or even more hazardous ones on their own.

Conclusion

Providing a safe and secure environment in which students can learn in the elementary classroom depends on proper management and safety awareness set in place by the teacher. As this chapter has attempted to outline, good classroom management is a balancing act between promoting confidence and curtailing certain behaviours that detract from establishing a positive classroom environment. Art activities can be hazardous, but with knowledge and awareness, teachers can make safe, appropriate choices for their students. Through promoting awareness and confidence, students will actually feel more comfortable with taking certain risks while creating.

References

Belvel, P. S. & Jordan, M. M. (2003). *Rethinking classroom management.* Thousand Oaks, California: Corwin Press.

Canada. Health and Welfare Canada (1994). *Art teacher, be aware: A booklet about the safe use of arts and crafts materials for elementary school teachers.* Ottawa, ON: Health and Welfare Canada.

Koster, J. B. (2001). *Bringing art into the elementary classroom.* Belmont, CA: Wadsworth.

Qualley, C. A. (1986). *Safety in the artroom.* Worcester, MA: Davis Publications.

Quick, P. H. (1996). Survival skills for new (and not so new) student discipline. In A. L. Nyman (Ed.), *Instructional methods for the artroom* (pp. 26 – 27). Reston, VA: NAEA.

Susi, F. D. (1996). Behaviour management in the art classroom. In A. L. Nyman (Ed.), *Instructional methods for the artroom* (pp. 23-25). Reston, VA: NAEA.

Susi, F. D. (1995). *Student behaviour in art classrooms: The dynamics of discipline.* Reston, VA: NAEA

CONNECTING, REFLECTING AND IMAGINING